THE IMAGE OF CHRIST IN M

The art of our age is by no means as secular as some think, and in this fascinating and finely documented study, Richard Harries traces some of the ways in which the image of Christ has tunnelled its way back into the central territory of the imagination in the work of some surprising modern artists. A fascinating and fresh survey.

Rowan Williams, Magdalene College, Cambridge, UK

This is a finely written, important and original take on the art of the last hundred years. Richard Harries faces the difficulty that modern artists have had in representing Christ in a largely secular and indifferent world. He calls up as witnesses artists such as Rouault, David Jones, Elizabeth Frink, John Piper and many others who make his point that Christ still lives on, and dynamically, in modern art. His argument is bold and completely convincing.

Melvyn Bragg, writer and broadcaster

Until fairly recently, modern art used to be discussed primarily in terms of its formal challenge and its rupturing of traditional habits and expectation. Today, we bring to this art a wider embrace, owing to the many perspectives from which it is now viewed. It is especially interesting to see what happens when a theological lens is held over modern painting and sculpture, as happens here. Richard Harries is an authoritative voice on the relationship between theology and the arts, and he is a brisk, compelling guide to Christian iconography in art. He focuses our attention on a rich seam of imagery, sourced by many things, not least a recurrent desire to return to the old in order to make it new.'

Frances Spalding, Newcastle University, UK

The Image of Christ in Modern Art explores the challenges, presented by the radical and rapid changes of artistic style in the 20th century, to artists who wished to relate to traditional Christian imagery. In this highly illustrated book, Richard Harries looks at artists associated with the birth of modernism, such as Epstein and Rouault, as well as those with a highly distinctive understanding of religion such as Chagall and Stanley Spencer. Through a beautiful range of images and insightful text, Harries suggests that the modern movement in art has turned out to be a friend not a foe of Christian art, and that which is visual can in some way indicate the transcendent.

To my darling John,

with all my love

June

May 24th 2014

For David and Natasha

The Image of Christ in Modern Art

RICHARD HARRIES
Professor Lord Harries of Pentregarth

ASHGATE

Published by
Ashgate Publishing Limited
Wey Court East
Union Road
Farnham
Surrey, GU9 7PT
England

Ashgate Publishing Company
110 Cherry Street
Suite 3-1
Burlington, VT 05401-4405
USA

www.ashgate.com

British Library Cataloguing in Publication Data
A catalogue record for this book is available from the British Library

Library of Congress Cataloging-in-Publication Data
Harries, Richard, 1936-
 The Image of Christ in Modern art / by Richard Harries.
 pages cm
 Includes bibliographical references and index.
 1. Jesus Christ – Art. 2. Christian art and symbolism – Modern period, 1500- 3. Aesthetics, Modern – 20th century. 4. Aesthetics, Modern – 21st century. I. Title.
 N8050.H37 2013
 704.9'48530904–dc23 2013007768

ISBN 9781409463818 (hbk)
ISBN 9781409463825 (pbk)
ISBN: 9781409463832 (ebk-PDF)
ISBN 9781409463849 (ebk-e-PUB)

Printed in the United Kingdom by Henry Ling Limited, at the Dorset Press, Dorchester, DT1 1HD

Contents

List of Illustrations

About the Author

Richard Harries was Bishop of Oxford from 1987–2006. On his retirement he was made a Life Peer and as Lord Harries of Pentregarth he continues to be active in the House of Lords. He is an Emeritus Gresham Professor, and a Fellow and an Honorary Professor of Theology at King's College, London. He is an Honorary Doctor of Divinity of the University of London and an Honorary Fellow of Selwyn College, Cambridge and of St Anne's College, Oxford. He is the author of 26 books mainly on the interface of Christian faith and the wider culture, including the arts, and he is a Fellow of the Royal Society of Literature. He is the author of *The Passion in Christian Art* (Ashgate, 2004). His book *Art and the Beauty of God*, (2000) was chosen as a book of the year by the late Anthony Burgess in *The Observer*. His most recent books include *The Re-enchantment of Morality*, which was shortlisted for the 2011 Michael Ramsey prize for theological writing.

Introduction[1]

Interest in contemporary art with a spiritual dimension or religious theme is keener today that it has been since Victorian times. Cathedrals hold exhibitions and commission works, and indeed so do some parish churches. Some of the biggest names in the art world often draw on or refer to a religious theme or seem, to the viewer, to have a spiritual dimension to their work.

It might once have been thought that the advent of modernism before World War I had put an end to art with any explicit religious reference. That has proved not to be the case. The first three chapters of this book reveal that there is more good and enduring work drawing on Christian iconography from the early decades of the twentieth century than most people were aware of at the time. Since World War II interest in Christian art has heightened. This is partly because of a recovery of confidence about placing modern art in sacred places and partly because of pioneering work by a few individuals and organisations. Particular mention must be made of the Methodist collection of modern Christian art which was initiated in the early 1960s by a Methodist layman.[2] There have been a number of key individuals, such as Walter Hussey, who are discussed in the text. More recently there has been Tom Devonshire Jones, who founded Art and Christian Enquiry (ACE) which has done more than any other body to encourage and comment on cutting-edge art from a Christian perspective, with a journal and substantial annual prizes for a range of different kinds of work. Some of the most interesting work in churches can be seen in their publication, *Contemporary Art in British Churches*,[3] and on their website.

A brief survey by Tom Devonshire Jones – *Art, Theology, Church* – gives an indication of the wide range of exhibitions and work during that period.[4] In 1984 Michael Day surveyed what was then available in English churches, going back to late Victorian times.[5] Since then there have been a number of exhibitions with useful catalogues indicating the range of work now going on, such as: *Images of Christ*,[6] *Seeing the Light: The 3 Cathedrals Exhibition*,[7] *Stations: The New Sacred Art*,[8] *Presence: Images of Christ for the Third Millennium*[9] and *Cross Purposes: Shock and Contemplation in Images of the Crucifixion*.[10]

[1] I would like to thank Gresham College and its staff for facilitating the original lectures in the Museum of London, out of which this book has grown. I would also like to thank Sarah Lloyd and those at Ashgate for their help and support in the publication of this book, and Professor Frances Spalding for reading the draft at an earlier stage, and for her comments.

[2] Roger Wollen, *The Methodist Church Collection of Modern Christian Art: An Introduction*, Trustees of the Methodist Church Collection of Modern Christian Art, 2000.

[3] *Contemporary Art in British Churches*, ed. Laura Moffatt, Art and Christian Enquiry, 2010.

[4] Originally published in *Theology*, and reprinted in *Images of Christ: Religious Iconography in Twentieth Century Art*, ed. Tom Devonshire Jones, St Matthew's (Northampton) Centenary Art Committee, 1993.

[5] Michael Day, *Modern Art in English Churches*, Mowbray, 1984.

[6] Ibid.

[7] Art 2000, 1999.

[8] Bury St Edmunds Art Gallery, 2000.

[9] Biblelands, 2004.

[10] Mascalls Gallery, Paddock Wood and Ben Uri Art Gallery, London, 2010, ed. Nathaniel Hepburn.

In this short book I have not been able to discuss all the artists who appeared in these and other exhibitions, and I apologise to those who feel overlooked. This book is also limited in its scope in other ways. Apart from one very brief reference to Barnett Newman, there is no art from America. There is also no art from outside Europe included, though I am aware of a rich field to be surveyed, for in every culture where the Christian faith has gained a place there have been artists who have wanted to express their faith through art. *Christ for All People: Celebrating a World of Christian Art*[11] indicates some of this richness and variety, as does *Beyond Belief: Modern Art and the Religious Imagination*.[12] There is Christian art from Africa, China and South East Asia. There has been some particularly interesting work from India from people such as Jyoti Sahi, reproduced in *Faces of Vision*,[13] and Solomon Raj.[14] The focus of this book however, though it begins with the German expressionists, is primarily on Great Britain, especially the post-World War II period.

It is possible to distinguish at least four senses in which the Christian faith might be said to relate to art. First, it is possible to argue, as I have elsewhere, that all genuine art has a spiritual dimension, just by being good art. The artist's personal beliefs or lack of them are another issue altogether.[15] Secondly, it is possible to point to the work of believing Christians, whatever the subject matter of their art. There have been, and there are, serious Christian artists who paint portraits or landscapes but who are not drawn to paint Christian scenes. Cezanne attended Mass daily and said 'If I did not believe, I could not paint',[16] but he expressed his faith in the wonderful paintings of mountains and landscapes for which he is well known. He did not paint Christ on the cross, or Mary. It is this understanding of Christian art that W.H. Auden had in mind when he wrote:

> There can no more be a 'Christian' art than there can be a Christian science or a Christian diet. There can only be a Christian spirit in which an artist, a scientist, works or does not work. A painting of the Crucifixion is not necessarily more Christian in spirit than a still life, and may very well be less.[17]

Thirdly, art can be said to be Christian if it seems to express or evoke certain characteristics associated with the Christian faith, such as redemption, forgiveness and loving kindness.[18] Fourthly, there is art that is related in some way to traditional Christian iconography, which might be the work of a Christian, a Jew or someone of another faith or of no faith at all.

The focus of the present book is exclusively with this fourth category of work. It does not set out to be a superior approach to the others, just one which gives a more precise focus than that of the three alternative approaches. It will look at some of the most interesting works of art of the last 100 years or so, not only from the standpoint of how they relate to the artistic climate of their time but also from their relationship to traditional Christian iconography. Some of the artists considered in this study defined themselves as believing Christians; at least two are from a Jewish background; and several would regard themselves as religious only in the widest sense of that

[11] *Christ for All People: Celebrating a World of Christian Art*, ed. Ron O'Grady, WCC Publications, 2001.

[12] *Modern Art and the Religious Imagination*, ed. Rosemary Crumlin, National Gallery of Australia, 1998.

[13] Eric Lott and Jyoti Sahi, *Faces of Vision: Images of Life and Faith*, Christians Aware, 2008.

[14] For example, in P. Solomon Raj, *Palm Leaf Prayers*, United Evangelical Mission, 1995.

[15] Richard Harries, *Art and the Beauty of God: A Christian Understanding*, SPCK, 1993.

[16] Alexander Liberman, *The Artist in his Studio*, Thames & Hudson, 1988, p.6.

[17] W.H. Auden, Complete Works: Prose. Vol. IV, 1956–1962, ed. Edward Mendelson, Princeton, 2010, p.776.

[18] This is obviously a very wide category, as can be seen in the discussion in the editions of *Art and Christianity* 69 and 70 for the spring and summer of 2012.

term.[19] No claims are being made about the intrinsic merits of work in this category compared to work in the other three. It has been chosen as the focus for this study because, as will become clear, modern movements have posed a particularly sharp challenge to this kind of art – for it almost goes without saying that most art that has reflected traditional Christian themes over the last 100 years has been pastiche. But some has been good. Much more has been good than is generally recognised, and it is this which makes this study worthwhile.

It is often said that people today, whilst reluctant to see themselves as religious, often define themselves as spiritual. That is a word that covers a multitude of meanings, and with such multiple meanings there has been in the past and is today and huge variety of work that could be considered. A major exhibition, 'The Spiritual in Art: Abstract Painting 1890–1985',[20] revealed how many of the abstract expressionists brought a definite spiritual viewpoint to their work derived from such sources as Theosophy, Cabala, Hermeticism, Neo-Platonism, Paracelsus, Madame Blavatsky, Zen, the Occult, Rosicrucianism, Swedendborg, Spiritualism and so on. That approach is outside the focus of this book; so too is the concept of the spiritual in an even wider sense as, for example, represented in a work like *100 Artists See God*.[21]

The term modern in the title also needs defining. There is a vigorous debate amongst art historians as to when the modern movement began. Clearly a strong case can be made for it originating with the impressionists. However, I am taking the period shortly before World War I as my starting point. This is because the source of modernism in music and literature is usually traced back to Paris in 1913, to the performance of Stravinsky's *Rite of Spring* and James Joyce's novel *Ulysses*. The other reason is that the German expressionists emerged and flourished at that time, and Christian themes were a much more pronounced feature of their work than it was for their immediate predecessors.

So the focus of this work is quite sharp. It is concerned with images of Christ in the period from before World War I until our own time, whatever the personal beliefs of the artist who produced them. Very occasionally I discuss images not of Christ himself but of persons or scenes that reflect him. This is because it has long been part of Christian tradition, one which is rooted in the New Testament itself, that we see Christ not only in the historical Jesus but also in those people and scenes most closely associated with him.

It has been possible to include a good number of illustrations in the book, but not as many as are discussed in the text, because sometimes I have wanted to consider an artist's more overtly religious work in relation to their *oeuvre* as a whole. Images which are included in the book are referred to in the text in **bold** type. Those which are referred to but not included are underlined in the text. These can mostly be found on the internet.

[19] My categorisation differs somewhat from that of Sister Wendy Beckett in her book *Art and the Sacred*, Rider Books, 1992, pp.2–8, one which is accepted by Keith Walker in *Images or Idols? The Place of Sacred Art in Churches Today*, Canterbury Press, 1996, p.106. They distinguish between religious art, which is governed by the images of a particular religion; spiritual art, which arrests us and takes us more deeply into things; and sacred art, which is simply spiritual art that has become transparent to the numinous. Rothko is given as an example of the latter to indicate that the subject may have no reference to any religious symbolism. I too find that Rothko's paintings open up to the numinous. I find this mysterious and do not know how to fully account for it. Nevertheless I am cautious about the category of sacred art as defined by Beckett and accepted by Walker, because I would lay more stress on our preconceived notions and images in inducing that sense of otherness.

[20] *The Spiritual in Art: Abstract Painting 1890–1985*, ed. Maurice Tuchman et al., Abbeville Press, 1995.

[21] *100 Artists See God*, ed. John Baldessari and Meg Cranston, Independent Curators International, New York, 2005.

Chapter 1

The Break

The artist and poet David Jones said that he and all his contemporaries were acutely aware of what he called 'The Break'.[1] By this he meant two things. First, the dominant cultural and religious ideology that had unified Europe for more than 1,000 years no longer existed. All that was left were fragmentary individual visions. Secondly, the world is now dominated by technology, so that the arts seem to be marginalised. They are of no obvious use in such a society, and their previous role as signs no longer has any widespread public resonance. Their work was 'idiosyncratic and personal in expression and experimental in technique, intimate and private rather than public and corporate'.[2] 'The priest and the artist are already in the catacombs, but *separate* catacombs, for the technician divides to rule.'[3] There was no corporate tradition and, he argued, one could not be looked for without a renewal of the whole culture. Writing after World War II, he remarked that the situation at that time was even more pronounced and dire than it had seemed in the 1930s.[4] This was a problem with which Jones wrestled all his life in both his poetry and painting, and it is arguable that his failure to resolve it to his satisfaction resulted in both his personal breakdowns and the complex strangeness of some of his work. His thought on this subject, as well as his art, will be discussed in more detail in Chapter 3.

David Jones and his contemporaries believed that this radical break with the past occurred in the nineteenth century. It is however arguable that it occurred before that. In a perceptive article in the *Spectator* in 1935 discussing Jacob Epstein's **Ecce Homo**, Anthony Blunt thought the break occurred much earlier.[5] He pointed out that in a society where religion is a natural part of life, religious art emerges with equal naturalness. But since the Enlightenment religion has not been woven into the texture of our culture, and artists who wish to convey a religious vision will almost invariably produce work which is private, out of step with the dominant culture and idiosyncratic, a good example being William Blake (1757–1827). In the nineteenth century an attempt was made to solve this problem by the revival of a medieval style, as with the Gothic Revival, or the early Italian one, as in the case of the Pre-Raphaelites. But Blunt did not think these attempts really met the challenge of the modern world, and were in fact an artifice for avoiding it. But whenever the break occurred, 'The great difficulty which has faced religious artists in Europe for about a century is that our natural tradition for expressing religious feeling is utterly used up and dead.'

Christian art was once part of what the distinguished art critic, the late Peter Fuller, once called a 'symbolic order'. This consisted of shared narratives and recognised images through which the deeper meaning of life could be explored. This has gone. 'The disassociation between art and faith is not written in stone but is not easy to overcome', as the contemporary artist Roger Wagner has observed. He writes that there are some formidable obstacles:

[1] David Jones, *The Anathemata*, Faber, 1952, p.15.
[2] David Jones, 'Religion and the Muses' (1941), in *Epoch and Artist*, Faber, 2008, p.98.
[3] Ibid., p.103.
[4] David Jones, 'Notes on the 1930s' (1965), in *The Dying Gaul and Other Writings*, Faber, 2008, p.49.
[5] The article was printed in *The Spectator* on 15 March 1935.

To begin with, there is the problem of style. The problem of how to avoid mere pastiche of what has gone before – how to bring freshness to subjects that have been treated so often that they feel used up – is not a new one. But whereas artists in the past inherited a broadly uniform language that was at any rate a starting point, contemporary artists faced with an overwhelming plurality are compelled to choose a language of their own, and, in choosing, to exclude a part of the potential audience. A private language chosen out of a competing Babel cannot speak to everyone. But stylistic problems of this kind are only a beginning. Much more formidable than the problem of finding an artistic language is the problem of finding a forum in which to speak. In an art world where novelty and shock value are highly prized, work expressive of any kind of religious commitment is unlikely to find a ready welcome. It is difficult, for instance, to imagine a conventionally religious work winning the Turner Prize.[6]

He goes on to say that this would not matter if the Church was commissioning art, but with a few honourable exceptions, he thought this was not happening.

If what Jones called 'the break' was the main reason for the disassociation of the church and modern art, the church itself must accept responsibility for its own role in this cleavage. This responsibility is one of the major themes of Keith Walker's book *Images or Idols?* He has written:

Whilst the cultural thrust of the times has had something to do with the estrangement between sacred visual art and the Church, blame must lie with the Church, both in clinging to an outdated theology and being unwilling to venture into an aspect of cultural life where once it claimed authority and admiration.[7]

One result of this situation is that the last 100 years of art have been characterised by radical and rapid changes in style. So the question behind this book is: how did artists who wished to relate to traditional Christian themes in some way do so whilst retaining their artistic integrity? How could they be fully of their time yet also standing in a tradition that goes back to the art of the catacombs in the third century? How could they find their own voice in a way that enabled them to be at once an authentically modern artist, and recognisably one belonging to all Christian time?

If that challenge is not formidable enough, there is an even greater one, which belongs not just to our own time but which has been there from the beginning of Christian representation and which remains in every age. How can what is invisible be rendered by what is visible, what is infinite by what is finite, what is transcendent by what is human and limited? The answer of Islam and Judaism in most ages is that it cannot be so rendered. Islamic art at its best, for example in the mosques of Sinan in Istanbul, conveys to the visitor an overwhelming sense of Tawhid, the unutterable, transcendent unity of God, which is way beyond anything that can be seen by the human eye or conceived by the human imagination. Christians want to affirm that truth, whilst suggesting it is not the whole truth. John of Damascus, the great standard-bearer of Orthodox Christian belief in the East in the eighth century, said that what God is in himself is totally incomprehensible and unknowable. That is why there is no attempt in Orthodox art to depict God the Father. And that is why it has always been such a crude mistake when this has been done in the Western tradition, as

[6] Roger Wagner, 'Art and Faith', in *Public Life and the Place of the Church: Reflections to Honour the Bishop of Oxford*, ed. Michael Brierley, Ashgate, 2006, p.133.

[7] Walker, *Images or Idols?*, p.45. The record was particularly bleak until post-World War II, but now, as will be explored in the last chapter, the situation is much more promising. Walker offers practical as well as theological guidance for the commissioning of art by churches.

for example in the depictions of God as an old man with a white beard. Of course we do not try to represent the invisible God, said John; but the invisible has been made visible. That is why we must have an iconic art. This means that art is not just an optional extra to the Christian faith, but is essential to it. We are called to try to convey, through the material of paint and canvas and stone, the fact that the invisible has been made visible; the Word has been made flesh.

The challenge remains: how to do this? How can an assemblage of paint or a carved stone indicate that other dimension which has become part of our world of space and time? The problem is further compounded by the Christian conviction that in taking our humanity upon himself Christ lived a truly human, and indeed an essentially hidden life. It was not one that drew attention to itself through shock and awe. It did not overwhelm. A recent magnificent exhibition of bronzes at the Royal Academy had one room given over to images of gods from all ages and cultures. As I entered the room I reflected on what I felt about this. How could God be represented? Surely it would not be right for Jesus – whom Christians believe to be 'God from God, Light from Light, true God from true God' as the Nicene Creed puts it – to be included in a room as just one more god in a category of gods? Some of the images were very beautiful, like the Buddhas of the Gandhara and Gupta periods; others were very striking, such as the dancing Nataraja Shiva of Hinduism. What could possibly distinguish the one and only true God of Christian belief? Then, there he was: a thoroughly human Jesus – *Seated Christ* by Adriaen de Vries (1556–1626), with nothing to distinguish him from any other human being.[8] God is revealed in a truly human, largely hidden, life; a life like the rest of us.

The problem for the artist wanting to depict the Christ of this truth is not essentially different from that of the theologian wanting to use words to understand who he is. It was the problem that preoccupied the Christian Church and its councils for nearly eight centuries. Jesus is completely human, and completely God. How can he be both and at the same time one person? It was this issue that lay behind not only the paradoxical formulations of the church councils, but also the gradual emergence of an officially endorsed system of Christian iconography in what we term icons. It is easy, we might say, to depict Jesus as a human being of his time, essentially anonymous in the midst of other human beings. So, in early Christian art he can be seen as a Roman youth with a sheep on his back; or, to give a modern example, a frail human being, as in Mark Wallinger's 'Ecco Homo'. But what is there about that ordinary anonymous figure that makes us think that he is also 'God of God, Light of Light, Very God of very God'? The temptation is to make the scene highly theatrical as in Baroque art, or highly emotional and dramatic as in the art of the Counter-Reformation. But this misses the point, that the divine has to be recognised in and through the essentially hidden, as Kierkegaard insisted. Yet there has to be something about that hidden figure that makes a difference to what we see and how we see not only him but life itself. As Rowan Williams has put it:

> Some of the history of Christian art is about the tension between recognising that the change associated with Jesus is incapable of representation and recognising that for the change to be communicable it must in some way be represented.[9]

Williams suggests that the element of irony is one way in which this divine difference is suggested, and that when this is lost, we get the banalities of so much Christian art, particularly in the nineteenth century, when Jesus is depicted as 'robed and radiant, calm and stately'. In this banal

[8] *Bronze*, ed. David Ekserdjian, Royal Academy of Arts, 2012, pp. 205 and 272.

[9] This and the next quotations are from a characteristically brilliant essay by Rowan Williams in *Presence: Images of Christ in the Third Millennium*, Biblelands, 2004, pp.5–8.

art the style is the very opposite of ironical or transforming; 'it renders visible the obviousness of religious sentiment of a certain kind, and so makes practically unthinkable any perception other than that already familiar'. Such art can act as a 'casual reinforcement of shared piety' but cannot bring about the reference-changing character of Jesus'.

Any genuine artist helps to change the way we see things, and so for the artist seeking to respond to Christ there will be something of 'almost paradigmatic seriousness' in the challenge. So:

> We watch expectantly as the artist searches for the appropriate form of the uncanny, waiting to see if our world becomes strange as a result of having this particular stranger, Jesus, introduced into it.

The church has sought different ways of responding to this challenge. In the Catacombs and the carvings of the fourth and fifth centuries artists drew on the features of both Dionysius and Apollo on the one hand, and Jupiter on the other, in order to bring out different aspects of his divinity. Looking for a literal likeness of Jesus, we find this contradictory. They evidently did not. The most obvious and long-lasting response was a very simple one, the adoption of the halo. The halo indicated an aura of divinity – divine status in the case of Christ and holy status for his devout followers.

This most fundamental challenge of all, how to indicate the transcendent through the mundane, has of course remained with artists in the period covered by this study. But, as I shall suggest towards the end, it may be that modern art, for all the difficulties it has posed to artists who wanted to reflect Christian imagery in some way, has at least delivered them from the twin tyrannies of literalness and pastiche. Modern art has opened up new ways of indicating that there is something more going on in the picture than straightforward depiction.

Chapter 2
The Explosion of Modernism

German Expressionism

Leaving aside the special category of art that sought to depict a biblical scene or Christian image, most art before the end of the nineteenth century was understood in terms of a response: a response to people in the form of portraits or a response to nature depicted in landscapes or still life. Expressionism is a term used to describe the move away from art as a response, to art as the expression of powerful personal emotion through the use of colour and line. Although its antecedents lie in the late nineteenth century, especially in the work of Van Gogh, as a movement it is particularly associated with a number of artists working in the period shortly before and after World War I, beginning with the Die Brücke (The Bridge) movement in 1905. In the work of these artists, as well as some startling use of colour there was a more pronounced element of distortion in the human figure, often with overtones of violence. The importance of this art from a religious point of view was highlighted by the theologian Paul Tillich. He argued that there are two forms of art that cannot serve specifically Christian purposes. One is naturalism, as for example we have in the landscapes and portraits of the eighteenth century. Naturalism is concerned with depicting the world as it appears to our physical eyes and, as such, does not seek to lift up our eyes to what might lie behind, beyond and within the physical.

The other form which cannot serve a Christian purpose is purely abstract art. This is because Christian art does require some figurative expression, for the reason suggested in the last chapter: the invisible has become visible. For Tillich expressionism was the ideal art from the standpoint of Christian faith. In expressionism there is a representative aspect, a particular subject. This may take an unusual, even idiosyncratic form, but that exaggeration or distortion of particular features may itself serve to indicate a transcendent dimension. There is also a sense of strong emotion which is both expressed and evoked by elements of such deliberate distortion. This element was particularly important to Paul Tillich, who had been deeply shaken by his experience as a chaplain in World War I. Because of that searing experience he believed it was the alienation of humanity from its true being that was the overwhelming reality that needed to be conveyed by the arts, as well as by other disciplines. For these reasons he argued that there was a particularly close relationship between Christian art and the expressionist features in the art of every age. As he put it:

> History shows that those styles in which the expressionistic element is predominant lend themselves most readily to an artistic expression of the Spiritual Presence.[1]

He thought that expressionism, like all art, involved two fundamental principles with a potential tension between them: dedication to the truth of life as it impinges on the artist, and artistic integrity.

It was for these reasons that both Tillich himself and the expressionist artists he discussed looked to the antecedents of the expressionist work of their own time in artists of Northern Europe,

[1] Paul Tillich, *Systematic Theology: Life and the Spirit, History and the Kingdom of God*, Nisbet, 1964, vol. 3, pp.210–14.

rather than those of the Italian Renaissance, with their quieter, more devotional appeal. Above all they looked to Matthias Grünewald's Isenheim Altar, which Tillich described as the 'the Greatest German picture ever painted'.[2] This was a picture which had a huge impact in the twentieth century.[3]

Tillich's affirmation of expressionism as the quintessential form of Christian art has been criticised for undervaluing the art of other styles and traditions when it did not reflect the human condition of estrangement. It has been suggested that he was too influenced by the art he knew best in Berlin and the Museum of Modern Art in New York (MoMA), and this helped shape a view of art, as well as theology, that was too narrow in its religious sympathies.[4]

The strengths as well as the potential weaknesses of expressionism as an appropriate style for art on Christian themes will be discussed at the end of the chapter. First I discuss Emil Nolde, Max Beckmann and Otto Dix briefly, before going on to fuller explorations of the work Jacob Epstein and Georges Rouault.

Emil Nolde (1867–1956) was only a member of the Die Brücke group for a short time but his work, with its vivid colours and hints of violence, reflects, in a marked way, the main characteristics of expressionism. Nolde was brought up on a Danish farm, which had been in his mother's family for nine generations, by deeply religious parents, and a visionary view of nature is reflected in all his paintings. Between 1909 and 1912 he painted a number of scenes for a life of Christ. He wrote about two of these paintings in particular, The Last Supper and **Pentecost**, in these words:

> I obeyed an irresistible impulse to express deep spirituality and ardent religious feeling, but I did so without much deliberation, knowledge or reflection. I stood almost terrified before my drawing, without any model in nature. I painted on and on scarcely aware whether it was day or night, whether I was praying or painting. Had I felt bound to keep to the letter of the Bible or that of the dogma, I do not think I could have painted these deeply experienced pictures so powerfully.[5]

Nolde worked quickly as well as intensely, and in 1915 produced 86 canvases, of which seven were religious. These religious paintings met with a very mixed reception. His champions gave them a special status, especially his nine-part polyptych, The Life of Christ, which they regarded as the culmination of his work. On the other hand academic painters, the Church and the general public found them too disturbing, and on that basis they were refused for some of the major exhibitions of the time. Of particular controversy was the fact that the figures in his paintings looked very Jewish. He was criticised for this by Jews and also by Christians, who expected to see the disciples and

[2] Quoted by Jane Dillenberger, *Style and Content in Christian Art*, SCM, 1986, p.148.

[3] . During the nineteenth century this work was hardly discussed. The change in the way the painting was received can be located accurately and dramatically to when it was taken from Colmar to be shown in Munich for a year during 1918–19. It, and the art books and photographs promoting it, promulgated and reinforced a German self-image which saw in Grünewald – as well as in the later twentieth century German expressionism – the idea of an anguished, martyred, angst-ridden people. During the twentieth century this self-image, originally contextualised at a particular point in German history, began to have a much wider resonance, particularly in Europe as a whole, as people became ever more conscious of the suffering and tragedy of human existence. (See Ann Stieglitz, 'The reproduction of agony: towards a reception-history of Grünewald's Isenheim altar after the first world war', *Oxford Art Journal*, 12.2, 1989: 87–103).

[4] John Dillenberger, *A Theology of Artistic Sensibilities: The Visual Arts and the Church*, SCM, 1987, p.221.

[5] Quoted by Jane Dillinger, *Style and Content*, p.202. She has a description and analysis of Nolde's picture 'The Entombment'.

Jesus depicted as Aryans.[6] It is paradoxical that Nolde himself was both anti-Semitic and had his art banned by the Nazis as being degenerate.

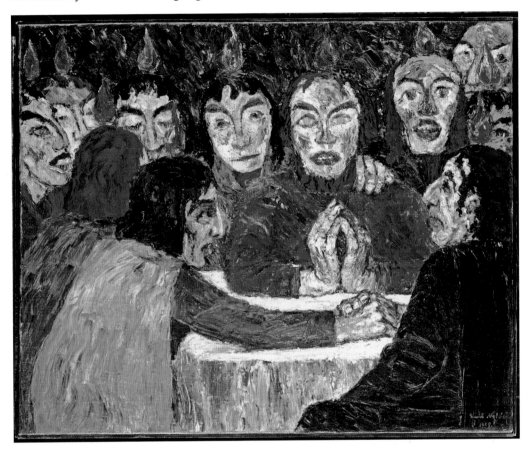

Figure 1 Emil Nolde, Pentecost, Berlin, Staatliche Museen, Nationalgalerie

In Nolde's **Pentecost**, it is the use of colour which first arrests the attention of the viewer: the green and blue of the cloak of the disciple in the foreground against a bright yellow tablecloth and faces (Figure 1). It is particularly startling that these colours also stare out of the eyes of the apostles. The six apostles at the back face forwards, eyes open, whilst the two in profile stare at each other and hold hands. The general impression is one of fierce intensity, even fanaticism, accentuated by the purple flames on the heads of the disciples binding the group together and making them eager for the future. It is certainly in marked contrast to the classical icon on the subject in the Eastern Tradition, in which the apostles sit upright in a dignified pose in a semicircle. However, this sense of heightened emotion in the painting by Nolde certainly captures some of the excitement which

6 Felicity Lunn, 'Religious Paintings', in *Emil Nolde*, ed. Peter Vergo and Felicity Lunn, Whitechapel Art Gallery, 1995, p113. This is the catalogue of the last major exhibition of Nolde's work in Britain. The curators express regret that they were not able to obtain more of Nolde's Christian art, which they regard as fundamental to his *oeuvre*; but the essay by Felicity Lunn is a useful discussion of his religious art as a whole.

the account of Pentecost in chapter 2 of the Acts of the Apostles describes, and may therefore in this respect be more faithful to the biblical account than the serenity and order of the classical depiction in the early centuries and in the Orthodox Church. Whether or not the viewer responds to the kind of religious intensity conveyed by the painting, it is not a painting that can be written off as dead to religious feeling.

Max Beckmann (1884–1950) rejected the term expressionism and what he thought it signified. Instead he was part of a movement that strove for a 'New Objectivity' (*Neue Sachlichkeit*). However critics suggest that this new short-lived movement is in fact best understood as an outgrowth of expressionism, whilst being opposed to its introspective emotionalism. Like Nolde, Beckmann much admired Northern European artists such as Bosch, Bruegel and Grünewald, and this is reflected in his own style. During World War I he served as a medical orderly, but was discharged with a nervous breakdown. As a result of his war experience his style changed dramatically. Beckmann was popular and respected as an artist until Hitler took power, when his work, like that of Nolde, was assigned to the category of 'Degenerate Art'. He eventually left Germany for Amsterdam and then New York.

Beckmann saw his work as an attempt to move 'from the illusions of life towards the essential realities that lie hidden beyond'. This interest in the spiritual side of life he shared with many other artists of the time, including Kandinsky and Mondrian. But Beckmann's more specifically religious painting also expresses a greater sense of suffering and anger. As he said:

> In my paintings I accuse God of his errors … my religion is hubris against God, defiance of God and anger that he created us (such) that we cannot love one another.

Beckmann's painting <u>Night</u> is particularly brutal in its depiction of pain being inflicted. This violence and suffering is even more specifically linked to Christ in his painting **The Descent from the Cross** (Figure 2)

Beckmann's 'The Descent from the Cross' is a fresh depiction of the subject in a number of ways. Those lowering Christ from the cross are situated just above the body which, diagonal across the picture, is thrust into the face of the viewer. This body, in which rigor mortis has set in, is stiff and angular, its sheer deadness a deliberate affront to the onlooker, and very different from the sense of sad repose usually conveyed by traditional paintings of the dead Christ. One man shields his eyes from the terrible scene. The woman, though pointing to the body, also looks away. Hans Belting wrote of Beckmann: 'His tragic experience seeks a formula of redemption.' There is perhaps an indication of this in that figure of the woman pointing at Christ. Above all, however, it is a painting designed to bring home the horrific reality of the scene, rather than encourage quiet devotion.

This painting by Beckmann is an indication of the kind of impact World War I had on depictions of Christ in the twentieth century. During that century, made terrible by two world wars and the Holocaust, the cross was widely used in art as a symbol of human suffering as a whole.[7]

The impact of war on Christian iconography is again apparent in the work of **Otto Dix** (1891–1969), who also saw himself as part of the New Objectivity movement in art. Dix served in World War I and won the Iron Cross. That war and its aftermath are depicted in his disturbing paintings of battlefields and of the disabled veterans and others who experienced the poverty that followed the conflict. Called up again in 1943, he faced the horrors of war once more and this is reflected in his work where the suffering of human beings merges with the suffering of Christ. In 1943 he

[7] This was brilliantly brought out in the exhibition 'Cross Purposes: Shock and Contemplation in Images of the Crucifixion', curated by Nathaniel Hepburn, Mascalls Gallery and Ben Uri Art Gallery, 2010.

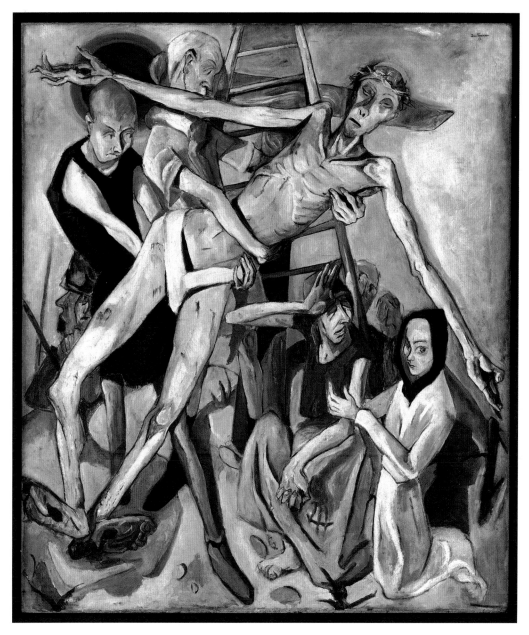

Figure 2 Max Beckmann, The Descent from the Cross, New York, Museum of Modern Art

was also investigated by the Gestapo, and in his painting <u>Christ and Veronica</u> it is German thugs, not Roman soldiers, who are taking Christ to be crucified.

In **Ecce Homo II** Dix has painted Christ as a prisoner surrounded by barbed wire, the barbed wire merging into the crown of thorns (Figure 3). At the same time the grim face beside Christ looking out through the wire is that of the artist himself. There is no glossing over or sentimentalising the suffering; it is stark and real, taking both physical and mental form. The

main impact of the painting, however, is to convey a sense that the anguish of Christ continues in the anguish of contemporary humanity. This was a pervasive theme amongst artists drawn to Christian imagery in the twentieth century.

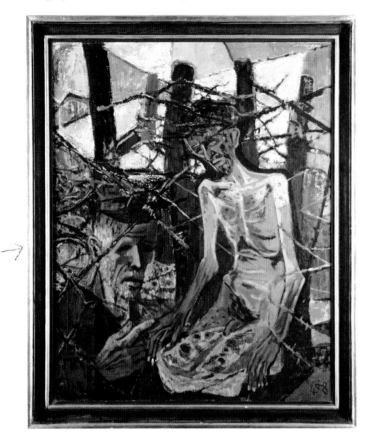

Figure 3
Otto Dix, Ecce Homo II

Jacob Epstein

Jacob Epstein (1880–1959) is often categorised as the leading sculptor of his time, in the romantic tradition of Rodin. This is true of his fine bronze heads, which were much in demand and through which he made his living. However, it was his monumental carving that meant most to him as an artist, and this is not so easily categorisable. It has some elements of expressionism, whilst also being influenced by the art of other ages and cultures.

Epstein was born in New York in 1880 at a time when it was packed with refugees from all round the world. Early on he developed a facility for drawing, and when his parents left the city he stayed behind, rented a room to make a studio, and went out into the streets to draw some of the fascinating people who had come there from so many different countries. He soon developed a strong conviction that he should be a sculptor and that he had to go to Europe – both to see great works from the past and to meet modern sculptors of quality. He studied in Paris and in 1905 came to London, eventually taking British citizenship.

At the age of 27 Epstein was commissioned to carve some statues on the front of the new British Medical Association (BMA) headquarters in London, which he did on the theme of Maternity (1908). This resulted in some strong, primal images of birth and maternity which deeply shocked people at the time. This indicates one of the defining features of Epstein's life – the sense of outrage that his carvings aroused. For example, the BMA building eventually came into the hands of the then Southern Rhodesia when, on inadequate grounds of safety, the carvings were almost totally obliterated. However, his work continued to develop, and this resulted in some superb carvings in flenite and marble. Much more controversial was Rock Drill (1913/14). This work took its place as part of the Vorticist movement of the time, and in a partly reproduced form was seen again in the Vorticist exhibition in Venice and London in 2011.

Called up in World War I, Epstein had something of a breakdown; but out of this and his sense of horror at the war, there emerged his Risen Christ. Epstein was Jewish, and had a Jewish upbringing; so how was it that his first major work on a religious theme should depict such a distinctively Christian image? In his autobiography he relates how in New York, as well as drawing, he read prodigiously and specifically mentions two books, the New Testament and Dostoevsky's *The Brothers Karamazov*, the most profound and searching of all novels which explore issues of belief and non-belief from a Christian perspective. So some Christian influence went in early. The face for 'The Risen Christ' was based on that of a friend and great supporter of his, Bernard Van Dieren, who lay very ill. Van Dieren's head seemed to Epstein to have a mystical quality, and he made a mask of it. 'The mask was filled with suffering, but it was so noble and had such a high quality of intellectual life, I thought of him as the suffering Christ', he wrote.[8] From this he made his first image of Christ in bronze, which he extended into the full-length Risen Christ.

One of the features of this work is the way that Christ points to the wound in his hand. This was an expression of Epstein's revulsion at the carnage of the war. Many years later, during World War II, he wrote about it: 'I must maintain that my statue of Christ still stands for what I intended it to be. It stands and accuses the world for its grossness, inhumanity, cruelty and beastliness.' He is not the artistic Christ of the past said Epstein, 'but the modern living Christ, compassionate and accusing at the same time'. He said he would like to remodel it to make it hundreds of feet high and set it where all could see it, where 'it would give out its symbolic warning to all lands. The Jew – the Galilean – condemns our wars, and warns us that "Shalom, Shalom" must still be the watchword between man and man.' Later, when he returned to that work, he felt he had achieved what he wanted. I recognised, he said, 'how in this work I realised the dignity of man, his feebleness, his strength, his humility and the wrath and pity of the Son of Man'.[9]

Epstein's personal life was, as they say, irregular. He had a wife to whom he was, in one way, devoted. But he had other loves, in particular Kathleen Garman, with whom he lived for 30 years and by whom he had three children in addition to the other two he had. Kathleen was the greatest of his loves, and when his wife died he married her. Before that he had maintained two separate homes, the one having no contact with the other. He carved The Visitation (1926) ostensibly about the pregnant Elizabeth visiting Mary, though it is modelled on Kathleen pregnant with their first child. He wrote that the figure 'expresses a humility so profound as to shame the beholder who comes to my sculpture expecting rhetoric or splendour or gesture'.[10] A few years later he produced Genesis, a more elemental and universal expression of motherhood.

[8] Jacob Epstein, *Let There Be Sculpture: The Autobiography of Jacob Epstein*, Michael Joseph, 1942, p.79, hereafter cited as *Autobiography*.

[9] *Autobiography*, pp.105–6.

[10] Ibid., p.115.

His next major work, *Day and Night* (1928/29), was sculpted for the outside of what was then the headquarters of the London Underground Electric Railways, which today is above St James's Park tube station, where it can still be seen. Despite the angry reaction to Epstein's previous work, the architect of this building, and other architects, saw in Epstein the artist they wanted for sculpture on the prominent facades of their buildings. These Epstein statues reveal a fundamental feature of his work: the inspiration provided by the carving of other cultures – African, Oceanic and Aztec. Indeed he himself developed one of the best collections of such sculptures. Like a number of other artists of the time he was able to renew a tired European tradition through contact with such work: some very ancient, like the haunting Cycladic carving, and some more modern. It is not hard to see why artists like Epstein found inspiration in such traditions. Their figures and heads are not representational in any straightforward sense, yet they clearly express something figurative. Their semi-abstract style and deliberate distortion often have a modern feel about them. Not least they are capable of evoking strong, if mysterious, emotion.

Once again there was a major furore over these carvings and, despite the wishes of a number of architects who wished to use his work, Epstein had no major public commission for a further 20 years. This and other rejections may have led him to carve his monolithic **Behold the Man (Ecce Homo)** (1934/35). This could not find a buyer for many years, but was donated to Coventry Cathedral on Epstein's death by his widow, where it now stands very fittingly in the ruins of the old cathedral. It is a powerful work, which again draws on the primal energy of the sculpture of earlier societies. It shows Christ suffering but intrepid; compassionate but implacable (Figure 4).

There were howls of outrage and derision at this new work of Epstein. The *Daily Mirror* even refused to show a photo of the statue, gaining plaudits from its readers for the decision. Epstein noted however that 'Actually my religious statues have had strong support from the clergy.'[11] In addition there was occasional support from art critics, including a particularly good article by Anthony Blunt in *The Spectator* which was referred to in the first chapter.[12] Blunt thought that Epstein had responded with great artistic integrity to the fundamental challenge posed to those artists of the time who wanted to produce art on a Christian theme. He had produced a powerful work, even though it was not in every way a success, because in clearing away sentimentality and concentrating on essentials there was perhaps too great a simplicity of expression.

During these times of public outrage at his monumental work, Epstein survived financially through his portrait heads which, as mentioned, were widely appreciated. He also began to have an important influence on people like Barbara Hepworth and Henry Moore, by whom he was much admired.

Not long after 'Behold the Man' Epstein produced <u>Consummatum Est</u> (1936). This brings out another fundamental point about Epstein's work. It was the stone, the shape and the material of the stone that dictated the direction he took. He would see a vast block of Subiaco marble, as he did with 'Behold the Man', or a long piece of alabaster, as he did with 'Consummatum Est', and keep it in his studio for a long time, looking at it until he saw various shapes in it. It was this, even more than the figurative image, that he sought to bring out with his carving. He conceived the final form for this work after he had been listening to Bach's B Minor Mass: 'I see the figure complete as a whole. I see immediately the upturned hands, with the wounds in the feet, stark, crude, with the stigmata. I even imagine the setting for the finished figure, dim crypt, with a subdued light on the semi-transparent alabaster.'[13]

[11] *Autobiography*, p.153.

[12] Ibid. The article was printed in *The Spectator* on 15 March 1935.

[13] *Autobiography*, p.154.

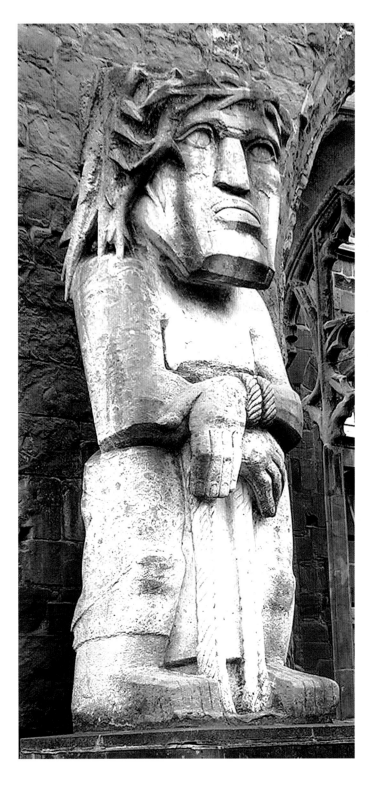

Figure 4
Jacob Epstein, Behold the
Man (Ecce Homo), Coventry
Cathedral

The art critic Richard Cork in his book on Epstein expresses admiration for this work. Noting the title, translated into English as 'It is finished', he wrote that this title 'does not match the sculpture's sense of residual strength. The head is still raised, as though resisting extinction, and the thrusting feet are obtrusive enough to suggest latent energy … If death is the theme here Epstein insists on exploring it with a characteristic sense of resilience.'[14] What Cork seems to have overlooked is that the words are of course the final words of Jesus as recorded in St John's Gospel. John's picture of Jesus, particularly in his death, is very different from that of the other Gospels. In John he goes to his death as a king, not buffeted by events but in control of his destiny. He came to fulfil the will of his heavenly father, and the great cry 'Consummatum Est – It is finished' refers to that great work of doing his will, which has now been accomplished. It is not an acknowledgement of defeat but a shout of triumph. So Epstein in his depiction of resilience has indeed caught something of the character of Jesus as portrayed by John.

People were puzzled that Epstein, a Jew, should depict so many major Christian themes. As mentioned earlier, Epstein was brought up in a very Jewish quarter of New York, which was a bit of Polish Jewry simply transplanted to America. His father was a leading member and benefactor of the synagogue. In his household there were daily prayers, Bible readings and Hebrew lessons. On the Sabbath the young Jacob had to spend most of the day in the synagogue. He duly went through his Bar Mitzvah. However, he found all this stifling, and distanced himself from it as soon as he could. Nevertheless, this upbringing gave him a deep knowledge and love of the Bible, and a sense of the sheer power of the biblical stories which shaped so much of his work.

Whilst in New York the teenage Epstein was also encouraged by people who ran a settlement there. This settlement was no doubt very like such institutions founded by educated people in England at the time, usually with a strong Christian motivation, to enhance the lives and open up wider opportunities to those living in the slums of some of big cities. Epstein found that this wider world liberated him from the stifling confines of the Jewish ghetto, and introduced him not only to Christians who were an influence on him but also to Yiddish intellectuals who had similarly thrown off their religious upbringing. In particular a Mrs Moore befriended him and believed in him when he had lost all faith in himself.[15]

With this dual religious background, a sense of the power of the biblical stories from his Jewish background, and the influence that the New Testament and certain Christians had on him it is not surprising that he should have been drawn to those biblical characters who are fundamental to both Judaism and Christianity. We see this in sculptures such as Adam (1938/39) and **Jacob and the Angel**, 1940/41 (Figure 5).

The story of Jacob and the Angel as set out in Genesis 32:22–32 describes how Jacob, on the run, finds himself wrestling all night with a stranger. Neither could prevail. At daybreak Jacob was wounded, but when the stranger asked Jacob to let him go, he said he would not do so without a blessing. The stranger then tells Jacob that henceforth he will be called Israel 'Because you have striven with God and with mortals and have prevailed.' When in turn Jacob asks the stranger his name it is not revealed, but he is given a blessing. Jacob calls the place Peniel because, as he said, 'I have seen God face to face yet my life has been spared.'

[14] Richard Cork, *Jacob Epstein*, Tate, 1999, p.54.

[15] June Rose, *Demons and Angels: A Life of Jacob Epstein*, Carroll & Graf, 2002, p.19. She writes: 'But in his autobiography written half a century later, Epstein shabbily omitted the whole episode, ashamed perhaps to admit how much he had been helped by the University Settlement. Mrs Moore does not rate a mention.'

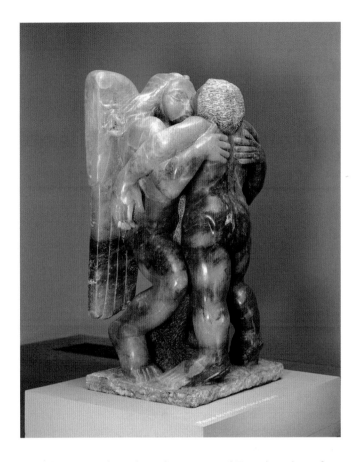

Figure 5
Jacob Epstein, Jacob and the
Angel, Tate

It is a mysterious, haunting story and Epstein, whose first name was Jacob, has conveyed this intense spiritual struggle with great power. It clearly reflects something of the struggle of his own life, both artistic and domestic, out of which he was to wrest a blessing.

From a Christian perspective it injects an important Jewish element into the Christian story, for in the Hebrew Scriptures people are not afraid to argue and wrestle with God. It is not simply a question of passive submission, as Christian obedience is often understood to be. We see this Jewish dynamism in the account of Jesus in the Garden of Gethsemane wrestling with God over his destiny.

Chronologically the rest of Epstein's work really belongs to the new climate of confidence in religious art that came with the Allied victory in World War II and the commitment to rebuild after the devastation it caused. This wider theme is considered in a later chapter. But in order to see Epstein's work as a whole it is discussed in more detail at this point.

The raising of Lazarus is a scene that has been depicted in Christian art from the time of the Catacombs. In the Orthodox Church it is the subject of one of the 12 canonical icons, and is associated particularly with Lazarus Saturday – the Saturday before Palm Sunday. For most of Christian history the iconography has been relatively unchanged. Jesus is shown lifting his hand (or in early depictions a wand) summoning Lazarus from the tomb. Lazarus emerges from the tomb swathed from head to toe in a winding cloth. Epstein, however, chose a totally different perspective on the scene. He focussed on Lazarus alone, with his head turned looking back from where he came. It is this new focus – not on Christ himself, but on the impact of Christ on someone else – that helps give a freshness to this traditional image.

Figure 6
Jacob Epstein, Lazarus,
New College, Oxford

The sculpture **Lazarus** (1947/48) was not the result of a commission. It was simply what Epstein was impelled to produce at the time. Richard Cork suggested that it captured something of the weariness and vulnerability of the national mood: 'The battle between death and life is still being waged within his body, and frailty remains its overriding characteristic.'[16] When the sculpture was exhibited it was widely praised, and regarded by discriminating critics as one of the best works he had produced (Figure 6). It was a turning point in Epstein's acceptance by a wider public. There was also a feeling that the sculpture would have been ideal for some kind of national memorial, but no offer came. In the end the Warden of New College, Oxford, when sitting to have his bust done by Epstein, saw the Lazarus standing in the studio, was struck by it, and raised some money to purchase it for the College. The sum raised was not enormous, but Epstein was gratified that it was going to be placed in a venue that he approved of – the foyer of the chapel in the college. There it stands, prompting reflection. As the great Oxford Theologian Austin Farrer asked once in a sermon in New College Chapel, 'This happy region of death from which he drags his eyes so unwillingly – what is it?'[17]

This new-found acceptance by a wider public led to Epstein being asked to produce Christ in Majesty (1954/55) for Llandaff Cathedral. Originally Stanley Spencer was going to do a mosaic on the Last Judgement for the underside of the arch on which it was to stand, but this never

[16] Cork, *Jacob Epstein*, p.65.

[17] Austin Farrer, 'Epstein's Lazarus', in *The End of Man*, Hodder & Stoughton, 1973, p.37.

materialised.[18] 'Christ in Majesty' is a fine, restrained, severe work. Unfortunately the vast concrete arch on which it stands rather dominates the central view down the cathedral and sits uneasily with the earlier architecture of the building. Nevertheless Epstein was pleased to join Henry Moore in having, at long last, a commission from the church.

Coventry Cathedral was almost totally destroyed by bombing in 1940, and in the early 1950s Basil Spence was commissioned as the architect for the building of a new cathedral. He invited Graham Sutherland, John Piper and Elisabeth Frink to do work for it. He also wanted Epstein, and in 1954 took the Bishop of Coventry, Neville Gorton, to look at the <u>Madonna and Child</u> (1950/52) in Cavendish Square. The bishop stood looking up at it, oblivious of the traffic, and said simply 'Epstein's the man for us.' Later, when Epstein's name was brought before the committee, Basil Spence noted:

> There was a shocked silence, at length broken by the remark, 'But he is a Jew', to which I replied quietly, 'So was Jesus Christ'.[19]

The sculpture was originally commissioned for the outside facade of Heythrop College. Today the building is the home of the King's Fund. The Mary depicted is a strong woman, with full features. She stands upright, arms at her side, with palms facing outward as though releasing her son for all the world. The son is shown of indeterminate age, arms outstretched as though ready to embrace that wider world.

When Epstein was being interviewed by cathedral officials about doing some work for Coventry, he was asked about his own religious faith. He responded by saying it could be seen in his work. In the event he produced **St Michael and the Devil** (1956–58) for the side wall just by the main entrance (Figure 7). It is a fine, accessible work. It is not innovative, but has life and strength and is entirely appropriate for its setting. The St Michael is at once young and mature, lean, youthful and vigorous. The arms are slightly akimbo, and the feet forward in a gesture of triumph. The devil is bound and defeated.

In a radio broadcast Epstein enlarged on his understanding of faith:

> My tendency has always been religious – it may not be known, but that is a fact … most great sculpture is occasioned by faith. Even the African sculpture, which we don't understand, is full of their faith.[20]

So Epstein was an innately religious person whose upbringing on the Hebrew Scriptures had gone deep. The other fact, in addition to the friendly encouragement by Mrs Moore and others at the settlement in New York, was his lifelong friendship with a number of Christian intellectuals and clergy, including T.S. Eliot and the influential Jacques Maritain. He and Eliot became friends and Eliot was amongst a small group invited to Epstein's 70th birthday party and was the person who lit the candles on the cake.[21] When Epstein died Eliot wrote to his widow to say 'It is as if some of my

[18] When Spencer and Epstein travelled to Cardiff together Spencer talked all the time, and eventually Epstein had to tell him to shut up. An interview with Noreen Smith, quoted by Rose, *Demons and Angels*, p.255.

[19] Basil Spence, *Phoenix at Coventry: The Building of a Cathedral*, Harper & Row, 1962.

[20] Interview on the Home Service in 1952, quoted by Rose, *Demons and Angels*, p.265.

[21] Rose, *Demons and Angels*, p.251.

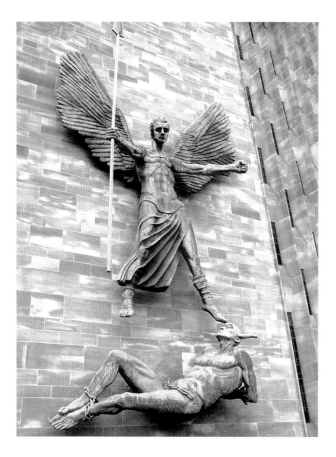

Figure 7
Jacob Epstein, St Michael and the
Devil, Coventry Cathedral

world has crumbled away. We loved him.'[22] Epstein was buried at Putney Vale cemetery, with Dr
Hewlett Johnson, the 'Red Dean' of Canterbury, taking the service. A memorial service was held at
St Paul's Cathedral, at which his friend Canon Mortlock said:

> If we ask how it was that a boy born and bred in the Jewish faith and never embracing any other,
> should become the interpreter of the sublime mysteries of our religion there can be no clear answer.
> Such things belong to the inscrutable wisdom of God.[23]

Georges Rouault

Rouault (1871–1958) was born in a working-class area of Paris, his father being a cabinet maker
and polisher of pianos. From him Rouault derived his respect for good workmanship, as captured
by his remark that he would rather be a good artisan than a sloppy artist. One of his self-portraits
shows him dressed for work very much like a baker. His father was galled even by the sound of a

[22] Ibid., p. 275.
[23] Cited in Richard Buckle, *Jacob Epstein, Sculptor*, Faber, 1963.

door squeaking, 'as if wood itself were being made to suffer'. This attitude of his father may lie behind Rouault's extreme sensitivity to human suffering.

The other decisive influence on him from the early part of his life was the dire poverty of the people around him. He never lost his profound sympathy for ordinary people struggling to survive, burdened by life.

Rouault did a series of woodcuts from 1917 to 1927, *Miserere* – from the refrain 'Lord have mercy on us', linking this with the misery of war – which were finally published in 1948.[24] The woodcuts depict scenes which also reflect his own childhood environment with titles such as In the Old District of Long Suffering; Take Refuge in Your Heart, Vagabond of Misfortune; and Lonely in this Life of Pitfalls and Malice. In his sensitivity to humanity Rouault is like Rembrandt, another deeply Christian artist. Other artistic models for him were Goya, some of whose work also reflects the dark side of life, as well as Cezanne. Rouault wrote:

> Art, the art I aspire to, will be the most profound, the most complete, the most moving expression of what man feels when he finds himself face to face with himself and with humanity. Art should be a disinterested, passionate confession, the translation of the inner life, as it used to be in the old days in the hands of our admirable anonymous Frenchman who sculpted the figures on the cathedrals.[25]

At 14 Rouault was apprenticed to a stained glass maker, and the influence of this early training can be clearly seen in all his work, with its heavy black lines and blocks of colour. In the evenings, however, he took art classes and then studied at the Ecole des Beaux-arts under Gustave Moreau, where Matisse was a fellow student and where Rouault won a prestigious prize. Moreau encouraged the individual talent of each student, and indeed with this in mind persuaded Rouault to leave the college, though he continued to give him private lessons afterwards. Moreau's death in 1898 sent Rouault into a major crisis, and that too is reflected in the sombre aspect of his paintings. Before then, though talented and innovative, his style recognisably belonged to the tradition of the great European masters. Now he began to paint with 'an offensive lyricism', his subjects being prostitutes and marginal people of the streets. He could paint nudes of great beauty in a way that showed the influence of Cezanne, but it was in the depictions of prostitutes that he showed his distinctive style and view of life. Unlike other artists of the time, he showed them as neither romantic nor erotic, but as human sufferers – abused and knocked about by the life they led. As he put it: 'behind the eyes of the most hostile, ungrateful, or impure being dwells Jesus'.[26]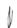

From this period of his life date his famous portraits of clowns and other circus performers.[27] There was a moment of revelation in 1905 when he wrote to a friend about what he had just seen:

> That nomadic wagon, parked on the road, the emaciated old horse eating thin grass, the old clown seated on the side of his trailer mending his glittering and colourful costume, the contrast of brilliant, scintillating things, made to amuse us and this life of infinite sadness … I clearly saw the clown was me, it was us … This rich and spangled costume is given to us by life, we are all clowns more or less, we all wear 'spangled costumes' but if we are caught unawares, as I surprised

24 Holly Flora and Soo Yun Kang, *George Rouault's Miserere et Guerre: This Anguished World of Shadows*, Museum of Biblical Art, 2006.

25 Fabrice Hergott and Sarah Whitfield, *Georges Rouault*, Royal Academy of Arts, 1993, p.16.

26 José María Faerna (ed.), *Rouault*, Cameo/Abrams, 1997, p. 12.

27 Georges Rouault, *Judges, Clowns and Whores*, Mitchell-Inness & Nash, 2007.

the old clown, oh! Then who would dare to say that he is not moved to the bottom of his being by immeasurable pity. It is my failing (a failing perhaps … in any case for me it is an abyss of suffering …) never to allow a person his 'spangled costume' whether he is a king or an emperor. The man that I have before me, it is his soul that I want to see … and the grandeur and more exalted in his person the more I fear for his soul.[28]

In contrast to other artists of the time, who depicted the gaiety of such scenes, he saw the sadness. We put on a mask for others, but inside ourselves life often feels very different. He thought that behind our glittering masks we all hide a tormented soul, a tragedy.

In Rouault's paintings the mask and the makeup of the clowns cannot hide the wrinkles and the sadness of the gaze. In the depictions of clowns, as in his other paintings, it is the face which is always so powerful. The intensity of feeling in a face is usually highlighted by some contrast with the clothing. In pictures of clowns, for example, the clothing can be bright, even garish; but we are caught by the haunting individuality and isolation of the face. He saw that each one of us is a clown and the rich, spangled garments given to us all to wear cover untold anguish. It was both his vocation and burden never to leave anyone with their outer covering. It is not surprising that 'Who wears no disguise?' or 'Who does not wear makeup?' were titles he used for a number of his paintings.

Another major theme from 1907–14 was that of judges in the courtroom. But here again his stance is distinctive. He did not paint them simply to condemn an oppressive system, any more than his paintings of prostitutes were designed to be social comment. What struck him was the anguish of human beings having to judge other human beings. So a judge's features could sometimes be identical to those of the defendant. As he wrote, 'All the riches of the world could not make me take on the position of judge.'[29] What he felt about judges is not dissimilar to what he felt about those who had to rule, as in the well-known painting <u>The Old King</u> – a king who looks burdened by his crown, the weight of ruling.

There were many who criticised Rouault's paintings and deplored his switch from an earlier more pietistic style. As one critic put it, it was 'lamentable that an artist … competent to paint seraphim (was now able) only to conceive abominable and vindictive creatures'.[30] But that is to misunderstand the effect which religion has and perhaps ought to have. As Rouault put it:

> I don't believe in vague and tremendous theories or ideas about the otherworld since, in practice, they are lifeless and not viable. I abhor such wanderings of thought and action. They can only culminate in a soggy and facile idealism which, in its arrogant attempt to explain and sort everything out, ends up blunting the edges and wearing the fabric until it becomes threadbare. Holding such bland softening in horror, I much prefer cynicism, and even the most grotesque or violent form of realism.[31]

This is an unusual statement coming from a devout believer. It is not surprising, in the light of it, to learn that he was also capable of satirical sketches. His more perceptive Catholic friends could understand what he was trying to achieve, not least Father Jacques Maritain. Religion was

[28] Georges Rouault, *Sur l'art et sur la vie*, Denoël, 1971, pp.171–2, quoted by Soo Yun Kang in *Miserere et Guerre*, p.32.

[29] Faerna, *Rouault*, p.32.

[30] Ibid., p.10.

[31] Ibid., p.6.

inseparable from every aspect of life, all art is sacred; or, as Rouault put it, 'There is no such thing as sacred art: there is just art and that is enough to fill one's lifetime.'[32]

Rouault did paint some pictures with more *joie de vivre* in them, as well as landscapes and still lifes, but it is the darker theme that we particularly associate with him, no doubt significantly due to his personal sensitivity to human suffering; but few would deny that it was a temperament that expressed one inescapable aspect of life, not least in the cruel twentieth century.

The woodcuts from *Miserere*, already mentioned, include scenes with titles like This Will be the Last Time, Little Father, in which a soldier is making his last confession with a skeleton looking over his shoulder; My Sweet Country, Where Are You?, which shows a countryside devastated by war; Homo homini lupus (words from Plautus translated, Man is a wolf to man); and We Are Insane. Rouault's woodcuts and paintings bring to mind the words of Wilfred Owen – 'The poetry is in the pity.'

From about 1914 onwards religious themes become an important part of Rouault's work but, as has been rightly noted, the characters depicted and the view of life behind them did not fundamentally change. The bowed Head of Christ (1937) reflects the bowed figures of his paintings of burdened humanity generally. Christ condemned to death re-images the criminal in the courts he saw being condemned to death. This is fundamental to understanding what is meant by calling Rouault a religious or Christian artist. For him, as mentioned, all genuine art was sacred art. As he said about his painting The Injured Clown (1932): 'In my view it is quite as religious as compositions with a biblical theme. To call a work "sacred art" it is not enough to invest it with religious significance.'[33]

In **Christ Mocked by Soldiers** (1932) we see the influence of Rouault's early training in stained glass in the leaded lines and blocks of colour. The dark tones of the painting generally reflect his sombre view of life, and the leering faces of the soldiers its cruelty. The figure of Jesus is bowed in total acceptance of what is happening to him, whilst his face exhibits a repose that permeates his whole body (Figure 8).

Rouault gave one of his pictures a quotation from the French philosopher Pascal, Jesus will be in agony until the end of the world. Like so many twentieth-century poets, writers and theologians, Rouault's understanding of God is that he is above all one who in Christ shares in the suffering of humanity as a whole.[34]

Despite his extreme awareness of the suffering and darkness of life Rouault believed that there were glimpses of hope and love along the dark road of life, and the journey is to be undertaken with hope for the dawning of a new eternal day. This is reflected in other woodcuts with titles like At Times the Road is Beautiful; It Would be Sweet to Love; Sing Mattins, a New Day is Born; and He that believeth in me, though he were dead, yet shall he live. It is clear, however, that for Rouault the great hope was an everlasting life the other side of death; this is where true joy lies, and there are only very fitful glimpses of this on the way, in a world that has gone so badly wrong.

The Mandylion is based on the story of how, as Jesus carried the cross on the way to the Passion, Veronica wiped his face with a cloth, on which his image was imprinted. This became a central image of Western art for 1,000 years. As a special type of icon (*acheiropoieta*, one made without hands) it reminds the believer that Christ is present in all circumstances and brings strength to us when we are in the depths.

[32] Ibid., p.54.
[33] Faerna, *Rouault*, p. 28.
[34] Dillenberger, *Style and Content*, p.206ff.

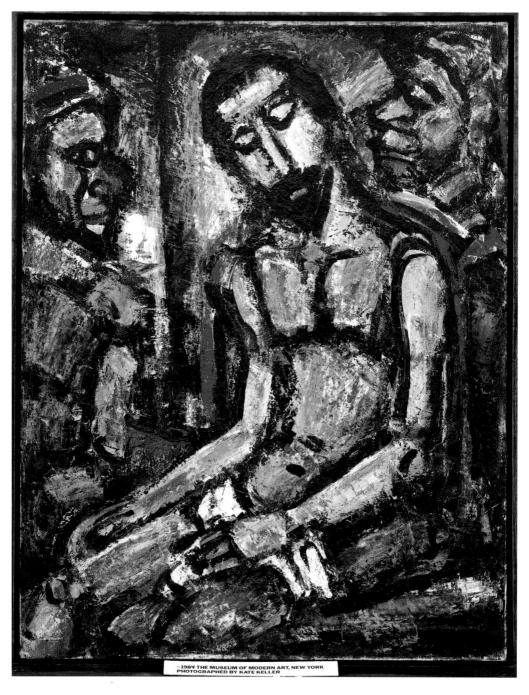

Figure 8 Georges Rouault, Christ Mocked by Soldiers, Museum of Modern Art, New York

Figure 9 *The Holy Countenance*
Georges Rouault, De Profundis,
from *Miserere*

In Rouault's painting **The Holy Countenance** (Figure 9), the dark is once again a fundamental feature; but this time it is lightened by the strip of white on the inside of the frame, the luminous yellow brown of Christ's face and the glowing orange yellow from which the face is emerging. The eyes are dark, open and spiritually transparent. The total effect is of a divine/human reality emerging from the depths of mystery to be with us.

The purpose and significance of the Icon of the Holy Countenance is well brought out in the woodcut **De Profundis** (Figure 10). A man lies dead or dying, whilst in the background grieving family or friends gather round a bell as it is about to be tolled. De Profundis is the opening of Psalm 130: 'Out of the depths have I cried unto thee.' In answer to this cry the face of Christ looks down in pity. The brightness of that face and the rays emanating from it illuminate the upturned face and hands of the man lying on the couch, though he also seems to be trying to lift up his head and eyes to look at Christ.

Not surprisingly, Rouault did a number of studies of the crucifixion. In one woodcut it could almost be taking place at night. The sky is dark, the land is dark and the outline of the cross is black. This serves to focus the eye of the viewer on the unearthly light of Christ's body and the faces of those by the cross. That light is not bright; rather it has a paleness that emphasises the humanity and vulnerability of the flesh. The figures either side of the cross are absorbed in the suffering in their own way. To the right John lifts his neck and face ardently in the direction of Jesus. To the left Mary kneels in devout prayer. The intense attention of these two helps to draw the onlooker into the picture and to make their own response. The head on one side, with the eyes half closed,

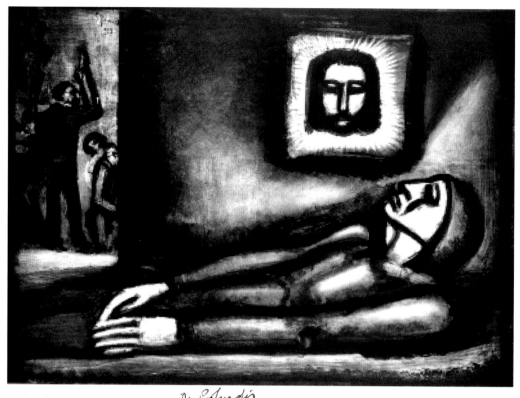

Figure 10 Georges Rouault 'Holy Countenance' *De Profundis*. Photograph: Vatican Museums. © ADAGP
Paris and DACS, London 2013

looks down gently and questioningly at the onlooker. This is not just a painting for public art, to
be viewed from afar. It is a deeply felt personal response to the crucifixion which itself seems to
require a personal response.[35]

It is no accident that Rouault's work often has the feel of Byzantine art or folk art, with something
of their anonymity. For Rouault saw his vocation not as one of self-expression as the twentieth
century came to understand it but as one of obedience to his personal vision, a vision which he
interpreted in profoundly Christian terms. As he put it: 'I am obedient. Just about anybody can be a
rebel; it is a much more difficult undertaking to obey silently the dictates of one's soul and to spend
one's life looking for the truest means to express ones temperament and talents.'[36] Having been at
the cutting edge of art at the turn of the century, he was enabled to find his own voice, and to that
voice he tried to remain true in all the succeeding changes of artistic fashion. His work appeared
in the prestigious Salon d'Automne exhibition of 1905, which was labelled *fauvist*, the wild one,
because of the vivid use of colour. But there was more to Rouault than that. Nor did he really
belong amongst the German expressionists, or to the French ones, though he was French. Although
he clearly belonged broadly within the expressionist tradition, he had his own highly distinctive

[35] A painting of the crucifixion is reproduced with commentary in Richard Harries, *The Passion in Art*,
Ashgate, 2004, p.114.

[36] Faerna, *Rouault*, p. 5.

a with poetry.

stance and style. Many would say he is the most profound of the artists who drew on Christian imagery in the twentieth century.

Conclusion

A study of the images of Christ produced by the expressionists, and especially those by Epstein and Rouault, show, I believe, that in their different ways they succeeded in meeting the challenge set out in the first chapter. They produced work which was fresh and arresting, enabling the viewer to see Christ in a new way. These artists were part of the avant-garde at the beginning of the twentieth century, and they continued as key participants in the modern movement for the rest of their artistic lives. Epstein was able to revitalise sculpture and give religious images in particular a new power through a combination of his own vitality and the influence of work from earlier cultures. Rouault was 'modern', paradoxically because of his early training in stained glass, which quite naturally led him to work with blocks of colour divided by dark lines. The Christian or Jewish themes they depicted did not belong to a special category of religious art, and was not suddenly characterised by a hushed tone. Secular themes and religious ones were of a piece as far as style was concerned. Rouault was painting clowns before he depicted Christ and, as discussed above, there was a fundamental similarity between the way Christ was shown and suffering humans in other paintings.

Once Rouault had broken away from the academic tradition, he quickly found an artistic voice of his own, which he retained for the whole of his *oeuvre*. Epstein had two artistic voices, one expressed in his early monumental sculpture and the other in his bronzes. 'Ecce Homo' is perhaps the finest example of his monumental work. On occasion the two voices merged to powerful effect, as for example with his 'Lazarus'.

One aspect of the challenge presented by the modern world to artists who want to respond to traditional religious iconography is to produce work which does not just express a private vision, but which can resonate with a wider public that is largely disassociated from religion. Epstein and Rouault did manage to do that, so that their work has taken its place both in the centre of modern art as a whole and in that narrower category where religious believers can recognise the work as standing within and revitalising the Christian tradition.

Expressionism at its origin indicated art in which powerful emotion was conveyed through a combination of distorted line and vivid colour. The effect was to strip away conventional pieties and shock people into awareness of harsh reality, as Nolde, Beckmann and Dix did. This has its dangers. There have been too many attempts in modern art to shock for its own sake. Or else there can be subtle and less than subtle messages of 'Look, I am feeling very strongly about this.'

I doubt if any good art can be produced without real feeling. Certainly, without a degree of intensity any religious art that is produced will only be an academic exercise. Real religion is nothing if it is not deeply felt. But that feeling will be focussed on what is being conveyed. It will be subsumed in the subject matter, and funnelled into the technical struggle to get the work of art right. So it is that the best works of Epstein and Rouault do indeed evoke strong feelings in the viewer; but they are not trying to call attention to the artist who is feeling strongly. Like all great art, they are not simply expressive; they are the product of a prolonged period of self-transcendence.

Chapter 3
Distinctive Individual Visions

Epstein and Rouault were able to produce striking and persuasive art on religious themes first and foremost because they were distinguished artists working at the forefront of the artistic developments of their own time. Secondly, because both, in their different ways, brought a religious vision to bear on their work. For Epstein, although the biblical stories had entered deep into his being, and Christian imagery clearly drew him, his religion, like that of Henry Moore, as will be shown later, was more primal. It was the sense that all great art both expressed and reflected a religious feel for life. For Rouault, however, it was quite specifically an orthodox Christian faith which both made him sensitive to, and able to live with, the terrible suffering of life, which imbued all his paintings, whether of ordinary human beings or Christ. The three people considered in this chapter, Marc Chagall, Cecil Collins and Stanley Spencer, were again distinguished artists, if slightly apart from the mainstream developments of their period. Even more significantly they all had a personal faith that did not fit easily into any orthodox framework. It was this distinctive religious perspective, allied to their artistic skill, that resulted in some remarkable fresh interpretations of traditional images and scenes.

Marc Chagall

Chagall (1887–1985) wrote *My Life,* in Moscow when he was 35. In it he tells the story of what had happened to him up to that point, when he was about to leave revolutionary Russia to resettle in Paris.[1] Though the basic facts of his life emerge, it is an impressionistic work, lyrical, emotional, expressing the feelings of a confused young man trying to find his way in the world, deliberately contradictory, full of pain and longing.

From his early childhood Chagall was fascinated by the little town of Vitebsk where he had been brought up.

> My sad, my joyful town! As a boy I would watch you from our doorstep, childlike. To a child's eyes you were so clear. When the fence blocked my view I would climb on to a little wooden post. If I still could not see you, I would climb up on the roof…And I would gaze at you as long as I liked. There in Pokrovakaja Street, I was born for the second time."[2]

The sights he saw as a boy, which were reinforced when he went back to Vitebsk in 1914 after a period in Paris, became the most fundamental images of his art, reflected for example in <u>Above the Town</u>(1917–18) which is dominated by the image of him, with his fiancée Bella, flying above the roof tops. In the town he cannot help noticing the Kosher butcher

[1] Marc Chagall, *My Life*, Peter Owen, 1965. pback 2011.
[2] *Ibid.*p.11

And you, little cow, naked and crucified, you are dreaming in heaven. The glittering knife has raised you to the skies."[3]

This cow dreaming in the heavens recurs in a good number of his paintings, such as I and the Village (1911) He hears his uncle and others playing their violins

My head floats about the room on its own. Transparent ceiling. Clouds and blue stars steal in along with the smell of the fields, the stable and the birds."[4]

Again, the image of the violinist is a familiar image in Chagall's work, such The Green Violinist (1923/4)
 Vitebsk was full of synagogues, and religion was fundamental to the life of his family, both his grandfather and father being very devout. The scene depicted in The Praying Jew (1914) was a familiar sight. So too were the yearly cycle of religions feasts, as reflected in The Feast of the Taberbacles (1916). They were for Chagall very much living experiences. At Passover his father tells him to open the door to let Elijah in

And where is Elijah and his white chariot? Is he still waiting in the courtyard, perhaps, to enter the house in the guise of a wretched old man, a hunchbacked beggar, with a pack on his back and a stick in his hand? "Here I am. Where is my glass of wine?"[5]

Elijah was to be one of the central images in his later work. This closed joyous world of Hasidic Judaism was to leave Chagall with an intense mystical feel for life, together with a sense of sadness at it's destruction, which we see in Solitude, (1933)
 It was very difficult for Jews in Vitebsk to make their way in a Russian dominated world but Chagall's mother bribed a teacher at the Russian School with 50 roubles to take her young son Marc. This was the first step out of the constricted world of his childhood and he was then able to win a scholarship to a local art school. The plaster casts of classical heads he was expected to copy at the school meant nothing to him, neither did the fashionable art of the time, cubism and all formalism.[6] From the first he was conscious of himself as being different, shy, isolated, and with a strong conviction of how he wanted to paint. Encouraged by some and rejected by others, struggling both with extreme poverty and all the disadvantages of being a Jew, he moved first to St Petersburg and then to Paris. Here he found artistic liberation in the galleries and artistic life of the city. His art now was expressive of someone caught up in the ecstasy of life, always wanting to break through to something, he knew not what. As he wrote 'I want to stay wild, cover myself with leaves, shout, weep, pray.'[7] This mood is well reflected in Paris through a Window, (1913) in which again a figure floats in a sky whilst a cat looks on from a roof top. As he wrote

The essential thing is art, painting, a painting different from the painting everyone else does. "But what sort? Will God or someone give me the power to breathe my sigh into my canvases, the sigh of prayer and sadness, the prayer of salvation, of rebirth?" [8]

[3] ibid. p.20
[4] ibid. p.25 and 118
[5] ibid. p.45
[6] My life p.69 and 111
[7] ibid. p.54
[8] ibid. p.69 and 111

Churches were prominent in Vitebsk, and one near his home particularly drew him. We see this church in <u>Over Vitebsk</u> (1914). As he wrote 'I always enjoy painting that church and that little hill again in my pictures.'[9] Clearly the presence of those churches, and their icons had something to do with the fact that later he was able to combine Christian with Jewish imagery in his art. Those churches and icons raised questions in his mind. He said he wanted to ask the Chief Rabbi 'What he thought about Christ, whose pale face had long been troubling me.'[10] Before leaving for Paris he remembers that

> I roamed the streets, I searched, I prayed. "God, Thou who hidest in the clouds, or behind the cobbler's house, lay bare my soul, the aching soul of a stammering boy, show me my way. I do not want to be like all the others; I want to see a new world." In answer the town seems to snap like the strings of a violin, and all the inhabitants begin walking above the earth, leaving their usual places. Familiar figures install themselves on the roofs and settle down there. All the colours spill out, dissolve into wine, and liquor gushes out of my canvases. I am very happy with all of you. But… Witebsk, I am forsaking you. Stay on your own with your herrings![11]

There is an interesting contrast with James Joyce who in *Portrait of an artist as a young Man* describes how the young artist left 'the pale service of the altar' to follow the 'call of life'. For Chagall, although he left Vitebsk, the mystical Judaism of his childhood was so much part of him that it remained fundamental to the way he saw and felt about life and therefore for what he painted and how he painted it. Even in Paris the mystical raptue he had in Vitebsk stayed with him. 'Oh! If only I could trace my way in the sky with my arms and legs, riding on the stone Chimera of NotreDame!'[12]

After Paris Chagall went back to Vitebsk intending to stay a few weeks and where he painted everything he saw. However, because of the war, this short stay turned out to be eight years. He had a period in the army, fortunately being able to spend his time working in an office. After the revolution, he was appointed commissar of an art school in Vitebsk. However, his art did not really fit what was required[13] and this, together with the chaos of the early revolutionary period, prompted him to leave for Paris again and then go to the United States. However, whilst in Vitebsk he married his love, Bella, who was to be the inspiration for so many of his paintings such as <u>The Birthday,</u> (1915) in which Chagall kisses Bella as they both float in the air, she with a bunch of flowers in her hand.

> I only had to open my window, and blue air, love and flowers entered with her. Dressed all in white or all in black, she had long been flying over my canvases, guiding my art."[14]

Bella was from a wealthy family who had lost everything in the revolution but they disapproved of the marriage. In a later painting we see Chagall protecting Bella a they begin to feel the tremors of war. <u>The Three Candles,</u> (1938–40)

Chagall began combing Jewish and Christian iconography early in his career, as in <u>Lazarus</u> (1910) where a figure associated with Christianity is placed in a Jewish graveyard with symbols of a Jewish burial including the star of David. However it was with <u>Golgotha</u> (1912), – the finished

[9] ibid. p.79
[10] ibid. p.126
[11] <u>My life</u>, p.95
[12] ibid. p.114
[13] ibid. p.137
[14] ibid. p.121

sketch being called Calvary(1912),– that he not only combined Jewish and Christian themes but firmly established himself in the avant-garde, for the style of this painting is clearly related to both Cubism and another movement of the time, described as 'Orphism'.[15] It is a highly unusual study, in that it shows Christ on the cross as a child. Chagall wrote

> The symbolic figure of Christ had always been very familiar to me and I was determined to give form to it in the guise imagined by a young heart. I wanted to show Christ as an innocent child.[16]

This idea is strengthened by a poem his friend Cendrars wrote dedicated to Chagall, which has the lines

> Christ
> he's Christ himself
> he passed his childhood on the cross.

This painting has been interpreted both against the background of Yiddish stories and more universal symbols, indicated perhaps by the boat in the picture, which might be the ferry of Charon. The man running away with the ladder has been seen as Judas.

The White Crucifixion (1938) Chagall's best known image, which combines Jewish and Christian imagery, was painted in 1938 after he had traveled in Europe and experienced at first hand the rise of Nazi brutality[17] (Figure 11). In June 1938 1500 Jews were taken to Concentration Camps and in that month and again in August synagogues in Munich and in Nuremberg were destroyed and pogroms carried out. The picture was originally even more specific then it is now, for before over-painting, the old man at the lower left-hand side had "Ich bin Jude "(I am a Jew) written on the plaque which he wears round his neck. The painting shows in vivid details, in an iconic way, the destruction of the joyous Jewish world he had known in Russia as a child. At the bottom of the Cross is the Menorah, the seven branched candlestick of Judaism, though here it appears to have only six candles on it with only five alight. Then going around the painting in an anti-clockwise direction, a mother hugs her child to her chest as she flees the destruction. Above her is a Torah scroll with white light streaming from it and a figure stepping over the light. This refers to a famous Hasidic tale, when a Bishop ordered the Torah to be burnt. Rabbi Israel prayed and his prayers pierced to the palace of the Messiah. As a result the Bishop fell into a fit, which frightened those who intended to burn the scrolls. A white light from the scroll, symbolising the Word of God, spreads to the Cross where it meets a beam of white light coming down from above. On the ground this white light is crossed by a green clad figure carrying a bundle. This figure appears in a number of Chagall's paintings. He has been interpreted as the Jewish wanderer of Yiddish tradition, begging because of the hardship of his people and fleeing pogroms. But there is also a more optimistic interpretation, in which the figure is seen as Elijah, who in times of tribulation brings help, appearing in all kinds of disguises. It would seem to be primarily Elijah to which Chagall is referring, for in his autobiography quoted above he describes the custom on the Day of Atonement of opening the doors of the house to let Elijah enter. Above Elijah a synagogue is being burnt by Nazi brownshirts, whilst behind them Nazi flags can be seen. The sacred furniture and books are being thrown out into the street. Above the door are two lions, which often appear in Eastern European synagogues. Here there may also

[15] Susan Compton, *Chagall*, Royal Academy of Arts, 1985. p.19, 174/5

[16] Quoted by Jackie Wullschlager, *Chagall:Love and Exile* Allen Lane, 2008, p.166

[17] It is reproduced and discussed in Richard Harries, *The Passion in Art*, Ashgate, 1993, p.108

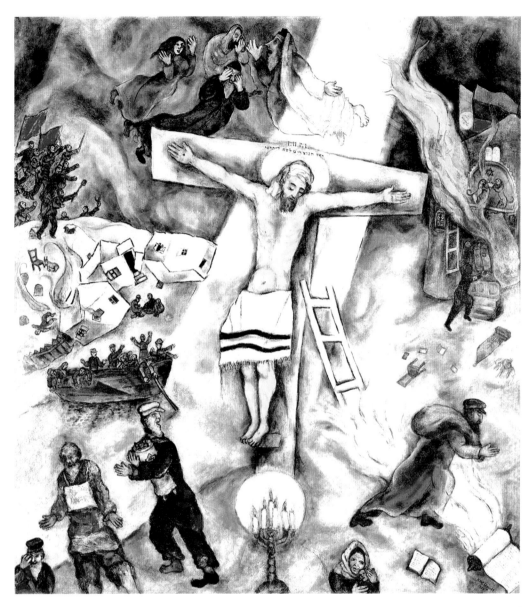

Figure 11 Marc Chagall "The White Crucifixion", 1938 (oil on canvas). The Art Institute of Chicago, IL, USA / Giraudon / The Bridgeman Art Library. Chagall ®/ © ADAGP Paris and DACS, London 2013

be a personal reference, for Chagall's first name was Marc, whose symbol in Christianity is the lion. At the top Jewish figures lament and flee whilst on the left of the picture as we look at it a Jewish *Shtetl* (village) is burnt by Communist troops with red flags. Flames flare from the roofs and the homeless sit on the ground outside. Below this scene there are Jewish refugees trying to escape in a boat to Palestine. At the bottom left Jewish figures clutching the sacred scrolls run from the destruction. Dominating the picture in the centre is the figure of Christ crucified. But

this is very much a Jewish Christ. Over his head written in Hebrew are the words King of the Jews, whilst round his body is wrapped a Jewish prayer shawl. A great shaft of white light comes down from heaven and a ladder is propped against the Cross. This ladder, the ladder of Jacob's vision reaching to heaven is described in Genesis 28, 10–17. It was a favourite motif of Chagall and appears in a number of his paintings. The story recounts how Jacob lay down to sleep.

In a dream he saw a ladder which rested on the ground with its top reaching to heaven, and the angels of God were going up and down on it.The image is given a Christian interpretation in John 1,51.Chagall once wrote a poem on the subject:

> Lying down like Jacob asleep
> I have dreamed a dream
> An angel seizes me and hoists me up on the ladder
> The souls of the dead are singing.

What is most remarkable is the fact that it is the figure of Jesus on the Cross which dominates the picture. The suffering of the Jewish people is summed up in a Christian icon. The agony of Jesus is seen as the agony of all Jewish people. This is startling, indeed shocking, when we remember that for many Jews the Cross has been a symbol of Christian oppression. Many Jews have, quite understandably, felt uneasy about this painting of Chagall. It is also difficult to see how, in the light of the Holocaust and our greater awareness of how traditional Christian anti-Judaism prepared the way for it, any Jew today could use this symbol. But Chagall did and he was not alone amongst Jews of his time. The most important sculptor in Russia at the turn of the century was a Jew, Marc Antokolsky whose letters reveal how he struggled to reconcile a Jewish and Christian viewpoint. Antokolsky accepted Jesus as a great prophet in the line of Biblical prophets and welcomed the love which he believed he showed, without accepting the doctrinal tenets of the Christian religion. When Chagall was studying in St Petersburg it was hoped by his Jewish patrons that he would become a second Antokolsky. In one of his letters Antokolsky wrote:

> For several weeks now I have been working on 'Christ', or as I call him, 'Great Isaiah'. Jews may have renounced him, but I solemnly admit that he was and died as a Jew for truth and brotherhood …The Jews think I'm Christian and the Christians curse me for being a dirty Jew (Zhid). The Jews rebuke me: 'Why did I do Christ', and the Christians rebuke: 'Why did I do Christ like that?'[18]

What is perhaps most remarkable about this picture is the dominance of white: the white light coming from the flames of the burning Torah, mingling with the white shaft coming from heaven onto the Cross and suffusing the whole picture. From one point of view this smoke is all part of the terrible conflagration and destruction. But it is also the white light of the Torah, the eternal Word of God which stands through all things. There is a stillness in the centre, focused on the figure on the Cross, which the terrible scenes of destruction cannot obliterate. From a Christian point of view that figure on the Cross is God himself sharing in the agony of his people during the terrible events of the Nazi period. From Chagall's point of view, in this bold use of Christian imagery for a Jewish theme, we have a symbol of Jewish faithfulness to the Torah even in the

[18] Royal Academy of Arts, London, 1985 Exhibition catalogue, *Chagall*, p16–19, 214

midst of utter destruction, a faithfulness which stands for ever, because it is founded on God's word.

Chagall painted the crucified Christ in a number of his pictures, including The Crucifixion (1940) in which the artist himself, in a Jewish shawl is bound to a stake with scenes of destruction all round together with familiar Chagall images such as an old man playing a violin and flying animals. These paintings include The Martyr, (1940) and The Martyr, (1970) and Yellow Crucifixion (1943).

In The Yellow Crucifixion Jesus on the Cross and the Torah scroll are equally prominent. An angel holds the scroll in the air whilst at the same time he holds a lighted candle in one hand and a shofar in the other. On the right a village is being destroyed and a figure both laments and rages before it. On the left a boat of refugees is sunk, whilst in the centre at the bottom a family flees on a horse or mule. The mother cradles her children to her whilst the father holds a ladder to heaven. The overall impression in one of utter devastation in the midst of which is an abiding Jewish and Christian faith that makes the dominant light at once a yellow fire of destruction and the gold of hope.

Chagall continued to paint scenes of Christ on the cross linked to Jewish suffering during the 1940's. Apocalypse en Lilas, Capriccio (1945) is a particularly painfully felt image, painted when the few who survived the concentration camps began to be released. There are scenes of Jewish suffering on the right. The Nazi has no hand, and a tail embraces the woman. The Jewish Jesus in a shawl has hips suggestive of the wives Chagall loved. The clock indicates the end of time. The familiar ladder appears. As mentioned above, Chagall seemed to identify the crucified Christ with humanity as a whole including himself, and in The Painter and Christ (1951) and In Front of the Picture,(1968–71) this is made more specific. The artist, with an animals head is looking at a self portrait of the artist on the cross. But he is also looking on from the side with his beloved Bella, and behind the cross his parents look on as well. His father had spent a life of hard drudgery carrying heavy herring barrels. Chagall felt for him. 'Everything about my father seemed sad and full of enigma. An inaccessible image.' Yet even so he would sometimes break into 'a wan smile. What a smile! Where did it come from?'[19] By 1922 both his parents were dead, and it was at that time that he reflected on his mother as well as his father in the words:

> A lake of suffering, hair prematurely grey, eyes–a world of tears, a soul that hardly exists, a brain that is no more. What is there then?… 'How can I beg you, beg God through you for a shred of happiness, of joy?[20]

The Exodus (1952–66) is a particularly remarkable combination of Jewish and Christian imagery. On the right there are scenes from Biblical history, whilst on the left are pictures of contemporary hardship, perhaps in part reflecting the founding of the state of Israel with Jews moving to it from persecution in countries such as Russia. Overall, instead of Moses, who is a smaller figure on the right, there is an iconic Christ leading his people to safety.

Chagall did a good number of drawings and paintings on Biblical themes after World War II, including the nativity, the Sacrifice of Isaac, Jacob's Ladder and **Abraham and the Three**

[19] *My Life* p.12
[20] ibid p.16 and p.27

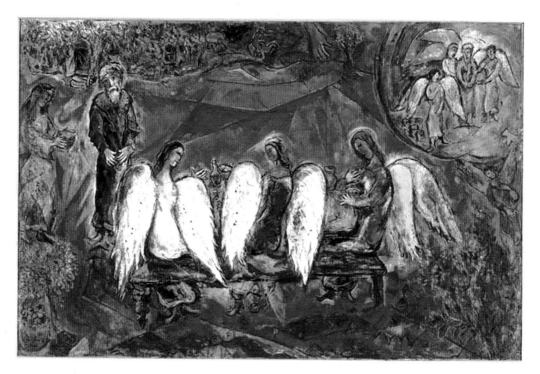

Figure 12 Marc Chagall "Abraham and the Three Angels", Musee Nacional Marc Chagall. Chagall ®/ © ADAGP Paris and DACS, London 2013

Angels (1960–66)[21] (Figure 12). This is a scene that early became part of Christian art, the three angels, signifying the Holy Trinity. In Rubliev's famous icon of the scene in the 14th century the angels face the viewer across the table, with the viewer is at it were invited to take her or his place at the table of God, which is also entry into the very life of God. For Chagall the image is more one of generous human hospitality, with Abraham, and Sarah serving the seated angels. However, the scene of heavenly angels in the top right hand corner indicates that this is an action that heaven watches and rejoices in.

After World War II Chagall was much in demand for stained glass in Germany, France, Switzerland, America and Jerusalem. He was commissioned by a number of churches, including Mainz Cathedral and by Dean Hussey for Chichester Cathedral. As John Piper was also to show, stained glass, which as an art form had languished for a long time, came into its own for modern artists who wished to respond to religious imagery. One of the most remarkable and accessible of Chagall's works is the glass in Tudely Church, not far from Tonbridge Wells. The d'Avigdor Goldsmid's who lived in the village very sadly lost a daughter in a sailing accident and they commissioned Chagall to do the big **East Window** (Figure 13). It shows the girl drowning, then carried on her favourite horse past a crucifixion .When Chagall came for the blessing of this window, he was so impressed by the space inside this church that he offered to do all the side windows free. The result is that this small church, totally unprepossessing on the outside, is a veritable heaven when you go inside. The church is filled with brilliant blues.

[21] See for example Marc Chagall, *Drawings for the Bible*, Dover, New York, 1995 and *The Bible, Illustrations by Marc Chagall*, Chronicle, San Francisco.

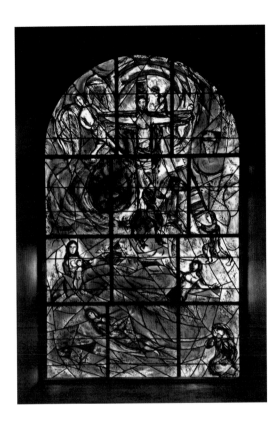

Figure 13
Marc Chagall The East Window, Tudeley
Church. Photo Peter Tulloch ARPS DPAGB.
Chagall ®/ © ADAGP Paris and DACS,
London 2013

Cecil Collins

Cecil Collins (1908–1989) was born in Plymouth to parents who had moved there from Cornwall.
His father originally had a good job as an engineer in a laundry and Collins said his childhood was
exceptionally happy. However the recession forced his father to work as a labourer on the roads.
Cecil had to leave school at 15 and was sent to work as a mining engineer. He hated this and left,
determined to become an artist. He was offered free drawing classes at the Plymouth School of
Art and then managed to win a scholarship to the Royal College of Art. There he met his wife who
was to be a lifelong companion, support and muse, and it is her face which influences so many of
his paintings such as The Artist and his Wife, (1939),Head of an Angel, (1987) and The Angel of
Flowing Light, (1968). As the titles of these paintings make clear, angels were a major theme of
his paintings throughout his life. For him they were one of the archetypes, the primordial images
which belong to all cultures and religions, and which manifest the divine to us. For him they were
not just images from the collective unconscious, as Jung believed, but 'the winged thoughts of the
divine mind.' They are part of a universal spiritual reality, that paradise from which we have been
expelled and to which we long to return.

After the Royal College Collins had critical and financial success with his own exhibition in 1935
and then as part of a surrealist exhibition. Looking at the biomorphic forms in his pictures The Promise,
(1936) The Joy of the World, (1937) and Hymn, (1953) it is easy to see why he was identified as a
surrealist, but he quickly distanced himself from them as they did from him. As he put it

I do not believe in surrealism, precisely because I do believe in surreality, universal and eternal above and beyond the world of intellect and senses; but not beyond the reach of humility and the hunger of the human heart."[22]

He felt increasingly out of sympathy not only with surrealism but with the geometric art of the time, and as a result was conscious of being artistically isolated. He did however move to Buckinghamshire for a period where he made contact with Eric Gill, who introduced him to the work of Jacques Maritain and David Jones. Although he did not share either Gill's religious beliefs or his aesthetic position, he wrote that 'Gill had more understanding of the desperate position of the creative mind in our time than most people in England.'[23]

In 1935, artistically isolated, Collins made the most important move of his life, to Dartington Hall in Devon. First of all he lived nearby, sharing its life, but then during the war, when he took over the teaching of art, into the hall itself. The teaching was important, because he found he had a natural talent for it in a way that developed the innate creativity of his students and which later, when he moved back to London, made him one of the most popular teachers at the Royal College of Art. Secondly as he has written, it was there

> that I painted and drew many of my best works. This period…was one of the most fruitful of my creative life, not only in writing for I was also writing a lot, clarifying my thoughts."[24]

It was his wife Elizabeth who first drew a picture of a fool, but thereafter it became one of his most fundamental images, as can be seen in The Sleeping Fool, (1943), Head of a Fool, (1974),The Pilgrim Fool, (1942) and Fool and Flower, (1944). The clown or fool had of course been a central image for Roualt, and the idea was in the air at the time. William Anderson has written about Collins that

> It was in the summer of 1939 that he came to see that what he most valued in himself was his childlike heart, and that the true purpose of his keen analytical mind was to defend his heart, not to betray it.[25]

As Collins himself wrote

> The Fool is the poetic imagination of life, as inexplicable as the essence of life itself. This poetic life, born in all human beings, lives in them while they are children, but it is killed in them when they grow up by the abstract mechanization of contemporary society.[26]

Not surprisingly Collins was drawn to the teaching of Jesus that to enter the Kingdom of Heaven we must become as little children, with their openness and capacity for simple wonder at the world around us.

After the war, with no fixed home for a period, Collins had some commercial success in London but the artistic climate was becoming colder for his type of painting. It was during this difficult

[22] Cecil Collins, *The Vision of the Fool*,(1974) p.26
[23] Gill, 1947, p.15 n.1
[24] Cecil Collins, *The Dartington Years, 1936–43*, Dartington Hall Trust, 1997, p.7
[25] William Anderson, *Cecil Collins: The Quest for the Great Happiness*, Barrie and Jenkins, 1988, p.51,
[26] Cecil Collins, *The Vision of the Fool*, 1947, reprinted 1981, Anthony Kedros, p.17

time from 1952-6 that Collins turned to more traditional Christian images. He had, however, and not unexpectedly, already written

> The greatest fool in history was Christ. The great fool was crucified by the commercial Pharisees, by the authority of the respectable, and by the mediocre official culture of the philistines. And has not the church crucified Christ more deeply and subtly by its hypocrisy than any pagan? This divine fool, whose immortal compassion and holy folly placed a light in the dark hands of the world.[27]

In <u>The Agony in the Garden</u> Christ has the same half moon face seen in <u>The Sleeping Fool</u>. The Chalice is not just the cup of suffering of traditional iconography for it appears in that unusual shape in an early picture of the artist and his wife where it clearly stands for the cup of inspiration and love running over. That shape is reiterated in the shape of the bodies of Christ and his disciples. Collins painted two versions of <u>Christ before the Judge</u>. In the first, done in 1954, Christ is meek and submissive. In the second, done two years later, the figure of Pilate has become much fiercer, now with bared teeth and reflecting Aztec and African sources. He represents the mechanism of law against Christ, now striated by the flagellation, and wearing a large crown of thorns. But Christ's eyes are wide open, revealing a strong, serene and eternal order that remains untouched by the harshness.

The Crucifixion of Christ contrasts the jagged, cruel lines on the left of Christ, with the fools and jongleurs of God dancing on his right, on whom Christ looks with sweet favour.[28] Collins had been earlier struck by a remark of Goethe that it was a disaster to have an image such as that of the crucifixion at the heart of a civilisation.

Perhaps most striking of all these images on Christian themes is <u>Resurrection</u>, where Christ as fool soars upward like a *tourbillon* of light, the crown of thorns transformed into a crown of glory. Below are the sharp weapons of the sleeping soldiers. Resurrection means awakening from this cruel sleeping world into the daylight of eternity.

During this time Collins also introduced an original theme of his own in <u>Angel Paying Homage to Christ</u>, as well producing an amazing the **Resurrection** (Figure 14). In this drawing a tall elegant angel emitting rays of light and blowing a long horn against the background of the sun dominates the picture. All down one side are bodies lying, waiting to be raised from the dead. It was resurrection that was important to Collins, resurrection to new consciousness, life in the eternal now.

Collins was a highly popular teacher but his art was out of kilter with the prevailing taste for American abstractionism. He was quite clear that art ought to have a theme, some content, and that it could not consist simply of pure form. However, there were a few who responded to his work, and it gradually obtained some recognition. A high point for him was when he was commissioned by Walter Hussey, the Dean of Chichester. Hussey had commissioned Graham Sutherland and Henry Moore when he was Vicar of St Matthew's, Northampton, and had already commissioned Sutherland for Chichester. At first Collins was unwilling to undertake the commission but soon saw it as a challenge to move beyond a purely personal vision of God to one which would engage a wider public. On the frame of the altar are the words from Revelation 'Behold, I make all things new'. What Collins produced was an altar cloth in orange and yellow marked with stars but dominated by a large sun out of which come rays of light. In the centre of the sun is an enigmatic face. It was an image that nicely brought together traditional Christian themes about God as light, with his own neo-Platonic understanding of religion.

[27] ibid. p.18

[28] Reproduced in Richard Harries, *Art and the Beauty of God*, SPCK, 1993,P.76

Figure 14
Cecil Collins The Resurrection,
1953 (oil on canvas) Photo ©
Peter Nahum at The Leicester
Galleries, London / The
Bridgeman Art Library. © ADAGP
Paris and DACS, London 2013.

One of the canons of the Cathedral at the time was Keith Walker, who when he became Vicar of All Saints', Basingstoke, commissioned Collins to do windows for his church.[29] The great west window **The Mystery of the Holy Spirit** (1988) made by Patrick Reyntiens, has the same theme as the altar at Chichester, one which was so fundamental for Collins (Figure 15).

More distinctive are the two side windows each entitled **Angel** (1985) but which are in fact on the theme of The Eye of the Heart (Figure 16).

At the dedication service for these in 1985 Collins said that he had drawn on a Sufi tradition that in all our hearts there is an eye.

> We are sleep-walkers, walking in the nightmare of the world. All real culture and real education are concerned with the existential knowledge of the opening of the Eye of the Heart – the one great basic need of our education and civilisation….It is the Eye that sees the world of angels, for like sees like, like attracts like.[30]

[29] Keith Walker, *Images of Idols? :The Place of Sacred Art in Churches Today*, Canterbury, 1996. This has a discussion of Collins, and also describes the difficulties that can be encountered in commissioning art for a church.

[30] Quoted by Anderson from Collins' manuscript. P.109

Figure 15 Cecil Collins "The mystery of the Holy Spirit" (Detail). West Window of All Saints Church, Basingstoke. Cecil Collins, made by Patrick Reyntiens. Dedicated 1988. Used by permission of Andrew Lane and All Saints Church, Basingstoke. © Tate / Estate of Cecil Collins.

Figure 16
Cecil Collins, "Angel Window, (The eye of the heart)" One of two in All Saints Church, Basingstoke, dedicated 1985. Used by permission of Andrew Lane and All Saints Church, Basingstoke. © Tate / Estate of Cecil Collins.

After this discussion of the more explicitly Christian imagery in Collins work, it is important to note what was even more fundamental for him, which for convenience can be described as Neo-Platonism. Platonism is based on the conviction that there is an eternal order to which we can have access through the three great absolutes of goodness, truth and beauty. There is a sense that in this world we are trapped or fallen, and our task is to recover our lost paradise through union with this spiritual dimension to life. It is not surprising that from the earliest days of Christianity Platonism in one form or another has been seen as a friend and ally of the Christian faith and it has often been taken into and merged with more orthodox faith. It is this Neo-Platonic perspective which lies behind Collin's paintings of fools, angels, sunrises and so on. For both Collins and his wife this vision imparted a lightness, a joy and an optimism to life. Once when asked to sum up his attitude to life and art he replied 'My face is set towards the dawn.'[31] It is a perspective on life which can be clearly seen in his haunting paintings Fool and Angel Entering City,(1969),Wounded Angel, (1967) and The Music of Dawn, (1988).

Stanley Spencer

Stanley Spencer(1891–1959) lived and worked for nearly all his life in and around Cookham. He trained at The Slade from 1908 to 1912 at a time when skilled drawing was stressed, particularly clarity of line. All his paintings exhibit his outstanding talent as a draughtsman. He was awarded a scholarship and won both the respect of his contemporaries and a number of prizes. During his life he mainly earned a living through his evocative landscapes, which were highly saleable. In his painting Silent Prayer, (1961) a cosy scene round the table evokes Stanley's childhood. His father was a musician and the whole family was full of music and talk. In many of his paintings he seeks to recreate the sense of safety and security he had as a child in that warm, loquacious household. For example, in Christ in the Wilderness:He Departed into a Mountain to Pray (1939) Jesus kneels with his hands together and face up in a childlike pose, by a rock that was like the pillow by which Spencer knelt to say his prayers as a child. In The Centurion's Servant (1914) the painting does not actually show the servant being healed. Instead it depicts a room as it were off centre stage, with the young Stanly lying on the family bed, whilst other members of the family kneel beside the bed. This warm, loving childhood was one of the sources of energy that went into his pictures, and which helped to give his religious scenes a fresh, arresting perspective.

On a vase in Silent Prayer is a cameo of his first wife Hilda in a pose Spencer loved, sketching one of the children. It is also Hilda who is dozing in the wickerwork chair in another part of the painting. This brings to mind a less happy, indeed poignant aspect of Spencer's life. Hilda was his deepest attachment and the source of inspiration for much of his painting. But in mid-life he became obsessed with Patricia, another artist who came to live in the village with her friend Dorothy. Stanley conceived a self-deceiving scheme of divorcing Hilda, marrying Patricia and then getting Hilda back to live with them. It seems that Patricia despised Stanley and only wanted to marry him so that he could make money for her through the sale of his popular landscapes. She succeeded in her scheme, though the marriage may never have been consummated and all the evidence suggests, though Patricia denied it, that she and Dorothy were lesbians. Hilda died in 1950 and after her death Stanley continued his project of trying to reclaim her through talking to her and writing to her. He painted Silent Prayer in 1951 at a time when he was intensely aware of their fusion. The unhappy aftermath

[31] Anderson, p.110

of his first marriage led to a very miserable, isolated period in his life but from this came some of his most moving religious images, the *Christ in the Wilderness* series.

Spencer had a wonderful capacity to see beauty in unusual places, a beauty which often had a strong sensual element about it. For example <u>Domestic Scenes :At the Chest of Drawers </u>(1936) shows a large woman bending right over, head down and one leg up, to get clothes out of the bottom drawer of a chest of drawers. The picture is dominated by the curve of her backside. Underneath the woman is Spencer as a young boy helping the woman to get the drawer open, with his head almost in the woman's stomach. The viewpoint is so original that the total effect is first of all startling, then strangely attractive, as we give way to Spencer's capacity to see beauty where others fail to do so because of their unthinking adherence to cultural norms of what counts as beauty. As in all great art, Spencer opens our eyes. 'I am very fond of chest of drawers and wives, they are both containers of things I like' he wrote.[32] As that sentence brings out, his writing has some of the characteristics of his painting, in being frank, somewhat quirky and vivid. He intended to write an autobiography, and for this kept extensive notes of how he worked and what it meant to him. The autobiography was never written but the notebooks have been archived at the Tate.[33]

Spencer was not consciously part of the modern movement. His own perspective on life, as expressed in his artistic vision, was so intense and singular, it would have been outside any movement. Nevertheless it is obvious that his religious scenes, and many of his domestic ones, unlike his highly popular landscapes, are not representational. There is exaggeration, distortion and often an odd perspective. In this sense he clearly belongs to the 20th century rather than any earlier period. But his unusual and characteristic figurations are not there as part of any prevailing style or fashion; they are fundamental to his feel for things. In this respect there is an illuminating contrast with a well known contemporary of Spencer's, William Roberts, who painted a fine crucifixion. But the tubular figures in this painting by Roberts are clearly shaped by the cubism of the time in a way that Spencer's paintings of the period were not. As has been written:

> He can be contrasted with Roberts, whose figures are simplified with more formal intention. Any abstraction in Spencer is expressive having more in common with the spiritual in trecento painting, particularly with Giotto, than with deliberate stylisation.[34]

Spencer brings to mind the remark of Francis Bacon, 'There is no excellent beauty without some strangeness in the proportion.' Interestingly this was the favourite quotation of Samuel Palmer, another painter with an intense religious vision.[35]

Spencer also saw the Holy where others see only the mundane, and indeed for him the sexual and the holy seemed to fuse in one stream of energy, as he made clear when discussing the crucifixion scene that he set in Macedonia, discussed later. Above all he saw the Holy in Cookham High Street and the people who traversed it daily. We see this for example in <u>Sarah Tubb and the Heavenly Visitors.</u>(1933). Sarah Tubb was a village lady who saw Haley's comet and taking it to be a sign

[32] Tate Archive733.3.3 quoted in *Stanley Spencer:The Apotheosis of Love*, Barbican Art Gallery, 1991, p.52

[33] Some of them are quoted at length, edited by Judith Nesbitt in *Stanley Spencer: A Sort of Heaven*, Tate 1992. Spencer was also a prolific letter writer. *Stanley Spencer:Letters and Writings*, ed. Adrian Glew, Tate, 2001

[34] Anthony Blond, *Stanley Spencer:Christ in the Wilderness*, The Art Gallery of Western Australia, 1983, p.4

[35] Rachel Campbell-Johnson, *Mysterious Wisdom:The Life and Work of Samuel Palmer*, Bloomsbury, 2011, p.133

of the end of the world knelt to pray in the street. This is also the theme of In <u>Villagers and Saints,</u> (1933), also set in Cookham High Street. In this painting children play marbles or sprawl around. An old man looks at his bag of empty beer bottles. Interspersed between them are angels, also observing the marbles or the beer bottles or just sitting around in the sun. Heaven is on earth and earth is taken up into heaven. Angels and men are dancing together as in Botticelli's nativity. But here, as in so many of Stanley Spencer's paintings, the earthly is earthy indeed. It is the ordinary, everyday, mundane aspects of life which for him radiated with the divine. As he wrote

> When I lived in Cookham I was disturbed by a feeling of everything being meaningless. Quite suddenly I became aware that everything was full of special meaning, and this made everything holy. The instinct of Moses to take his shoes off when he saw the burning bush was very similar to my feelings. I saw many burning bushes in Cookham. I observed the sacred quality in the most unexpected quarters.[36]

<u>Christ Preaching at Cookham Regatta,</u>(1959), is one of Spencer's most famous paintings. Here all is crowds and jollity. The man in the front of the picture is carrying mops and assorted boat gear, practical tasks to be done, which were always important to Stanley. Christ sits in a wicker chair on the ferry a little way off shore. Behind the ferry is a row of punts. It is a picture based on the scene in Mark Chapter 4 where it is recorded that the crowds were so great that Christ got into a boat where he sat and from which he talked. The crowd gathered at the water's edge. Here Christ has bare feet, a long coat and hat, like a Chasidim. He is sitting in a basket chair, leaning forward with such excitement that he has to hold himself in his chair to stop himself going forward. Children and little people are in the ferry. The scene took him back to his youth when literally thousands of people came down from London to join locals in the exuberance of the regatta. To Stanley the regatta was a symbol for the fulfillment of everyone's wishes.

> If it is carnal wishes, they will be fulfilled; if it is creative wishes, they will be fulfilled. If it is sexual desires or picture making inspiration that is to be satisfied, then Christ will heave the capstan round … all will be met. Everything will be fulfilled in the symbol of the regatta. The complete worshipfulness and loveableness of *everything* to do with love is meant in this regatta scene. In that marvelous atmosphere nothing can go wrong.[37]

The children on the ferry are, he said 'like little frogs which have jumped accidentally into punts from the riverbank'. We are reminded of the words of Jesus that we must become like little children and that babes and sucklings cry out in praise.

Another painting in which the story of Jesus is set very firmly in the present day is **Christ Carrying the Cross** (1920) which shows Christ carrying his cross through Cookham High Street (Figure 17). The light seems to come from high up on the right as we look. The men on the bottom left are shielding their faces from it. The light casts strong shadows on the houses from the people. The light seems pale, almost unearthly. The sky is not bright blue. Is it moonlight, or early morning light? The colours too are interesting with their subdued, pastel shades. The people are looking out of windows and the net curtains are blowing out rather like angels' wings as the people look all about. The presence of the ladders derives from what actually happened when Stanley Spencer was working on this composition. He saw workmen carrying ladders across the

[36] *Sermons by Artists*, Golden Cockerel Press, 1939, p.50
[37] Stanley to Unity, Private Archive, quoted by Kenneth Pople, p.506

Figure 17 Sir Stanley Spencer, "Christ Carrying the Cross" ©Tate, London 2012. © The Estate of Stanley Spencer 2013. All rights reserved DACS.

houses and this provided, as he put it 'the reality of everyday life' and enabled him to locate the *via crucis* in Cookham High Street. The ladders are a visual echo of the shape of the cross. Women with doll-like faces are by the railings, which are in the shape of sharp spears suggesting violence. Christ himself is hidden under the cross whilst men with caps, perhaps bricklayers with hods, and a slight sense of Klu Klux Klan menace lead the crowd. Overall there is a sense of people being out and about and busy, with the procession to the crucifixion hardly noticed, lost amidst ordinary, everyday things. Yet it is the light that indicates something strange taking place, perhaps it is one of those shafts of light that you get sometimes just before or after a storm. The Tate Gallery originally

mistitled this picture 'Christ *Bearing* his Cross' which intensely irritated Stanley Spencer. As he said, the false title implied

> A sense of suffering which was not my intention. I particularly wished to convey the relationship between the carpenters behind him carrying the ladders and Christ in front carrying the cross. Each doing their job of work and doing it just like workmen ... Christ was not doing *a* job or *his* job, but *the* job.[38]

Again, when Stanley Spencer's dealer thought of cataloguing the painting as 'Christ Carrying *His* Cross' Stanley was furious. The cross was for him universal. We all have to carry the cross.

The Crucifixion, (1959) was the last major painting that Stanley Spencer executed before his death. It was painted for the chapel of a school funded by brewers, hence the brewers cap on the men nailing Christ to the cross. The painting caused a public outcry and when Stanley Spencer went down to talk to the school about the meaning of the painting his remarks would hardly have helped. He told the boys 'It is your governors and you who are still nailing Christ to the cross'.[39] In this painting we stand as spectators on a pile of rubbish in Cookham high street, with other spectators looking out of their windows. Mary is spread-eagled on the ground as though thrown by a wave. A schoolboy ties Christ's legs and the face of one thief is twisted in grotesque form as he shouts abuse. The brewer's men are using all the force they can muster to bang home the nails. Storm clouds gather above and Christ looks up, accepting of his fate.

Spencer himself was a man of holy simplicity, seeing life in a way that cut across the usual assumptions of pomp and power. As Hilda wrote

> Being with Stanley is like being with a holy person to one who perceives. It isn't that he is consciously or intentionally good or bad, or intentionally anything, for he *is* the thing that so many strive for and he only has to *be* and a sermon is preached.[40]

But as the painting on the crucifixion reveals, an attitude that was particularly shown in his hostility to Sir Alfred Munnings the former President of the Royal Academy who tried to get the police to prosecute him for obscenity, Spencer was quite capable of strong anger at the convention and cruelty of the world.

The Resurrection, (1924–26) was not only the title of a painting but a theme which preoccupied Stanley. In addition to the famous resurrection in Cookham Churchyard he painted but The Resurrection of Soldiers (Figure 18) in the Sandham Memorial Chapel and the wonderful series of Port Glasgow Resurrection scenes. In the Cookham Churchyard resurrection everything has personal significance. Stanley is lying on the tomb at the bottom right. Hilda is shown a number of times, each representing a luminous moment, a sudden flash of awareness which lifted his spirit in joy. As Stanley himself wrote

> No-one is in any hurry in this painting. Here and there things slowly move off, but in the main they resurrect to such a state of joy that they are content and happy to remain where they have

[38] Archives of Arthur Tooth and Sons, in the Tate as 8917. The painting was about to be hung at the Venice Bienalle. Kenneth Pople, p.91

[39] *Stanley Spencer, The Man:Correspondance and Reminiscences,*ed. Sir John Rothenstein, Elek, London 1979, p.131. Kenneth Pople, p.492

[40] Tate Archive, 733.1.1640 quoted in *The Apotheosis of Love*, p.95

resurrected. In this life we experience a kind of resurrection when we arrive at a state of awareness, a state of being in love ... and at such time we like to do again what we have done so many times in the past ... Hilda mooches along and slowly goes over a stile. She wears a favourite dress of hers. The people read their own headstones. By the ivy-covered church tower a wife brushes the earth and grass off her husband. Another buttons a man's coat up and another straightens a man's collar. Further down you see Hilda smelling flowers ... in each part of the picture the meaning of the resurrection is conveyed by bringing people into contact with their customary surroundings. To emphasise the place and bare fact of myself, I have thought of an open book ... and when you read a book you settle down to it ... and this me settling down between the two lids of the tomb is my signature to the painting.[41]

It is all about the 'fresh realisation of the possibilities of heaven in this life' as he put it.

During World War I, after a long period of agonizing, Spencer joined the RAMC, serving first as a hospital orderly, then in Macedonia and finally with the Royal Berkshires. His time in Macedonia is reflected in a painting he did for the War Artists Commission, <u>Travoys Arriving at a Dressing Station at Smol, Macedonia</u>, but especially in the frescoes for the Sandham Memorial Chapel. There he depicts, in fact celebrates, the ordinary activities of soldiers and also scenes in the hospital. Unlike the well known poets of this period he did not concentrate on the suffering of war but on the joy that can be found even in the midst of it in the down to earth details of everyday living. Macedonia is also the setting for <u>The Crucifixion,</u> (1921) which was commissioned for a village hall war memorial which eventually fell through. It depicts Macedonian topography and Mediterranean clarity of light. The composition is scattered, with a soldier on the left with spear and robe which he has won in the lottery. On the right at the bottom is the Centurion. Middle right are the spectators shaking their heads. The force of this imagery lies in Spencer's experience in the Vardar hills in Macedonia in 1918. He saw three ravines standing out in the snow 'like three spear wounds'. They did not make him think of the crucifixion. Nor did he simply use the imagery in an illustrative way. His experience was both of the worst that lay ahead and yet great hope. As he walked along

> I suddenly had a feeling of the completeness and fitness and ultimate redemption of everything ...
> I felt I was a walking altar of praise.[42]

The worst experiences which lay ahead are expressed in the distorted composition, very different from a camera view of the plain. The picture could also of course be given a Freudian interpretation. But Spencer was aware of this. As he wrote honestly and revealingly

> I start off in the direction of vision and am drawn towards secular wishes and desires. In expressing them, I come across a religious feeling as if by accident and not ready for it; I am unable to express it as it should be expressed and realised. Conversely, if I start off in the same vision way ... trying literally to find this real religious something, I achieve ordinary uninspired secular feelings like in landscapes. The element I want in the religious picture I find in secular and in secular love and

[41] Quoted by Kenneth Pople,*Collins*, 1991 p.227/8. This is the major biography of Spencer, drawing extensively on the Tate archive. There is a good introduction with plenty of reproductions in Duncan Robinson, <u>Stanley Spencer,</u> Phaidon, 1990

[42] Quoted by Pople, p.205

feeling; and the secular element I don't like or want I find when I do a religious picture that is minus the sex element.[43]

Spencer's sexual energy went into everything he saw and painted. It was not focused on scenes calculated to bring about sexual arousal. Rather it was expressed in an all prevailing emotional affirmation of everyone and everything. In <u>Bathing Pool Dogs</u> (1957) it is not just the bottoms and the legs of the women which are accentuated in an erotic way, but the dogs they are leading. Their curve and line is no less sensual than that of the humans. This sensual element can appear also in his religious scenes, for example <u>The Marriage at Cana:Bride and Groom</u> (1953) where the focus is on the groom pulling back the chair for his bride to sit down on. She smoothes her dress on her bottom in order to stop it creasing, accentuating its rounded shape, and this is what the groom is looking at. This sensual element was, for him, inseparable from the Holy. The sexual and the holy were fused into a holistic vision of life, which was at the same time a vision which made him see the most ordinary activities raised into new life now. They remained ordinary, but the ordinary was extraordinary, miraculous, and that is what most of us fail to see most of the time. We see this understanding of Spencer well illustrated in the Sandham Memorial Chapel.

The Sandham Memorial Chapel was commissioned by Mr and Mrs Behrend in memory of their son who died in Macedonia. It is reminiscent of the Arena Chapel in Padua by Giotto. There are however major differences. In <u>The Resurrection of Soldiers,</u> (1927– 1932), the central Christ has been replaced by two resurrecting mules turning their heads, perhaps reminiscent of childhood memories of horses in the Vale of Health in Hampstead. The driver wakes between the mules, a scene perhaps based upon Stanley waking after a nightmare and taken to sleep between his parents. A tiny Christ is receiving the crosses of the soldiers. Below him a small Stanley gazes at the flattened wagon.

Christ is not there as judge but as one who with great compassion receives the cross which each soldier brings. As in other scenes in the chapel, based on his experiences as a wartime hospital orderly, where we have scenes of scrubbing floors, serving tea, making beds and washing furniture each soldierly activity is evoked in a way which is at once affectionate and affirmative. In the resurrection scene the soldier on the right lower side polishing brasses corresponds to Giotto's depiction of hell in the corresponding place in his Scrovegni chapel. For there is no place for hell in Spencer's scheme of things. Furthermore, ordinary physical tasks, however mundane, were for him part of the glory of things, provided their spiritual meaning can be discerned. What do the soldiers do as soon as they are resurrected on the battle field where they had fallen? They polish their belts and brasses. The most mundane of activities, but not mundane for Spencer. As he put it, referring to his time in the hospital

> I did not despise any job I was set to do, and did not mind doing anything so long as I could recognise in it some sort of integral connection with the spiritual meaning that demanded to be clarified.[44]

He was much influenced in his attitude to work by some words of St Augustine about God being always at work and always at rest, which he thought of as God always fetching and carrying, but with an inner serenity.[45]

[43] Tate Archive 733.3.375 quoted by Pople, p.207
[44] Kenneth Pople, p.106
[45] ibid, p.113

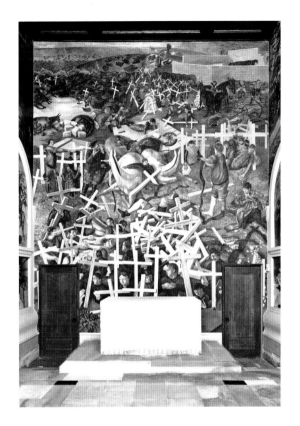

Figure 18
The east wall with the altar and THE
RESURRECTION OF THE SOLDIERS
by Stanley Spencer (1891–1959) at
Sandham Memorial Chapel, Burghclere,
Hampshire". ©National Trust Images/
John Hammond © The Estate of Stanley
Spencer 2013. All rights reserved
DACS.

During World War II Spencer went as a War artist to Port Glasgow on the Clyde, 15 miles down river from Glasgow itself. He was fascinated by the communal life of the city. 'I liked it here being lost in the jungle of human beings, a rabbit in a vast rabbit warren.' He wrote. He also liked the process of production in the ship yard. He valued good work for its own sake. He did the preliminary sketches on a roll of toilet paper, 'The roll'. These paintings of shipyard workers are amongst the finest he ever did.[46] They were well received in both London and New York. For many years it has not been possible to view them, but now wonderfully restored they were on view in the Stanley Spencer Gallery in Cookham in 2011. For Spencer there was no distinction between secular and religious art, for all was holy. He said about the men working in the shipyard 'I was as disinclined to disturb them as I would disturb a service in church'.

Whilst in Port Glasgow he also did a superb series of studies of the resurrection. After describing the vivid life of the city he wrote that it

> Seemed to me full of some inward surging meaning, a kind of joy, that I longed to get closer to and understand to in some way fulfill; and I felt that all this life and meaning was somehow grouped round and in some way led up to the cemetery on the hill outside the town…and I began to see the Post Glasgow Resurrection that I have drawn and painted in the last five years. I seemed to see that it rose in the midst of a great place and that all in the plain were resurrecting and moving towards it…I knew that the resurrection would be directed from the hill.[47]

[46] *Men of the Clyde:Stanley Spencer's Vision at Port Glasgow*, Scottish National Portrait Gallery, 2000
[47] *Stanley Spencer: Resurrection Pictures*, Faber and Faber, 1951,p.6

In this brilliant series he paints people rising from their graves into the life they have known. They yawn and wake up, they greet one another, they look around and tidy up. They were the people with whom he had worshipped in chapel as a child.[48] This was not everyone's idea of a resurrected life. Winston Churchill wrote 'If this is the resurrection give me eternal sleep.'[49] The paintings are full of visual subtlety. Spencer himself wrote about this series of paintings and what each was trying to convey. About <u>Tidying</u> Spencer wrote

> In several of these paintings I have wanted to suggest an idea of different kind of 'looking' – the steadfast look of the grandparents in the big picture for example; and here I wanted to give the difference between the daughter on the right who looks with affection and devotion at her father and the kind of peeping round the head-stone of the child and mother and the conversational look of the man and woman at the top on the left who are just talking sympathetically; and in the centre I wanted to make the contrast between the nurse-maid woman looking into the right-hand world and aware of the import of all she sees, and the look of the child she carries who is turned to the left and looks at what he sees with wonder.[50]

As so often the scenes drew on childhood memories. About <u>Rejoicing</u> Spencer wrote

> In the foreground a woman waters flowers on a grave, another kneeling, holds a vase of flowers, and a third cuts the grass round the grave with scissors (a nice homely woman who once looked after me used to say 'I've just been down to the churchyard and given me mother another a clip round') and she did it just so with scissors.[51]

Spencer wrote about **Reunion**.

> Here I had the feeling that each grave forms a part of a person's home just as their front gardens do, so that a row of graves and a row of cottage gardens have much the same meaning for me. Also although the people are adult or any age, I think of them in cribs or prams or mangers. 'Grown ups in prams' would perhaps express what I was after – the sense of security and peace that a babe has as it gazes over the rim of its pram out into the world around it.[52]

Spencer painted scores of Biblical scenes, all from his distinctive perspective and with his intense personal feelings about life. Some work better than others, but none could be accused of depending on stale imagery.[53] It would be possible to illustrate a life of Jesus almost entirely from his paintings. To take one example:

The <u>Last Supper</u>,(1920), takes place in bare brick surroundings. It is the inside of a garage or warehouse or more probably an old house in Cookham. There is monastic simplicity and a sense of seclusion. Light from the low window slants across the disciples on either side. On one side the disciples sitting upright raise their hands palms open. On the other side they grip the table,

[48] *The Apotheosis of Love*, p.13

[49] Rothenstein, p.198

[50] *Stanley Spencer: Resurrection Pictures*, p. 18

[51] ibid. p.14

[52] ibid. p.22

[53] Some of these can be seen in the Stanley Spencer Gallery at Cookham, see the catalogue of religious paintings produced by the Gallery for their Millennium exhibition

arms outstretched and bodies pushed back. All eyes are on Christ. The familiar details of the Last Supper scene are present. The beloved disciple reclines on Jesus bosom whilst he breaks bread. Judas is there his hand dipping into a bowl on the left. There is a sense of mystery and horror as all is close attention. What is not familiar is the focus on the legs and feet of the disciples, large, exposed and vulnerable. There are classical folds in the garments of the disciples as they stretch their legs forward and the feet are not unbeautiful. These are the feet that Christ washed, exposed with pristine pride, clean and drying in the sun.

Of particular interest is the series Spencer did on *Christ in the Wilderness*.[54] Spencer originally conceived it as 40 paintings, one for each day of Lent. In 1981 The Art Gallery of Western Australia had the opportunity to acquire the whole collection, together with 16 drawings. The series celebrates the unity of all living things. This love of the natural world went very deep in Spencer. Of the nine paintings in that series I comment on two of them.

Rising from Sleep in the Morning (1940). This painting dates from the very bad time in Spencer's personal life mentioned earlier. His marriage had broken up and he was living on his own in Swiss Cottage, extremely isolated. But this very isolation created the context for a profound spiritual awareness. Spencer wrote that he felt there was something wonderful about the life he was living

> I felt a part of God and it did not matter where I was because God and I would be there so that everything could only be part of that. This is what gives everything a chance of being its real true self. I loved it all because it was God and me all the time.[55]

In this painting Christ arises from sleep in the morning with a sense of anticipation and joy.Christ's white robe forms the petals of a flower, whilst his hand reaching up is a stamen rising to the sun. There are not only the inner white petals but the outer brown ones formed by the rock. The rock is also a bomb crater dating from World War I that Spencer had seen at some point. It is a flower growing out of a rocky wilderness, new life rising out of destruction. As far as Spencer himself is concerned, this is the flower of his true self growing in the rocks of his wilderness.

The Scorpion (1939) was painted during the same low point of Sencer's personal unhappiness (Figure 19). Mark I.13 has the words: 'And he was in the wilderness 40 days tempted by Satan; and he was with wild beasts; and the angels ministered to him.'

It is strange and wonderful that Spencer should have chosen a scorpion for Jesus to cup in his hands and gaze down on, for the scorpion was feared and rejected. In Luke 11.11 and 12 we read, 'What father among you, if his son asks for an egg will give him a scorpion?'. Yet there are other texts which can illuminate this picture. In Ezekiel 2:6 the Son of Man is told to speak to the people of Israel, who will be rebellious. 'And you, Son of Man, be not afraid of them, nor be afraid of their words though briars and thorns are with you when you sit among scorpions.' Then there is Luke 10:19. The disciples are given power over evil with the words, 'Behold I have given you authority to tread upon serpents and scorpions and over all the powers of the enemy; and nothing shall hurt you.'

The colours in this painting are very striking: subdued browns, greys and yellows. The hills are bare and the sky is overcast, with clouds threatening, not blue. All the focus is on the face of Jesus, which is dark brown with a kind of sheen on it. His gaze is on the scorpion cupped in his hands. The scorpion, feared and rejected, is taken up gently. The Son of Man is not afraid. He does not have to tread on the scorpion. He tends it. If the Fall of Adam brought about a disruption in nature,

54 *Stanley Spencer:Christ in the Wilderness*,

55 Stanley to Hilda. Tate Archive, 733.2.182. Quoted in Stanley Spencer:*The Apotheosis of Love,* ed. Jane Alison, Barbican Art Gallery, 1991

Figure 19 Sir Stanley Spencer "Christ in the Wilderness: The scorpion 1939". oil on canvas/
 56 × 56 cm 69 × 69.1cm (framed). State Art Collection, Art Gallery of Western
 Australia, Purchased 1983. ©Tate, London 2012. © The Estate of Stanley Spencer
 2013. All rights reserved DACS.

leading to disorder and mutually antagonistic chaos, here there is a new harmony between man and
his ancient enemy in nature. There is extraordinary gentleness in the way Christ holds the scorpion
and looks at it, an infinite pity. Spencer's own sense of isolation and suffering gave him a fellow
feeling with this outcast, with its shells and its sting. But he holds it gently cupped in his hand with
tender gaze. The angels who ministered to him came in the guise of a scorpion. Stephen Cottrell
in his book of meditations on this series of painting on Christ in the wilderness goes further than
this to account for the presence of this creature of vicious sting. For example, seeing the Scorpion
in relation to the text from Luke quoted above, he suggests that the scorpion is precisely what the

loving father of Jesus *has* given his son, namely a vocation to death, and it is part of the experience of temptation in the wilderness that Jesus accepts this destiny, rather than rejecting it.[56]

This painting not only reflected Spencer's experience at the time when he worked on it, but an attitude to nature which was part of him from childhood. As a child he used sit in the outdoor lavatory at Cookham with frogs or insects which he used to pick up and place on his naked leg. He delighted in the empathy he felt with all creatures. It was a oneness he also felt with the whole physical universe.

Spencer has a way of treating fabric that gives a simple monumentality to the form of the body, and sometimes the shape of the fabric is related to the landscape. Here, for example, the contours on the horizon are echoed in the contours of Christ's garment. It can also be noted that when Spencer painted a scene he not only painted it as looked on from outside, but as physically felt from inside. This helps us to understand the prominent, outsize hands. When we look down at our own cupped hands they do indeed suddenly loom large, strange and out of proportion. This capacity to be physically inside his paintings accounts also for example for the long spread-eagled legs in his painting of The Last Supper as well as for the way Jesus is kneeling or sprawling in some of the other paintings in the wilderness series. They are how Spencer actually felt his body, as he himself was in these positions.

I believe Stanley Spencer fully met the challenge set out in the first chapter of this book and I have suggested some of the reasons why he succeeded in doing so. In his religious paintings, as opposed to his landscapes, he was clearly part of the 20th century, even though he was not consciously part of any movement. But as indicated earlier, the strangeness of his style arises out of the way he saw life, as a vision of felt love. As he wrote 'Distortion arises from the effort to see something in a way that will enable him to love it.'[57] He never sought to swim with current fashions. On the contrary, he found his own artistic voice early and remained consistent to it throughout his life. One of the strengths of British art in the 20th century, as brought out by the art historian Frances Spalding, is the fact whatever the prevailing fashion, there were always a number of different schools and styles. It was characterized by a variety of approaches. Spencer is a good illustration of this. He never belonged to any one school. He was *sui generis*, and his art, much appreciated in his lifetime, has become increasingly recognised and valued since his death. The reason why his art succeeds is not only his draughtmanship, superb though that was, but the originality and intensity of his personal vision. What is conveyed above all is his affirmation of life in all its aspects and forms, and his sense of the holy in ordinary things and activities. He saw all things as redeemable and he painted them in their redeemed state, as raised into true life even now. This vision gave him a very different perspective on biblical scenes from that of any artist before, often one that was derived from his childhood experience or which he had seen later as he continued to look at the world with the innocent directness of a child.

The intensity of Stanley Spencer's feelings can be gauged by a remark he once made, perhaps about his friends the Slessors.

> I remember having some friends I was always meeting in the evenings and did not see anything special about them until one day I went to have breakfast with them, and seeing them at breakfast gave me wonderful feelings about them. I was so overcome that I could not eat my breakfast, not even bread and butter.[58]

[56] Stephen Cottrell, *Christ in the Wilderness*, SPCK. 2012, pp 58

[57] *Sermons by Artists*, Golden Cockerel Press, 1934,p.52

[58] Pople, p.195

For Stanley Spencer this feeling was above all that of love, about which he once wrote

> Love is the essential power in the creation of art and love is not a talent. Love reveals and more
> accurately describes the nature and meaning of things than any mere lecture on technique can do.
> And it establishes once and for all time the final and perfect *identity* of every created thing.[59]

This love not only establishes the identity of every created thing but raises that thing into a
harmonious relationship with all other things and people. For Spencer this was about taking the
'in Church feeling out of church'[60] If we believe with Thomas Aquinas that grace does not destroy
but fulfill nature then in Stanley Spencer's paintings we see grace at work on our disfigured world,
transforming human relationships into a holy communion of the divine and the human, the divine
expressed in and through the human, the spiritual in and through the physical, the holy in and
through the mundane, the beautiful in and through what sometimes strikes us in his pictures as
the ungainly or ugly. For all was embraced in his vision and raised into a heaven of here and now.

[59] *Sermons by Artists*, Golden Cockrell Press, 1934,p.51 The whole sermon is a powerful hymn to love.
[60] Duncan Robinson, p.25 and p.123

Chapter 4
Catholic Elegance and Joy

In this chapter I consider two artists, Eric Gill and David Jones, whose approach to art, as well as to life, was decisively motivated and shaped by their Roman Catholic faith. They occupy a special place in twentieth-century art, if it is considered from the standpoint of consciously Christian artists who thought deeply about what it was they were trying to do. However, before that I will note briefly the artists who decorated Berwick Church in Sussex during World War II. These were Duncan Grant, Vanessa Bell and Quentin Bell, the son of Vanessa and Clive Bell. Vanessa was the sister of Virginia Woolf. The decoration was conceived as a unified scheme and owed its patronage to Bishop Bell of Chichester. The church is interesting to see, but from the standpoint of this book what stands out is that though these artists belonged to the Bloomsbury Group, the fashionable avant-garde of the time, the paintings do not come across as modern in the same way as do the majority of artists considered in this book. Although Duncan Grant and Vanessa Bell had come to be decisively influenced by post-impressionism, their inspiration in the church is primarily the Italian Renaissance. An exception might be made for Duncan Grant's The Victory of Calvary, but overall the effect is illustrative and decorative, rather than the expression of any marked religious sensibility.

I also wish to note briefly one currently neglected artist, Leon Underwood, who does not fall into the same category as Gill and Jones, but who made his reputation about the same time as they did; and whilst primarily known for his work on more general subjects, he also produced a limited number of works on Christian themes before and after World War II.

Leon Underwood

Leon Underwood (1890–1975) trained at the Slade. He was a highly versatile artist and worked in a range of materials, but is best known as a sculptor. Described as 'the father of modern sculpture in Britain', he taught Henry Moore, who often acknowledged his debt to him. His work is included in the collections of major galleries and museums, nevertheless, as has been written 'No artist of his generation of remotely comparable achievement has been so little honoured: indeed so neglected.'[1]

One reason for his neglect may have been his whole approach to art, which was contrary to the prevailing fashion of the time. He believed art went in cycles, from high points to low ones, and he believed that 'modern art is decadence'. Paradoxically he was himself at the forefront of the modern movement of his time, and admired many of the abstract artists, but thought they would have been even better in a different epoch. He linked this decadence to modern art's emphasis on form alone. Of course there needed to be form, he argued, but subject was equally necessary. Furthermore he believed that a spiritual dimension to this was crucial: 'For Underwood subject, which for him means spiritual content, is all-important.'[2] For him this was revealed above all in the art of earlier cultures. A turning point came with his detailed study of the cave paintings at Altamira in 1925. This led him to take long journeys to Mexico and other countries to look at their early art,

[1] Christopher Neve, *Leon Underwood*, Thames & Hudson, 1974, p.7.

[2] Ibid., p.8.

Figure 20
Leon Underwood, African
Madonna, St George's Cathedral,
Cape Town

and found in such work an inspiration even before Henry Moore and other artists of the time did so. For Underwood this art of earlier cultures consisted of 'forms created by inspired belief'.

Underwood had an early interest in metaphysical beliefs and produced 10 paintings on the theme of 'Casement to Infinity'. As far as work on Christian themes is concerned he produced a substantial decorative programme for the church of St Michael and All Angels, New Marston, Oxford, which was dedicated in 1955. This consists of two murals, one behind the main altar on the Resurrection and one in the Lady Chapel on the Annunciation. In addition to the murals in the church he did an acrylic panel for the altar and a stained glass window. He also produced a strong and evocative **African Madonna** which stands today in St George's Cathedral, Cape Town (Figure 20). Made of lignum vitae, it was sculpted in 1935 for St Peter's School for Natives, Rosettenville, Johannesburg. I first saw this work some 30 years ago, when it made an immediate impression which has remained with me. It seemed at once quintessentially modern, thoroughly African and fully Christian in its depiction of the spiritual strength of the mother of Jesus.

Eric Gill

Eric Gill (1882–1940) studied at Chichester Art and Technical School and then started to train as an architect in London. At the same time he took evening classes in both stone cutting and calligraphy. In 1903 he gave up architecture to concentrate on these skills and he became the most influential

calligrapher, letter cutter and type designer of the twentieth century, associated particularly with Perpetua and Gill Sans typefaces.

Gill was influenced by Hindu sculpture on South Indian temples, as well as by the Indian writer Ananda Coomaraswamy, and these influences, allied to his unremitting sexual appetite, gave much of his work an erotic quality. His highly active sex life – unconventional, immoral, illegal and much publicised in recent years – is beyond the scope of this study, except for the point that an elegant sensuality permeated all his work.[3] Gill moved to Ditchling in 1907 and after the end of World War I founded a Catholic artistic community, the Guild of St Joseph and St Dominic. The name is significant. Joseph was a carpenter, and Gill highly prized the basic skills of making. St Dominic was the founder of the Dominican Order, whose vocation includes intellectual work. Gill was much influenced in his approach to art by the Catholic philosopher Jacques Maritain, and he himself wrote a great deal on the subject. In 1924 Gill and the community moved to Capel-y-ffin, in the Black Mountains, and then in 1928 to Pigotts, a house in Speen, near High Wycombe, where in addition to other work he set up a press. As well as number of memorials, Gill produced some major public sculpture, such as three of the eight 'Studies of Wind' for what is now St James's Park Underground Station, where Epstein's work is also prominent. However his best-known sculpture is Prospero and Ariel on Broadcasting House in Langham Place, which was carved in the late 1920s. It is still a striking piece of work. There was a row over the size of Ariel's genitals, and Gill was forced to make them smaller.

Gill's best-known religious works are the Stations of the Cross which he did for Westminster Cathedral in 1914. This raises the issue of his Roman Catholic faith, and how he came to it. His father was originally ordained as a congregational minister but, rebelling against the doctrine of hell, joined the Countess of Huntingdon's Connection, a small sect that had separated from the Church of England but kept the prayer book. He then moved once again to become ordained in the Church of England. Eric Gill was one of a large, poor but basically happy family, for whom religion was fundamental and taken for granted. However, when as a young man Gill joined an architect's office he became what was then called a free thinker. His journey from there to Roman Catholicism and how it became integrated into his whole philosophy of life is told in his autobiography. There he makes great play of making up a new religion for himself, and then discovering that it had been there all the time in the form of Roman Catholicism. Amongst all the rather playful, paradoxical, not altogether convincing reasons he gives for becoming a Catholic, what is clear looking at it from the outside is that Gill was by temperament and upbringing a deeply religious person. What Monsignor Ronald Knox said about himself, referring to his relationship to his own evangelical father, is also true of Gill: 'I must have a religion and it must be different from that of my father.' In short there was both continuity and discontinuity with his religious upbringing. The continuity lay in the seriousness with which he took religion. The difference lay in the fact that, like Ronald Knox, he converted to Roman Catholicism. However, Gill's whole being was obviously moving in that direction for some time, drawn as he was by its sacramental view of life and the way it held together the material and the spiritual. In the end it was hearing some plainsong in a Belgium monastery that convinced him. As he put it:

> I knew, infallibly, that God existed and God was a living God – just as I knew him in the answering smile of a child or in the living words of Christ.[4]

3 The full story of Eric Gill's sexual life is disclosed in Fiona MacCarthy, *Eric Gill*, Faber, 1989.

4 Eric Gill, *Autobiography*, Kessinger Publishing Rare Reprints, 2010; originally published 1941, Devin-Adair, pp.193–4.

Figure 21
Eric Gill, Christ Crowned,
The Four Gospels of Our Lord
Jesus Christ

Gill experienced life with extraordinary intensity, and sometimes the strength of his own perceptions almost knocked him over. One such moment was the first time he saw a great friend and mentor engaged in calligraphy. As he wrote:

> I did not know such beauties could exist. I was struck as by lightning, as by a sort of enlightenment … there are many occasions when, in a manner of speaking, you seem to pierce the cloud of unknowing and for a brief second seem to know even as God knows – sometimes when you are drawing the human body, even the turn of a shoulder or the firmness of a waist, it seems to shine with the radiance of righteousness.[5]

Catholicism shaped not only his understanding of art but also his social and political views, leading him to be fiercely anti-capitalist.

Gill produced a good number of religious carvings, crucifixes and Madonnas using traditional imagery, some now in the Tate collection such as <u>Crucifix</u> (1910), <u>Crucifix</u> (1913) and the print <u>Crucifix</u> (1926). <u>Madonna and Child</u> is now in Glastonbury. Some of the imagery is specifically designed to reinforce Catholic teaching and often uses imagery from the mediaeval period, such as the print <u>Crucifix, Chalice and Host</u> (1915).

Gill's work on the Bible, both the exquisite calligraphy and the evocative illustration, is some of his most outstanding work. **The Four Gospels of Our Lord Jesus Christ** contains, amongst

[5] Ibid., p.119.

other illustrations, <u>Jesus Entering Jerusalem on Palm Sunday</u>, <u>The Shepherds Worship the Infant Jesus</u> and <u>The Wise Men Bring their Gifts to the Infant Jesus</u>.[6]

In **Christ Crowned** from this series, we see a typical Gill approach to this work in that it is steeped in both traditional and personal imagery (Figure 21). A tree with flourishing foliage was a Christian symbol from early times, both in the form of a flowering cross and as a Tree of Jesse on whose branches stand all the prophets and kings with Christ at the top. Gill has drawn such a tree, but with Christ dancing on it in a great swirl of feminine elegance. Over the archway are the letters PAX indicating not just the peace 'which passeth all understanding' brought by Christ, but also the fact that Gill himself was a pacifist. In the background the figures reflect indicate that Gill was also working at that time on carvings both for the Sower and his Ariel playing a pipe for Broadcasting House. A further personal note derives from the fact that Gill was a Dominican tertiary and this is indicated by a hound, a symbol of St Dominic.

How are we to assess Eric Gill today? First, since the publication of Fiona MacCarthy's biography of Gill in 1989, based on his highly intimate personal diaries, there is the old debate about the relationship between art and an artist's personal morality, focussed sharply in the case of Gill on the puzzle as to how he related his omnivorous sexual appetite to his Roman Catholicism. Without going into the case of Gill himself, it can be said in general terms that what matters from an artistic point of view is artistic integrity, that is, the artist having a vision of what she or he wants to produce, and remaining true to it despite all pressures of fashion and finance. Great art cannot be produced without such integrity, and in that sense good art is rooted in morality. How this fundamental artistic integrity is related to the sometimes rackety lives of individual artists is another question. Secondly, it is obvious that Gill was a highly talented draughtsman, with an extraordinary capacity for elegance of line in all his work. He combined this, as we have seen, with recognisably traditional imagery. Thirdly, it is clear from everyone who encountered Gill that he was a quite extraordinary, fascinating person, who stood bravely in the face of the main trends of his time. He loathed capitalism, and believed in simple living and solid craftsmanship. Though he recognised his dependence on the art world to make a living, he despised the art for art's sake attitude of the artistic elite of the time. He regarded all such art as simply an excrescence on the rampant capitalism of the period, and therefore inevitably an art which was infected by its false values. But is this enough to make him a significant religious artist in the twentieth century, when the whole tradition of both belief and imagery had fragmented so badly? Does his work speak religiously to us? The best person to answer that question is Eric Gill's protégée, David Jones.

David Jones joined the Catholic fraternity with Eric Gill at Pigotts and then at Capel-y-ffin, and Gill was a huge early influence on him. But that influence did not affect the balance of Jones's judgement about Gill as an artist. He recognised that Gill was superbly talented as a letterer, and that there was a wonderful linearity in all his work. But he did not think he was a great artist. This had less to do with any shortcomings in Gill himself than with the cultural situation in which all artists then and now find themselves. For, as will become clear when discussing Jones's own work, and as he put it in his essay on Gill, the best artists produce their work unselfconsciously because they are integrated into a wider culture. Such a culture no longer exists, and the artist today is an 'agreeable extra' not an integral part of a wider cultural world. Jones thought that Gill's great talent enabled him to produce work that looked as though it might be the product of a true culture. But because in his view there was no true culture in that period, it could not be great work. Indeed Gill himself recognised this. As remembered by Jones, he in effect said, 'What I achieved as a

[6] Eric Gill, *The Four Gospels of Our Lord Jesus Christ*, Golden Cockerel Press, 1931.

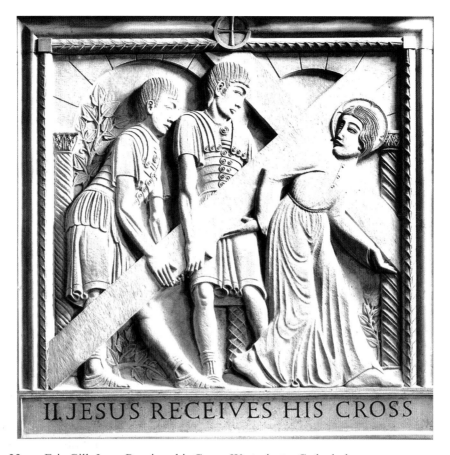

Figure 22 Eric Gill, Jesus Receives his Cross, Westminster Cathedral

sculptor is of no consequence – I can only be a beginning – it will take generations, but if only the beginnings of a reasonable, decent, holy tradition of working might be effected – that is the thing.'[7]

The other weakness may have been Gill's steady focus on the linear, rather than working in the round, and his overriding commitment to sheer elegance of line. Was this because of a reluctance to face fully the darkness and lostness of our time? Ours is not an age when all can be gathered into an elegant unity. This is one of the very reasons that make modern art modern. So Jones wrote: 'I do not think that one could say that the **Stations at Westminster** [for example as shown in Figure 22] are profound works of sculpture, but they are adequate and right and the most live things in that fine interior and No. 12 in particular has great feeling and is a true icon.'[8]

In the end Jones gives a generous tribute to Gill: 'The astonishing thing is that within certain bounds, and in spite of all deficiencies, he achieved what he did achieve – the relative success is the surprise, not the obvious limitations.'[9] If Gill was aware of the limited achievement of his own art, he was no less generous and perceptive in his judgement about that of David Jones. Once, round a

[7] David Jones, 'Eric Gill as Sculptor' (1941), in *Epoch and Artist*, ed. Harman Grisewood Faber, 2008, p.295.

[8] Ibid., p.292.

[9] Ibid., p.295.

crowded dining table, Gill remarked 'We have been talking a lot about art but there is only one real artist in the room', and he then pointed to David Jones.[10]

David Jones

David Jones (1895–1974) was brought up in south London, but his father's side was Welsh, and this Welsh identity became of fundamental importance for both his art and his poetry. He went first to Camberwell Art School but in 1915 enlisted in the Royal Welsh Fusiliers. The war was one of the three decisive experiences of his life and out of it came, but not until 20 years later in 1937, his 126-page poem *In Parenthesis*. This has an introduction by T.S. Eliot in which he wrote 'On reading the book in typescript I was deeply moved. I then regarded it, and I still regard it, as a work of genius.'[11] Its central figure is Dai Greatcoat, the ordinary soldier in every battle in history, a name Jones used of himself and which is the title of his published letters.

After the war Jones went to Westminster School of Art, and though he admired Walter Sickert who taught there, he did not really fit in and so in 1921 went to Ditchling in Sussex to visit Eric Gill. Jones recognised in Gill a true master in the mould of William Morris. This immediately points to the other two formative experiences on Jones, in addition to his war experience: the impact of Gill on his life and work and his conversion to Roman Catholicism.

David Jones had been brought up in a devout Anglican home but during the war he became 'inwardly a Catholic' as he put it. Then when he was back in London he got into the habit of slipping into Mass in Westminster Cathedral. He formally converted in 1921.

David Jones had a natural talent which his mother, who had also drawn well in her younger days, encouraged. There is a drawing of <u>The Dancing Bear</u> that he did at the age of seven, which is a good, lively likeness. He said that drawing was as natural to him as stroking a cat, and he decided at that age to be an artist. But there were other important influences in the family as well. His father was a printer's overseer concerned with the appearance of the printed page, and one grandfather was a mast-and-block maker. This craft side of the family found expression when Jones first went to Eric Gill at Ditchling. Gill told him 'to start again with something that can be done with reasonable certainty' and set him work as a carpenter making looms.

At Ditchling David Jones became part of the craft Guild of St Joseph and St Dominic, a community of Dominican Tertiaries which had been founded in 1919 by Hilary Pepler and Eric Gill 'as a religious fraternity for those who make things with their hands'. This was a life not only of work but also of corporate prayer, with a philosophy of art shaped by the Catholic philosopher Jacques Maritain.[12] Jones was no great shakes as a carpenter, but the community was a pioneer in wood engraving and this became a natural medium for him. Wood engraving has the advantage of making the artist responsible for the whole process; there are no middle men, and it forces a respect for the medium, as Gill put it. It had the further advantage for Jones of delivering him from the easy realism into which his natural talent flowed, to focus on the essential feeling of what he

[10] Jonathan Miles and Derek Shiel, *David Jones: The Maker Unmade*, Seren, p.51.

[11] David Jones, *In Parenthesis*, Faber, 1963, p.vii.

[12] Jacques Maritain (1882–1973) was a seminal figure for religious art in the twentieth century, both because of his writings and his friendship with leading artists, particularly in France. He wrote *Art and Scholasticism with Other Essays* (1923), republished by Filiquarian, 2007. He is discussed by Rowan Williams in *Grace and Necessity: Reflections on Art and Love*, Continuum, 2005, chapter 1, and in relation to David Jones in chapter 2.

wanted to convey through line and colour. We see some of the fruits of that period in <u>Madonna and Child</u> (1921), <u>Jesus Mocked</u> (1922/23) and <u>The Flight to Egypt</u> (1924). This work with woodcuts developed into some highly skilled and evocative engravings both for *The Book of Jonah* (1926) and to illustrate Coleridge's poem *The Rime of the Ancient Mariner*. In <u>The Albatross</u> (1929), a particularly striking work, the albatross on the mast which is also the cross of Christ, is an image of sacrifice. As Jones made clear, the ship is the church and the voyage is the journey of everyone, and for this the sacrifice of the Mass pleads. <u>Nativity with Shepherds and Beasts Rejoicing</u> (1930) is also an evocative example of Jones at his best in this kind of work.

Jones lived with the Gill family at Ditchling, at Capel-y-ffin in the Black Mountains, and then at their house Pigotts near High Wycombe in Buckinghamshire. He fell in love with Gill's daughter Petra and they were engaged for three years, but then she married someone else. At this time he produced <u>The Garden Enclosed</u> (1924), a good example of how Jones's religious themes permeate all his paintings. The title refers to Song of Solomon, 4:12, 'A garden enclosed is my sister, my spouse', and this was a familiar image for the Virgin Mary. Geese which appear in the painting were sacred to Juno. They sound the alarm, and a doll thrown down indicates the end of childhood. It is a painting that has lent itself in fairly obvious ways to a psychological interpretation of Jones and to the fact that, though he had a number of close relationships with women, he never married.

Capel-y-ffin is a lovely, peaceful spot in the heart of the Black Mountains, near the ruins of the ancient abbey of Llanthony. There was another religious house in the valley, and it was there that Gill and his entourage, including Jones, moved in 1924 to continue their community life of craft and prayer. It was here that Jones really discovered himself as a painter – not in oils, which was never his preferred medium, but in a mixture of watercolour and pen and ink. The contours of the hills and valleys and flowing streams took shape in his artistic imagination, as in <u>Y Twmpa, Nant Honddu</u>. But for Jones landscapes were never just landscapes. <u>Landscape was always sacramental</u>, an outward and visible manifestation of the divine glory. So where others see just landscape, he sees Christ. This is made clear in his later poem, *The Anathemata*:

> Stands a lady
> on a mountain
> who she is
> they could not know.
> His waters were in her pail
> her federal waters ark'd him.
> He by whom the welling fontes
> are from his paradise-font mandated
> to make Gwenfrewi's glen, Dyfredwy
> to crystal his ferned Hodni dell
> dewy for the Dyfrwr
> by this preclear and innocent creature.[13]

This needs some explanation. Hodni is the same river as the Honddu after which Llanthony is named, and an earlier writer speaks of St David drinking of the 'crystal Hodni'. The stream is crystal clear, its banks are ferny and David had a cell there. Y Dyfrwr is the Welsh word for waterman, and David is called David the waterman. This 1952 poem is prefigured in his earlier landscapes <u>The Waterfall</u> and <u>Afon Honddu Fach</u> (1926). It is one of Jones's overriding themes:

[13] David Jones, *The Anathemata*, Faber, 1952, p.235.

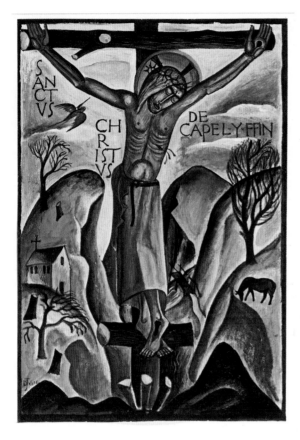

Figure 23
David Jones, Sanctus Christus de Capel-y-ffin

landscape seen through the eyes of Christian belief, Welsh history and legend. Understood in this way landscape discloses the glory of God.

In **Sanctus Christus de Capel-y-ffin** (1925) landscape is combined with a crucifixion scene in the form of a wayside shrine in the Black Mountains (Figure 23). Christ's limbs are like the branches of a tree. It is important to note, however, that this landscape for Jones had Christian importance even without a crucifix in the foreground. This is a major factor when consideration is given to his later watercolours, in which he tries to convey a transcendent dimension without any, or very little, Christian iconography. Lettering became very important to Jones; indeed in the last part of his life it was his major focus. This passion originated in lettering inside paintings like this one.

From time to time Jones went to stay with the monks on Caldey Island, and produced some memorable scenes of the coast and sea. In The Artist (1927) he imagines himself in the scriptorium of a monastery, like a medieval limner copying ancient manuscripts with the hand of God above blessing his work and surrounded by animals. As in his landscapes, both a sense of enclosure and an opening up to what is above and around interpenetrate one another.[14]

With The Terrace (1929) and Manawydan's Glass Door (1931) Jones's religious import becomes more oblique and complex. These are not obviously religious paintings. It is possible for

[14] Anne Price-Owen, *Materialising the Immaterial. David Jones: Painter-Poet*, a helpful introduction available on the internet by the director of the David Jones Society who has written extensively on him: http://www.flashpointmag.com/priceowen.htm.

people to look at a work by Jones and say 'That's very pretty', or attractive or whatever and move on. That is a pity. First, Jones was a modernist influenced indeed in the early stage of his artistic life by Gill, but more decisively by others, for he was at home with the leading avant-garde names of the time with whom his work was exhibited as a member of the Seven and Five Society. This was a highly selective group to which only modernists were elected, seven painters and five sculptors. Even when in the country he kept in touch with London and what was going on there. Indeed there are aspects of his work which seem related to Cezanne, Nash and Ben Nicholson as well as the surrealists.[15] But all the time there was his own distinctive vision and individual style. That vision was, in a word, sacramental. He saw the outward and material reflecting the invisible and spiritual, and he had an equally intense passion for both the material and the spiritual. He wanted to express the universal through the particular.[16] The challenge for him was how to achieve this. To do justice to the spiritual he needed to eschew realism. As he lamented to one friend, 'Isn't it awful these yards of 'able' paintings of various kinds that seem only seen with the eye of the flesh?'[17] Yet abstraction took him away from the particular which always so excited him. He writes in one letter about being demented trying to capture the beauty of a new garden, on which he had made four or five attempts. His solution to the challenge of conveying the transcendent in and through the particular was to paint in watercolour, but in a highly distinctive way: first, with a strong grounding of white, which gives the painting a translucent character; then, to use drawing not just as a preparation for the painting, as painters since the Renaissance had tended to do, but as an essential aspect of the painting itself; finally, through his use of line work, to give a sense of fluidity and movement to the whole. As Paul Hills put it about an early painting, but in words which are applicable to the whole *oeuvre* of Jones, the organisation of shapes is not the sole source of unity, for:

> The individual marks of pencil and brush share a distinctive character, irregular yet rhythmic, tremulous yet bold … individually these marks may appear graceless, undisciplined, even messy; yet at the right distance they signal across the paper in vibrant patterns. The matrix of white paper is crucial to this essentially linear art; the character of each touch must tell.[18]

Jones took to heart the post-modernist dictum that a painting should not be an impression of anything but an object existing in its own right. But what he wanted to depict as existing in its own right he also wanted to show as imbued with a greater reality, a something more, 'an excess'.

In addition to these distinctive technical concerns there is the question of content; the way, already mentioned in relation to landscapes, that Jones imbues his paintings with historical or mythical significance. This is true of <u>Manawydan's Glass Door</u>, for the title Manawydan refers to a figure in the collection of Welsh folk tales known as *The Mabinogion*, who shut himself away from passing time and the harsh reality of the world. When he eventually went through the door to take up his responsibilities again he had to experience the pain and sorrow of the world once more. It is telling that when Jones was painting this picture he was also writing *In Parenthesis* in which he relives his experience in World War I from 20 years before. In this painting the pattern of the carpet flows into the blood-red sea anemones of the shore. The ocean gives the feeling of rocking on a

[15] This, as well as other matters, are explored in the excellent introduction by Paul Hills to the retrospective exhibition catalogue *David Jones*, Tate, 1981.

[16] Eric Gill, *Last Essays*, Jonathan Cape, 1942, pp.150–52.

[17] David Jones, *Dai Greatcoat*, Faber, p.46.

[18] Hills, *David Jones*, p.25. Hills notes the influence on him of his teacher at Camberwell, A.S. Hartrick, and the artistic link with medieval scribes.

ship, yet the frame of the window gives a sense of stillness and stability in the midst of movement and the ship of life sails onward. All in all, as he put it about his paintings:

> I should like to speak of a quality which I rather associate with the folk-tales of Welsh or Celtic derivation, a quality congenial and significant to me which in some oblique way has some connection with what I want in painting. I find it impossible to define, but it has to do with a certain affection for the innate creatureliness of things – a care for, and appreciation of the particular genius of places, men, trees, animals, and yet withal a pervading sense of metamorphosis and mutability. That trees are men walking, That words 'bind and loose material things'.[19]

He went on to refer to the Alice books to indicate how things can be metamorphosed in strange, haunting ways. Jones certainly had a strong sense of place, and indeed almost thought in terms of the spirit or spirits of particular places, though he did this in specifically Christian terms, especially associating them with Christ or Mary. But this sense of place was also linked to his knowledge that everything is also on the move, on the way to being changed. All was at once sacramental and mutable.

Jones did a frontpiece for *In Parenthesis* that showed a common soldier like John Bunyan's pilgrim bearing his burden, and an endpiece that showed a lamb or perhaps a scapegoat caught in a crown of thorns made of barbed wire. It was dedicated, amongst others, to 'the enemy front fighters who shared our pains against whom we found ourselves by misadventure'. Epiphany 1941: Britannica and Germanica Embracing similarly looks beyond the terrible conflicts of the twentieth century to an ultimate reconciliation. It is inscribed 'O sisters two what may we do', a line taken from the 'Coventry Carol', which was associated with the massacre of the innocents, which Jones uses to refer to the destruction of Coventry Cathedral by German bombs in November 1940. The spire of the cathedral is on the left of the painting. Germanica wears antlers, in the manner of mummers enacting the sacrifice of the tree god according to German folk tales. The dogs howl and the birds whirl overhead, but a lighthouse blinks steadily. Not long before the war, the lighthouse had been added to penny coins, so it serves here as a sign of both Britannica and of the Virgin Mary, who is the *Stella Maris*, 'Day star o' the harbour'.[20]

Aphrodite in Aulis (1941) was originally called simply 'Aphrodite'. Jones then reflected the title of the play by Euripides, *Iphigenia in Aulis*, by incorporating the words 'in Aulis' in his own title. The symbolism in the painting is crowded and complex. Jones wrote:

> My intention in changing Aphrodite in the title was to include all female cult figures … the figure is all goddesses rolled into one – wounded of necessity as are all things worthy of our worship – she's mother-figure and *virgo inter virgins* – the pierced woman and mother and all her foretypes.[21]

He then gives examples of these mother figures and indicates the meaning of other symbols. The moon and stars are attributes of the Madonna in the Book of Revelation. Doves were sacred to Aphrodite. They add 'their chorus to the confusion of sacred and physical love which is the essential theme'.[22] The deliberate mixture of architectural styles is to show that the marble goddess in the sacred enclosure belongs to all ages. A key pictorial clue is the crucifixion-lance of Longinus,

[19] Quoted by Paul Hills, ibid., p. 49 and associated note.

[20] Jones, *The Anathemata*, p.195. See also T.S. Eliot, 'Lady, whose shrine stands on the promontory', *The Four Quartets: The Dry Salvages*, IV.

[21] René Hague, *A Commentary on the Anathemata of David Jones*, Wellingborough, 1977, p.38.

[22] Jones, *Dai Greatcoat*, p.138.

Figure 24
David Jones, Vexilla Regis

who is depicted as a German soldier. The statue is cracked and broken. Under the pedestal on which it stands the Lamb of God bleeds into the chalice, to redeem our cracked and broken world. Soldiers on both sides are united in a love that is both sacred and profane. It was a painting at once rooted in his own soldierly experience, and with a universal meaning.

In 1947 Jones suffered the second of his major, mysterious breakdowns. During the long months in the nursing home he started to draw trees in the grounds. Trees had been important to him ever since he had been wounded in World War I and had found himself in a wood. This is reflected in both in *In Parenthesis* and **Vexilla Regis**, 1947 (Figure 24). Again it is a painting that is full of complex symbolism, which he explained in a long letter to a friend. He stressed that the meaning was all fluid and could not be tied down but that the essential theme was the cross of Christ as a great tree, which is also the main image in the great fourth-century hymn 'Vexilla Regis'. In the painting it is this tree that grows out of a collapsing Roman world. Cavalry horses have been let loose and armour is lying around. The tree on the right is at once the tree of the bad thief and a Roman column, the dove above it indicating this too could be redeemed. The other tree has a pelican perched on top, the symbol of sacrifice.

After his breakdown in 1947 Jones wanted to stay near the nursing home where he had been treated. The house where he lodged, Northwick Lodge, remained his home until 1964. Here he began to draw again, and in particular did a large number of drawings of flowers in a glass on his table. Glass Chalice and Mug (1952), Chalice with Flowers (1950) and Flora in Calix Light (1950)

are amongst them. He was drawn to the word calix because of its link with chalice, and he saw water as both the origin of life and the water of baptism. Kenneth Clark wrote in 1967:

> Some of the finest of David Jones's recent paintings are not of literary subjects ... but represent a simple glass of flowers on a table. A pleasant subject; but we are not for long under the illusion that this is an ordinary 'still life'.

Clark then refers to the imagery, chalice, altar, the different colours of the flowers representing parts of the Eucharist and so on: 'Every flower is there for a dozen reasons, visual, iconographical, or even on account of its name, and how far they can be interpreted as Christian imagery no one, perhaps not even the painter can tell.'[23]

Paul Hills has commented:

> Though he was to paint for another ten years, the chalice drawings represent a peak that David Jones never surpassed. In them the universal shines forth from the particular; through visible forms we are caught up into love of things invisible.[24]

He then quotes some words of Jones himself:

> Cezanne said we must 'Do Poussin again after nature'. Perhaps we might almost say that we must do Cezanne's apples again after the nature of Julian of Norwich's little nut, which 'endureth and ever shall for God loveth it'.[25]

Rowan Williams, referring to the more obviously religious painting on the Annunciation, has commented in relation to the chalice paintings:

> At this level, there is no real difference between this explicitly religious picture and 'Flora in Calix-Light'. This is how you paint 'excess': by the delicate superimposing of nets of visual material in a way that teases constantly by simultaneously refusing a third dimension and insisting that there is no way of reading the surface at once. As in the Byzantine icon, visual depth gives way to the time taken to 'read' a surface: you cannot construct a single consistent illusion of depth as you look, and so you are obliged to trace and re-trace the intersecting linear patterns.[26]

From the 1940s Jones experimented with inscriptions, not to imitate any style from the past but to express his own vision now. 'Here lies Arthur the once and future king' is a fairly early example from Malory's, *Morte d'Arthur*. The concept of the Once and Future King was one of the myths that permeated the work of Jones. It has been well said of the inscriptions:

> He is a bard, 'a carpenter of stone' and a celebrant. He was a maker of shapes and forms and in the inscriptions were often useful artifacts as well as pure art, devotional aids used like 'mass cards on the altar ... to help him through his daily office.' Jones had bridged the gap between the Ditchling ethos and the more abstract art of his contemporaries and he did it without losing sight of his

23 Kenneth Clark in *Agenda: David Jones Special Issue*, 5/1–3 (1967), pp. 99–100.
24 Hills, *David Jones*, p.170.
25 David Jones, *The Dying Gaul and Other Writings*, ed. Harman Grisewood, Faber, 2009, p.142.
26 Rowan Williams, *Grace and Necessity: Reflections on Art and Love*, Morehouse, 2005, p.69.

civilizational predicament, for the letters which make up the inscriptions often appear embattled, a purely formal expression of struggle and loss.[27]

In the light of this discussion of the paintings it is now possible to look in more detail at David Jones's whole understanding of art. It was a subject with which he wrestled all his life. As already stressed, for David Jones the whole of life was sacramental. That is, outward and visible things body forth what is invisible and spiritual. In the words of Gerard Manley Hopkins, 'The world is charged with the grandeur of God.' What distinguishes humans from other animals, said Jones, is that 'man is unavoidably a sacramentalist and his works are sacramental in character'.[28] Without this prior belief the Christian sacraments, in the technical sense of the word, would have no meaning. Nor without this premise can any sense be made of the arts. Within this sacramental world, a fundamental distinction can be made between objects made for a practical purpose, which are useful for something, and works of art which have no discernible practical purpose. Jones calls this a distinction between utile and extra-utile. He contrasts the ordered line of a Roman legion, which has a definite purpose, and the ordered line of a hexameter, which is 'a thing wholly extra-utile and explicable only as a sign'.[29] He also makes a further distinction between *prudentia* and *ars*. *Prudentia* involves the motives and intentions of the person making things. It concerns the character we are forming through our actions. But *ars* is not concerned with character, but solely with the actual work of art.[30]

But what is it that makes a particular production a work of art? It is first of all the element of pure form. It is important to remember that Jones was and remained all his life, both in his painting and poetry, a modern; that is he is to be understood as someone concerned with form. He thought a human being is essentially a seeker of form, *venator forarum*, and he used the phrase 'the splendour of forms'. As mentioned, he was in the 1930s a member of the 'Seven and Five', the elite group for which you had to be fully committed to abstract art to be elected a member. Although his art, like that of others in the 1930s such as John Piper, moved on in style, right to the end of his life he defended purely abstract art. He thought that all art – from the Lascaux cave paintings, which he much admired, through the intricate designs on the swords of La Tène Celtic culture, to his own later paintings which ostensibly deal with objects – had this element of formalism, and it was this which defined them as works of art. Yet he also believed that objects made for a purely utilitarian purpose could have an element of form. Bridges, for example, can be beautiful. So what is it that makes a work a work of art? For Jones a work of art is not only characterised by form: it has no utilitarian purpose and it exists purely as a sign.

Again, this sign making has a wider reference. For Jones human beings are not just sacramentalists; they are essentially sign makers. Most obviously we give someone a bunch of flowers or a kiss as a sign of what we feel for them. So what are works of art a sign of? Here we come across the great crisis mentioned in the first chapter with which Jones wrestled both in his writing and his art. For, to repeat what was said in the first chapter, he believed – and he said this view was shared by his contemporaries in the 1930s – that the nineteenth century experienced what he called 'The Break'.[31] By this he meant two things. First, the dominant cultural and religious ideology that had unified Europe for more than 1,000 years no longer existed. All that was left were

[27] Miles and Shiel, *The Maker Unmade*, p.274.
[28] David Jones, 'Art and Sacrament' (1955), in *Epoch and Artist*, Faber, 2008, p.155.
[29] David Jones, 'Use and Sign' (1962), in *The Dying Gaul*, p.178.
[30] Jones, *The Anathemata*, p.29.
[31] Ibid., p.15.

fragmentary individual visions. Secondly, the world was now dominated by technology, and the arts are marginalised. They had no use in such a society, and their previous role as signs no longer had any widespread public resonance. Their work was 'idiosyncratic and personal in expression and experimental in technique, intimate and private rather than public and corporate'.[32] 'The priest and the artist are already in the catacombs, but *separate* catacombs, for the technician divides to rule.'[33] There was no corporate tradition and one could not be looked for without a renewal of the whole culture. Writing after World War II, he remarked that the situation at that time was even more pronounced and dire than it had seemed in the 1930s.[34]

This general understanding of the arts and their role in society was for him focussed and underpinned by his Christian faith and, more specifically, by his membership of the Roman Catholic Church. The insights that came from his faith fused with his understanding of art. There was for him a personal revelation when, just before and after World War I, he came to understand the meaning of post-impressionism. It made him realise that art was not meant to be an impression of something, any more than it was meant to be a representation of something. It was a work in its own right 're-presenting' something in the medium of paint or stone or whatever.[35] This was the time that he became a Catholic, and he came to believe that similarly in the Mass we do not have either a representation or an impression of Christ's offering of himself once for all on the cross, but that the sacrifice of Christ was made present, or rather 're-presented', under the form of bread and wine. So he came to think that what happened in the Mass defined and made clear the essential purpose of all art. That is why in all his art, but particularly some of his later work, it is the Eucharist which is a key theme, whatever other details are present.

Nevertheless, however central the Eucharist, it is important to remember that for him all art had this sacramental quality. This is because works of art:

> can be justified *only* as signs of something other, are evocative, are incantive and have the power of 'recalling', of 'bringing to mind' – are in fact one with that whole world of sign or sacrament whether it be the flowers sent to Clio on her birthday or the profound intention of the art of the man at the Altar, the work known as anamnesis, 'an effectual recalling'.[36]

In case all this sounds too heavy, Jones believed that the first requirement of a work of art is that it should bring delight and pleasure, and he links this with Holy Wisdom playing before God before the creation of the world.[37] There is a gratuitousness about art, a sheer givenness which is to be appreciated and enjoyed for its own sake.

Whilst moderns can understand and appreciate the stress Jones laid on the importance of form, for many people there are too many details present in his paintings, linked with too much complex symbolism. There are three reasons for this feature. First, although Jones was a very definite and convinced Catholic, his faith could not have been more inclusive. It included, in anticipatory or fragmentary ways, all religions, all myths whether secular or religious, and all cultural history. All was gathered up, unified and underpinned in the Christian story. He tried to convey this highly ambitious inclusiveness through a mass of details.

[32] David Jones, 'Religion and the Muses' (1941), in *Epoch and Artist*, p.98.

[33] Ibid., p.103.

[34] David Jones, 'Notes on the 1930s' (1965), in *The Dying Gaul*, p.49.

[35] Jones, 'Art and Sacrament', pp.171–2.

[36] Jones, 'Notes on the 1930s', p.47.

[37] Jones, 'Art and Sacrament', pp.154 and 164.

Secondly, given his conviction about the sacramental nature of all life, Jones had the confidence to include in his poetry and painting all that was of interest to him, everything that was lying about in his mind. He quotes the early British historian Nennius: 'I have made a heap of all I could find.'[38] This included the early Welsh myths, Welsh history, the stories connected with King Arthur and mediaeval romances, together with a love of words, their sounds and multiple associations. The sounds include the slang of soldiers and London cockneys. All this could be in his mind as much when he painted as when he wrote poetry.

Thirdly, like T.S. Eliot, he believed that an artist must live in association with the art and culture of the past, and although he recognised that this had now disappeared as a living religious force, he saw it has his vocation to try to keep alive the culture that had once unified Europe. He was not an antiquarian or one who wanted to hold on to the past for its own sake. On the contrary, he passionately believed that an artist had to be of the age, and for him that meant being a modern. The artists he admired were the makers of modernism, such as Joyce in the novel and Eliot in poetry, whose works also reflected the broken cultural world in which we live. But again, like them, he thought they were able to be of their age, precisely because they were deeply in touch with the great culture of the past. However acutely aware he was of the crisis of our times, he wrote in one of his poems 'I have been on my guard to not condemn the unfamiliar ... for it is easy to miss him at the turn of a civilisation.'[39]

Jones thought that the debate about the value of abstract art compared with art of a more traditional kind was missing the point, for 'The one common factor implicit in all the arts of man resides in a certain juxtaposition of forms.'[40] Only with that in mind can we then go on and ask what possible 'aridities or impoverishments' may or may not be present in what was called pure abstraction. So, as emphasised, Jones was a modernist and continued to be so in two senses. First, he never lost his overriding concern as an artist for sheer form. However crowded with detail are his paintings, and indeed his poetry, he conceived them with a view to their integrative form. Secondly, he continued to believe that artists had to be at the heart of their own time, even if that time was characterised by an emptiness and loss of overall meaning.

We see how these fundamental convictions work themselves out in his poem *Anathemata*. In a passage that begins by extolling the art of pre-classical Greece, that is the sixth and seventh centuries BC, he wrote:

> And the Delectable Kore:
>> by the radial flutes for her chiton, the lineal chiselled hair
>> the contained rhythm of her ...

The poem then goes on to evoke this Kore as the archetype of all beautiful women in myth until, as he puts it

> Not again, not now again
>> till on west-portals
>> in Gallia Lugdunensis
> When the Faustian Lent is come
>> and West-wood springs new
> (and Christ the thrust of it!)

[38] Jones, *The Anathemata*, p.9.
[39] Jones, 'Art and Sacrament', p.179.
[40] David Jones, 'Abstract Art', in *Epoch and Artist*, p.265.

In these lines he jumps from the archaic period in Greece to the Romanesque and early Gothic carvings on the west fronts of European cathedrals, completely bypassing classical art. This is because in these two periods, the Archaic and the Romanesque, a highly distinctive formal element in art, a conscious stylisation, was combined with an element of the representational. It was, he believed, only some combination like that which could act as a sign of something other.

We see the same thesis at work in his essay on the ancient statue at Pergamon, 'The Dying Gaul', and its affinity with Celtic art. So he writes of a carved stone head of that period that:

> it is illustrative of the continuous characteristic Celtic tendency to transmogrify observed objects (in this case elements of the human face) by the use of stylised motifs which none the less retain a powerful representational significance within a dynamic abstract form.[41]

An example of this approach at work in his painting can be seen in <u>Human Being</u> (1931), which both is and is not a self-portrait, and again in <u>Portrait of a Maker</u> (1932) – for these are not portraits as we normally understand them. They are highly stylised to bring out particular points: 'The human being, suspended between maturity and childhood, is also suspended between individuality and archetype.'[42] We notice the prominence given to the ears, the eyes looking elsewhere, and the prominent delicate hands of a maker.

If we take a word like 'wood', a word which once had huge cultural resonance and now has none, Jones felt he had at once to recognise this loss, and at the same time to be in touch with the rich tradition connected with wood in a truly modern way. It was a hugely ambitious undertaking. The same challenge is taken up in his painting. As he put it:

> If one is making a painting of daffodils, what is *not* instantly involved? Will it make a difference whether or not we have heard of Perspephone or Flora or Blodeuedd?

He asserts it does make a difference, but that even those who have not heard of these women would in fact paint daffodils 'as though they had invoked her name'.[43]

It will be obvious from this discussion that David Jones was an anguished, complex person, who wrestled more seriously than any other, in theory, poetry and painting, with what he perceived as the fundamental challenge facing artists in our time. Whatever the success or failure of any particular work of art of his in meeting that challenge, he remains of huge significance not just for his talent, but for the integrity, courage and persistence with which he faced it, and the insights which resulted from this.

[41] David Jones, 'The Dying Gaul', in *The Dying Gaul*, p.55.

[42] They are perceptively discussed by Merlin James, *David Jones, 1895–1974: A Map of the Artist's Mind*, Lund Humphries/National Galleries and Museums of Wales, 1995, pp.10–11.

[43] Jones, *The Anathemata*, p.10.

Chapter 5
Post-War Recovery of Confidence

This chapter focusses on a number of artists who made their reputation in the 1930s but whose work reached a wider audience after World War II, helped by a number of major church commissions.

A line in a poem by W.H. Auden describes the 1930s as a 'low, dishonest decade'[1]. The attitude of upper-class socialites was brilliantly caught by Terrence Rattigan in his 1938 play *After the Dance*. Ominous clouds of war darken the sky but they spend their time endlessly rehearsing the great parties they attended in the 1920s. Yet, even they at last began to realise that something serious was occurring, and that a personal response was going to be required. World War II brought about a new seriousness, one which, after the conflict was over, was expressed politically in the aspirations of the Attlee Government and the creation of the welfare state. This new mood lasted until the end of the 1950s. One expression was the return to the Christian faith of a good many who had previously been indifferent to it. Billy Graham's missions brought about the conversion of a number of people who later became leaders in Britain's churches. It was reflected, for example, in the fact that 1962 saw 628 people ordained in the Church of England, the highest number of people ordained since World War I, and higher than any year since.

One expression of this new religious seriousness was the popularity of Salvador Dalí's painting <u>Christ of St John of the Cross</u> (1951). This was bought by the Glasgow Art Gallery for £8,200. The purchase was savagely criticised on the grounds that it was far too expensive for a poor work of art. However, the painting immediately became hugely popular, the most reproduced of all twentieth-century religious paintings. There was a time when every other devout Christian would have had Salvador Dalí's painting hanging in their room. Based on a drawing, allegedly by St John of the Cross, set in Port Lligat in eastern Spain, it contains some small figures from seventeenth-century Spanish painting at the foot of the cross. But the total effect is not just of Christ on his cross looking down on water but gazing on the world as a whole. Painted in what Dalí called his mystical period, he set out to convey the opposite of what Grünewald had done. As he put it, 'No more Surrealist malaise of existential angst. I want to paint a Christ that is a painting with more beauty and joy than have ever been painted before.'

Another important expression of this new seriousness was the decision to rebuild churches bombed during the war. This included the exquisite Wren churches in the City of London, and the building of a new cathedral in Coventry, which itself became a symbol of this surge of religious confidence. Designed by Basil Spence, it has been called the last of the mediaeval cathedrals because of its long nave looking up to the altar at the east end. Ironically it was just at that time that the best liturgical opinion recommended that churches should have a central altar with the people of God gathered round it. That movement for liturgical renewal has been assimilated by the church as a whole, but Coventry Cathedral, old-fashioned in design though it may be, remains a highly impressive building.

Artists who had made their reputation with the avant-garde before World War I were called on by the church in ways they had not experienced before World War II. These artists included Chagall, who produced many wonderful stained glass windows, and Epstein. His new work for

[1] W.H. Auden, 'September 1, 1939'.

Coventry, <u>St Michael and the Devil</u>, was more obviously accessible than his earlier work, <u>Ecce homo</u>, sculpted in 1934/35 which aroused such antagonism at the time and which did not find a home until presented to Coventry Cathedral in 1969 on the artist's death by his widow. The work of Chagall and Epstein were discussed in earlier chapters. Coventry Cathedral is however also associated with two somewhat younger artists, Graham Sutherland and John Piper, who also made their reputations before the war but who achieved wider fame after it, not least through their work for Coventry Cathedral.

Graham Sutherland

Graham Sutherland (1903–80) was brought up in south London in a professional family. The experience was not an entirely happy one and this left its scars in the form of a certain insecurity. He left school early and went as an engineering apprentice to the Midland Railway Works in Derby. Discovering that he was unsuitable for this kind of work, Sutherland left to study art for five years at Goldsmith's College, but his time in Derby gave him a feeling for the shape of machines which remained throughout his artistic life. His early work was on lithographs, in which he was much influenced by Samuel Palmer. In particular he was impressed by the way Palmer's strong emotion could transform the appearance of things. Sutherland's lithographs sold. Indeed, although he did not make any serious money until after the age of 50, he was lucky in always being able to sell at least some of his work, to add to the money he earned by teaching at Chelsea Art College. He was fortunate in having powerful patrons like Kenneth Clark, who believed in him and promoted his work.

Sutherland took up painting more seriously and began to discover his own distinctive style in 1934–39 in the Pembrokeshire countryside.[2] In Pembrokeshire he was not interested in trying to represent the landscape in any realistic way; nor was it his method to sit down out of doors and paint. Rather, he liked to walk through the landscape, soaking himself in its forms and construction, until some aspect gave him a sense of intellectual and emotional excitement, which he took away with him.[3] He became preoccupied with organic growth, and how such forms could catch the essence of a human figure. Through them 'the mysteriously intangible must be made immediate and tangible, and vice versa'.[4]

In particular he liked to stop and look at particular objects: a rock soaked by the sea, a gorse bush, a twig or whatever caught his eye and excited him visually. He called such studies 'an individual figurate detachment'. As far as his religious painting is concerned it was above all thorns that became important to him, as in <u>Thorn Bush</u>, and they found a continuing place in his studies of the crucifixion: 'While preserving their individual life in space, the thorns rearranged themselves and became something else – a sort of paraphrase of the Crucifixion and the Crucified head – the cruelty.'

Sutherland was always interested in developments on the continent and some influence of surrealism can be seen in his work, especially in his depictions of strange forms inspired by nature, but going way beyond nature to convey something else. Indeed some of his work appeared in an

[2] There is now a Sutherland Gallery in <u>Picton Castle, near Haverford West</u>, although the bulk of the work Sutherland later donated has been transferred to the National Museum of Wales in Cardiff.

[3] His approach to landscape was very different from that of John Piper; see Alexandra Harris, *Romantic Moderns: English Writers, Artists and the Imagination from Virginia Woolf to John Piper*, Thames & Hudson, 2010, pp.224–4.

[4] The quotations in this and the next paragraph are from Sutherland's own notes on his painting of the crucifixion in the Tate.

exhibition of surrealistic art. Many of these seem harsh, and he was accused of having a tragic sense of life. However, as he pointed out, the artist 'cannot avoid soaking up the implications of the apparent tragedy of twentieth century civilisation. Subconscious tragic pictures may be painted and without, necessarily, having a tragic dimension.'

Sutherland's wife was a believer, and no doubt it was partly due to her influence, as well as that of a teacher and fellow lithographer, F.L. Griggs, that he became a Roman Catholic shortly before he was married. How deep did this go? Shortly before he died he wrote:

> Although I am by no means <u>devout,</u> as many people write of me, it is almost certainly an infinitely valuable support to all my actions and thoughts. Some might call my vision pantheist. I am certainly held by the inner rhythms and order of nature; by the completeness of a master plan.[5]

For a long time Sutherland was an observant Catholic but when he started suffering from claustrophobia in church, churchgoing became more occasional. There is clearly some truth in his own account of his belief: as discussed above, he received much inspiration not directly from his religious beliefs, but from seeing a particular form in a landscape or object such as a tree or a thorn bush. But this more immanent understanding does not rule out a more transcendent dimension in Sutherland's outlook as well. Christianity has always affirmed that God is both in all things and beyond them, at once immanent and transcendent.

Sutherland did a range of work in the 1930s, including designing well-known posters and china. During World War II he worked as a war artist, drawing and painting some of the buildings that had been bombed. After the war he found it difficult to return to his pre-war work and it may have been the friendship and influence of Frances Bacon, a young and at that time much less well-known artist who was working on some shocking depictions of the crucifixion, that helped to get him going again.

Walter Hussey had commissioned Henry Moore to do a Madonna and Child for his church, St Matthew's, Northampton, and shortly after that he suggested to Sutherland that he did an agony in the Garden, to which the reply came: 'One's ambition would be to do a Crucifixion of a significant size. Would that be alright?'[6]

There was no deadline, and it was not long after this that the image of the thorn took hold of Sutherland's imagination. For two years he was to paint thorns with passion and intensity, a theme he was to return to sporadically for many years after. They were for him an image of cruelty and, as mentioned, they came to stand for the head of the crucified. It was in 1946 that he began in earnest on the crucifixion scene itself, inspired to do so by the photos of the terribly emaciated bodies of people released from Belsen. They reminded him of the body of Christ on the cross painted by Grünewald for the Isenheim Altarpiece, and his own image became a symbol of the endless cruelty of human beings to one another. Whilst motivated by the effects of twentieth-century cruelty, and tempted to produce a less naturalistic work, he made a conscious decision to produce a painting 'immediately intelligible and within the tradition'.[7] **The Crucifixion** at St Matthew's, Northampton was a success (Figure 25). The artist began an enduring friendship with Hussey, who saw in Sutherland a deeply religious person, unsure of his faith, yet anxious to keep it. Having found success with this image, Sutherland continued to mine its artistic possibilities and produced a number of crucifixions, experimenting with different forms – including <u>Crucifixion</u> (1947) that

[5] Letter to Roger Berthoud, quoted in his biography, *Graham Sutherland: A Biography*, Faber, 1982.
[6] Berthoud, *Graham Sutherland*, p.114.
[7] Ibid., p.127.

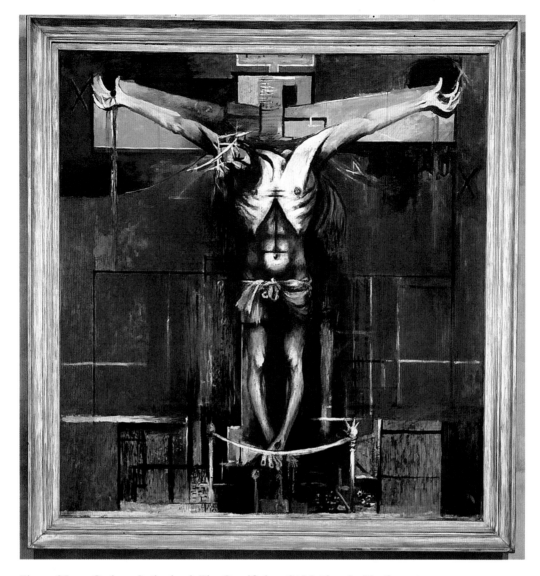

Figure 25 Graham Sutherland, The Crucifixion, St Matthew's, Northampton

shows Christ like a large bird or insect trapped on the cross.[8] Others include a fine Crucifixion (1927, Pallant House, Chichester), Crucifixion (1946, Tate), another radical study and what some regard as his finest work on this theme, Crucifixion (1963, St Aidan, East Acton). This was painted at the invitation of the parish priest, Sutherland's only commission for a Roman Catholic church. He got down to this in a single burst of activity at the beginning of 1963 but went back to make the colour bolder, having lunch every day with the parish priest who sometimes saw the artist praying in the church. He also painted Descent from the Cross (now in the Fitzwilliam Museum) and a Pietà (now in the Methodist Collection).

[8] For a good note on one of these see *The Evill/Frost Collection*, Sotheby's, 2011, Part 1, p.44.

Figure 26
Graham Sutherland, The Lion of St Mark, Coventry Cathedral tapestry (detail)

During this period Sutherland also became increasingly successful as a portrait painter, and he himself became well known, not least for his association with well-known people. This fame was magnified both by a row he had with the Tate Gallery, and the fact that the Churchills so disliked the portrait that Sutherland did of Sir Winston that Lady Churchill destroyed it.

As mentioned earlier, during the 1950s theologians were coming to a new understanding of the Eucharist as a gathering of the Christian community, rather than the sole act of a priest celebrating the holy mysteries at a distant east end. The new Roman Catholic Cathedral in Liverpool, which is in the round and which as a result was quickly nicknamed 'Paddy's wigwam', is a fine example of this new shape for the liturgy. Nevertheless, Coventry was designed in the old style, with the focus on the east end, and Sutherland was asked to produce a giant tapestry to go on the wall behind the altar. It focusses on the majesty of Christ, as seen by the Book of Revelation in Chapter 4, with the four beasts of the apocalypse at the corners and a small Christ crucified below.

The tapestry was a major enterprise and involved, on and off, 10 years' testing work. Sutherland had been looking at a great deal of religious art in the previous years. He was particularly impressed by the wonderful apse mosaic of the Last Judgement in Torcello on the Venetian lagoon, the Pantocrators in the domes of Greek churches and the sculpture of the great French cathedrals. He wanted to convey the majesty and otherness of Christ as seen in these works, but also the power and mystery of nature. The cathedral was finally finished and the tapestry unveiled in 1962. In each of the corners there is a symbol of the four evangelists taken from the description of the beasts of the apocalypse in the Book of Revelation and from an early age associated with the four evangelists, **The Lion** (1962) for St Mark (Figure 26), the Ox for St Luke, the human for St Matthew and the eagle for St John.

Noli me tangere, 1961 (Figure 27), was again commissioned by Walter Hussey, who by then had become Dean of Chichester Cathedral. It occasioned a certain amount of hostility, including an attack by a vandal, as well as praise. The severity of the squares and sharp, concrete diagonals of the stairs serve to accentuate the bends and folds of the two figures. Indeed so bent is Christ that he is almost hunchback. Similarly, Mary Magdalene is so folded over that she looks physically uncomfortable. But the rounded shoulders of Christ and the rounded bottom and breasts of Mary, together with the gentle curves of Christ's knee and Mary's neck, emphasise the warm and human, in contrast to the impersonal and angular of the architecture. Here is a human meeting.[9] There is a tenderness and intimacy. Christ looks gently down and reaches out to Mary, who is looking up to him with pleading eyes. But all this is set, as it were staged, on an outside staircase on which Christ is ascending. The meaning of the story in John is that Mary is not to cling to Christ in his present, physical form. The promise that he will be with his followers for ever is to be fulfilled in a different way. When he has ascended, then he will be close to them in an abiding, spiritual form, through the Holy Spirit in their hearts.

[9] This description appeared first in Richard Harries, *The Passion in Art*, Ashgate, 2004, p.124.

Figure 27
Graham Sutherland, Noli me tangere,
Chichester Cathedral

This scene, in a brilliant manner, depicts a moment which is at once one of intimacy and withdrawal. Mary reaches out in a desperate longing to touch and grasp the risen Christ. Jesus bends over, towards us, looking down and reaching out with a look and gesture of intimate meeting. Yet this moment is at the same time one of withdrawal, for Christ is ascending the steps. His elongated body and leg, with foot dragging on the ground at the bottom of the stairs, his arms along the banister, finger pointing heavenwards, indicate a movement towards the heavenly. Yet his heaven is not just 'up there'. The azure sky can also be seen, as it were, through the building. The ochre of the building and the blue sky (heaven) are not simply set one against the other. 'We can look through earth to see heaven in our midst', as well as up. Christ, set against the sky behind the building, could just as much merge into and emerge from that as he could shoot into the heavens. Indeed, the palms behind him are almost rays of light. And the whole scene is bathed in the bright sunlight of eternity. Christ in his old gardener's hat has come amongst us as a human being, and a little keyhole at the bottom left of the picture could indicate a sign through him into God. Christ meets Mary in a moment of intimate recognition. But this intimacy is at the same time his moment of withdrawal into heaven, behind, beyond and within all things. He disappears into that background in order that he might be in our foreground in a new way: a spiritual presence in our hearts and minds. Whether or not all this was in the mind of Sutherland, it is an arresting, successful painting which sets the mind going in a spiritual as well as an aesthetic direction.

Pre-war Intimations, Henry Moore and Patronage

Before considering the other major artists of this period, Henry Moore, John Piper and Ceri Richards, it is important to note that there was an intimation of this post-war recovery of confidence

in religious art that can be discerned in the shift of artistic consciousness that occurred in the 1930s. It is also important to discuss two people in this period who were key figures for the patronage of art in churches: George Bell, already mentioned in connection with Berwick Church; and Walter Hussey, who has already been mentioned in connection with the commissioning of modern art for St Matthew's, Northampton and Chichester Cathedral.

In the 1930s there was a change of mood and style amongst a group of artists and others, forming what Alexandra Harris termed a group of 'Romantic Moderns'. This affected every area of creative human endeavour, including religion. In religion it first took the form of a revival of religious drama under the patronage of George Bell, who was Dean of Canterbury (1924–29) and then Bishop of Chichester (1929–58). As Dean he had been responsible for arranging the production of John Masefield's *The Coming of Christ*, the first dramatic performance in a cathedral in modern times. In his enthronement address as bishop in 1929 Bell said that he earnestly hoped, referring not just to the diocese but to the wider church, that: 'We may seek ways and means for a restoration of the artist and the church.'[10]

He appointed Martin Browne as director of religious drama, and meeting T.S. Eliot in 1930 helped to facilitate *Murder in the Cathedral* for performance in Canterbury Cathedral, as well as encouraging the novelist Charles Williams and others. He was equally keen to bring painters and sculptors into the orbit of the church. In particular he supported the refugee artist Hans Feibusch in his work for St Wilfred's, Brighton. Although Feibusch was not a modernist there was still fierce controversy over his work but, as Bell said, 'I think we have been taking too narrow a view in what we have thought of as fitting for church decoration.'[11] He was sympathetic to Feibusch when the artist remarked, 'I would rather be burned as a heretic than as a bad artist.'[12]

This bringing together of religion and the arts, in particular Anglo-Catholicism and the arts, flowered after the war in literature, being associated not only with Eliot but also with writers such as Rose Macaulay and Dorothy L. Sayers. It also found expression in the commissioning of works of art by leading artists for churches. As Alexandra Harris put it, referring to the post-war revival, 'The beginnings of all this, however, were in that particular turn to the local that marked English Art in the late 1930's and early 1940's.'[13] It was a turn which, as she rightly remarks, is above all expressed in Eliot's *Four Quartets*.

The first major public expression of this mood in the visual arts was the commissioning by Walter Hussey of **Henry Moore** (1898–1906) to carve a **Madonna and Child** (1943–47) for his church of St Matthew's, Northampton (Figure 28).

Walter Hussey, more than anyone, has been responsible for reconnecting the church and the visual arts in the modern world. Hussey did not begin with any particular connections in the artistic world; nor did he have much money. What he did have was a love of the arts, a discriminating eye and ear, and a desire only for the best. He combined this with a simple boldness. He just wrote to some of the best-known figures in the artistic world of the time and asked them if they would do some work for his church. His persistence and capacity for enduring friendships with those he commissioned resulted in some of the best work for churches in the twentieth century.

What makes Walter Hussey 'the last great patron of art in the Church of England', as Kenneth Clark rightly called him? As Clark wrote:

[10] R.C.D. Jasper, *George Bell*, Oxford University Press, 1967, p.121.

[11] Jasper, *George Bell*, p.130.

[12] Ibid.

[13] Harris, *Romantic Moderns*, p.201.

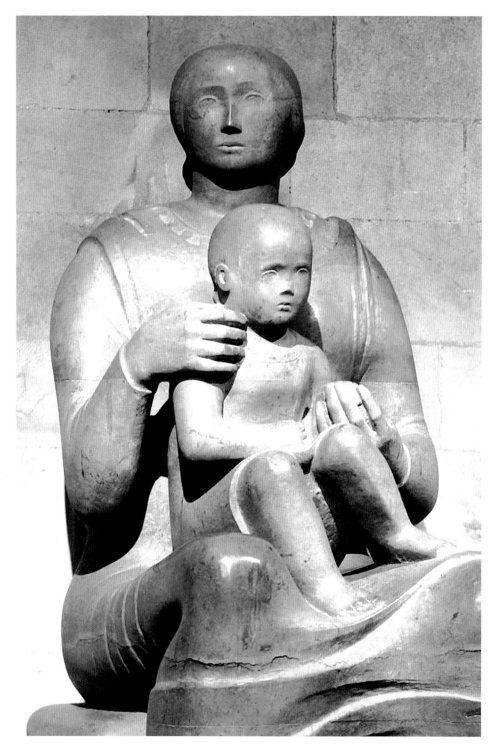

Figure 28 Henry Moore, Madonna and Child, St Matthew's, Northampton

He is sensitive, perceptive, insistent and imaginative, not gifted as an artist himself, except in the art of patronage, and not very rich. Yet his gifts as a patron are phenomenal. Once he decides that a composer, a painter, a sculptor is 'for him' nothing deters him, and he will fight – though ever so gently and patiently – to get the work performed or shown, until finally it is accepted by an appreciative and even grateful public. Reciprocation by artists is inevitable and it is safe to say that all those he has commissioned remain friends for life.[14]

Hussey commissioned Benjamin Britten's *Rejoice in the Lamb* as well as music by Leonard Bernstein and William Walton. In art he commissioned Henry Moore, Graham Sutherland, John Piper, Marc Chagall and Cecil Collins.

Hussey went to London, saw great power in some of Henry Moore's wartime drawings and said to a friend, 'That's the man for me.' Henry Moore was interested but told Hussey he did not know whether he would be able to do the work until he tried. Asked by Hussey whether he would believe in the work he would be doing, Moore replied 'Yes, I should, but whether my theology agrees with yours I could not say.' He then added that 'It is only through art that we artists can come to understand your theology.' He said that the work had forced him to go into his own beliefs 'very strongly, very deeply'. Hussey cared that the artists he commissioned had a belief that mattered to them, though he rejected any kind of inquisition about them. He did not commission one artist who told him that he thought an artist ought to do any work that was asked of them 'from the Bible to Bradshaw'. On the other hand he gave the artists a completely free hand, which they much welcomed. Only with Chagall, who really pressed him in Chichester for some steer, did Hussey indicate what might possibly be a way of approaching the subject.[15] One reason Henry Moore was uneasy about doing this work for the church was that he felt the great tradition of religious art had got lost. However, despite his misgivings, he felt his way back into that tradition to great critical acclaim. This was his first public commission, about which he said: 'I have tried to give a sense of complete easiness and repose as though the Madonna could stay in that position for ever (as being in stone she will have to do).'[16]

I am not going to deal extensively with Henry Moore in this book, as he falls outside the main focus, which is the image of Christ, whilst Moore's main work is of a more abstract kind. However he did produce a Mother and Child for St Paul's Cathedral and an <u>Altar</u> for St Stephen Walbrook – the church of Chad Varah, the founder of the Samaritans. It caused a huge outcry at the time, and a rare decision had to be made by the highest ecclesiastical court in the land, the Court of Ecclesiastical Causes Reserved, to allow it. Although Moore's work on Christian themes is limited, he is vitally important for another reason, which we note in passing. The main body of his work, though not drawing on any obvious religious symbolism, is not only widely appreciated – it also seems to many people to have an innate spiritual quality. This is not unrelated to a remark by Moore himself:

[14] Walter Hussey, *Patron of Art: The Revival of a Great Tradition Among Modern Artists*, Weidenfeld and Nicolson, 1985, p.ix.

[15] The information in this paragraph is from a film of interviews with Hussey made by the composer Robert Walker.

[16] Henry Moore, *Writings and Conversations*, ed. Alan Wilkinson, University of California Press, 2002, pp.267–9.

Artists, in a way, are religious anyway. They have to be; if by religion one means believing that life has some significance, and some meaning, which is what I think it has. An artist could not work without believing that.

That remark could I think be equally true of a number of contemporary artists who may or may not have any orthodox religious faith, but whose work seems, in different ways, to have profound spiritual significance – amongst others, Mark Wallinger, Anthony Gormley, Bill Viola and Anselm Kiefer.

John Piper

In the mid 1930s John Piper (1903–89) was one of the leading British modernists. He was elected to the exclusive 'Seven and Five' – which, as already mentioned, consisted of seven painters and five sculptors – whose criterion for admission and continued membership was abstract, severely abstract and only abstract art. Yet as the thirties progressed he moved gradually and then firmly away from this international modernism, and his post-war reputation rested on very different kinds of work and a different style. He was not alone in this. As mentioned, Alexandra Harris showed in her book *Romantic Moderns* that he was one of a group that rediscovered a native tradition and a native style. This, as she shows, covered not only the high arts but also garden design, cooking and other activities. There are of course explanations for this change of mood which affected a whole generation, but my concern is with John Piper's personal switch. What is clear in his case is that certain experiences and interests that went into him very early and very deeply emerged to shape his whole post-modernist *oeuvre*. It was, as Harris says, one of the most remarkable trajectories of an artist in the twentieth century.

Piper was born and brought up in Epsom and (like Graham Sutherland) went to Epsom College. He early wanted to be an artist, but his father wanted him to qualify first as a solicitor. He did his best to resist this but when his elder brother Charles, who was going into his father's firm, was killed in the war John felt he had no alternative but to conform. However, when his father died five years later, he felt released from this obligation and went first to Richmond School of Art and then to the Royal College. The key influences however, had already entered his psyche: first, a love of places in all their particularity and, with this, a love of guidebooks about them. On his tenth birthday he was given a guidebook to the county of Kent, and his earliest drawings are copies of the vignettes in this guide. He cycled around the countryside with his father, developing an interest in both architecture and archaeology. At 16 he wrote his first article for the *Architectural Journal* and at 17 became the secretary of the Wiltshire Archaeological Society. At the age of 10 he went to France, which not only sparked an interest in French painting but was also when he had his first visit to Notre-Dame. As he said, 'I still remember a thrilling shock at the first sight of the stained glass.'[17] Later in life he was to say that it was through copying a small thirteenth-century piece of glass that he learned more about colour than he had learned before or after.[18]

Another early influence was William Blake, not least his saying 'Shall painting be confined to the sordid drudgery of facsimile representation of merely mortal and perishing substances and not be, as poetry and music are, elevated to its own proper sphere of invention and visionary conception.'[19] Also influential were the paintings of Rouen Cathedral by Monet and the stage

[17]　Quoted in Frances Spalding, *John Piper, Myfanwy Piper: Lives in Art*, Oxford University Press, 2009, p.14
[18]　John Piper, *Stained Glass: Art or Anti-Art*, Studio Vista, 1968, p.19.
[19]　Spalding, *John and Myfanwy*, p.18.

designs of the Ballets Russes. After a very short-lived marriage to a fellow art student, John and Myfanwy fell in love, married and lived the rest of their lives at Fawley Bottom Farmhouse in the heart of the beautiful Chilterns near Henley. Myfanwy was a significant figure in her own right, as well as a big support for and influence on John. It is right that Frances Spalding's biography of the Pipers should treat them together. An Oxford graduate, Myfanwy edited the pioneering modernist magazine *Axis*, wrote librettos for Benjamin Britten operas, was a highly perceptive critic and reviewer, and kept a wonderful house, always full of interesting visitors for whom she cooked innovative and beautiful food. Their life was full and ebullient, and all the while John's work took many forms, from popular designs to major opera sets.

Then, at the height of his fame as a modernist, John Piper in the late thirties started to head elsewhere. Partly it was because he felt that severely abstract art had nowhere else to go, that this particular seam had been exhausted, or was undernourished, to use his phrase; but above all it was the emergence of his early, most fundamental experience, his love of the distinctiveness of a particular place. He began to be excited by painters like John Sell Cotman, Samuel Palmer and Turner.[20] At this time he also began photographing Romanesque carvings, and was drawn to paint the sea and mountains, especially the mountains of North Wales, which remained hugely important to him for the rest of his life. He was commissioned to do paintings of famous country houses and other buildings, which he continued to do after the war. In these paintings the building emerges from a brooding background of geology, landscape and history. They are not just 'views', for they carry the penumbra of a long time scale. Piper also did a series of views of Windsor Castle. He continued to produce these views of Windsor Castle with his characteristic dark skies, despite being urged to lighten them a bit for the Queen. When the Queen saw them she made some appreciative comments, but King George VI looked at them in silence for some time before remarking, 'You seem to have had very bad luck with your weather, Mr Piper.'

Although John Piper made a radical change of direction in his artistic style, it is important to stress that he was not a representational artist. A remark of Blake which meant much to him has already been quoted. He also much admired a remark of Pissarro to his son: 'I am more than ever for the impression through memory, it renders less the object – vulgarity disappears, leaving only the undulations of the truth that was glimpsed, felt.'[21] As Frances Spalding puts it, 'Because his work is culturally conceived and carefully observed, we find him searching for the new while fully conscious of the tradition.'[22] During World War II Piper, like Moore and Spencer, became a war artist, focusing particularly on bombed buildings. It was at this time that he painted Coventry Cathedral after it had been bombed, a scene which became iconic for wartime Britain.

During the war, as already mentioned, Walter Hussey, the perceptive vicar of St Matthew's, Northampton, commissioned work from both Henry Moore and Graham Sutherland for his church. This led in due course to Piper being commissioned, on the recommendation and prompting of his close friend John Betjeman, to design some new stained glass windows for the chapel of Oundle School. Taking the theme of the great New Testament images of Jesus as the Vine, the Bread of Life, the Judge, he produced windows of strong colour and line which clearly owed much to the thirteenth-century windows he so much admired, as well as to the elongated figures of Romanesque and early Gothic sculpture. The windows were judged a great success, and this set

[20] The influence of Samuel Palmer on British artists in the twentieth century who wanted to rediscover a spiritual dimension to art has been remarkable. See Rachel Campbell-Johnson, *Mysterious Wisdom: The Life and Work of Samuel Palmer*, Bloomsbury, 2011, chapter 23, though she fails to mention David Jones.

[21] Spalding, *John and Myfanwy*, p.246.

[22] Ibid., p.271.

the scene for a final triumphant phase of Piper's career. Working with Patrick Reyntiens, who often made important contributions to the work, he then produced windows for Eton and numerous other churches. John Betjeman, who was a very devout Anglo-Catholic, wrote to John and Myfanwy to say 'Will you both seriously consider joining the C. of E.' They did so, and in 1940 were confirmed by the Bishop of Oxford. John remained in the Church of England, though becoming disillusioned somewhat after the ordination of women and changes in the language of the liturgy. After the war Piper played a key role not only in designing windows for churches, but also in saving churches from inappropriate alteration or conservation. In 1950 he became a member of the Diocesan Advisory Committee of the Diocese of Oxford, a body which is charged with the responsibility for innumerable design issues, minor and major, for 500 or more churches, two-thirds of them listed. He remained a member for 38 years. He was not a conservative in the usual sense, anxious to preserve all that was old. He recognised that churches are there first for the use of a worshipping congregation, and this meant he shared the familiar tensions that this sets up between adapting a building for modern needs whilst preserving the best of what is already in place.

Piper took a major interest in all aspects of the church and the arts, both writing on the subject and being consulted for advice. As discussed earlier, it was a time of liturgical renewal, with a recovery of the more holistic view of the Eucharist as celebrated by the early church. There were interesting developments on the continent inspired by Father Couturier. Nationally 283 churches had been lost during the war, though due to shortages of material only 41 Anglican churches were consecrated in the period 1945–56. Nevertheless there was more than enough work to keep Piper fully occupied. The highly influential Kenneth Clark, who had been an opponent of Piper in his abstract phase, now became an enthusiastic supporter.

Of Piper's post-war work the best known is the **Baptistery Window** in Coventry Cathedral (Figure 29). A major piece of work, 85 feet by 65 feet, it took five years to produce. Moving away from the idea of a detailed iconography, it is a great burst of life surrounded by vibrant colours. It was judged a success at the time and continues to be so.

Another major work was the lantern in Liverpool's Roman Catholic Cathedral. Built in the round, with the altar in the centre in accord with the recovered understanding of the Eucharist as an act involving the whole congregation, the light from the lantern above the altar is again regarded as a success.

Piper's work was not confined to stained glass. Walter Hussey, who had become Dean of Chichester and who had commissioned glass by Chagall and a painting by Sutherland, commissioned Piper to do a large tapestry for the altar, which he did in 1964–66. Following the advice of a clergyman friend whom he much respected, this is a symbolic rendering of the Holy Trinity. In addition, he designed vestments for Chichester, as he had done for Coventry. He also designed the tiny but exquisite chapel for Nuffield College, Oxford, a graduate college associated with the social sciences.

Piper continued to receive commissions for stained glass windows and other church work. They included Christ in Glory for the East Window of the chapel of the Hospital of John the Baptist without Upper Barres, Lichfield (1984), The Light of the World for Robinson College, Cambridge (1978–80), The Road to Emmaus, a mosaic for St Paul's, Harlow (1959) and the Benjamin Britten Memorial Window in Aldeburgh Parish Church, with its wonderful scenes of **The Return of the Prodigal** (Figure 30) and the 'Burning Fiery Furnace'. There are a number of fine windows in the churches of Berkshire, Buckinghamshire and Oxfordshire, the area covered by the Diocese of Oxford, my favourite being the one in St Mary's Iffley, based on a **Christmas Carol** (Figure 31)

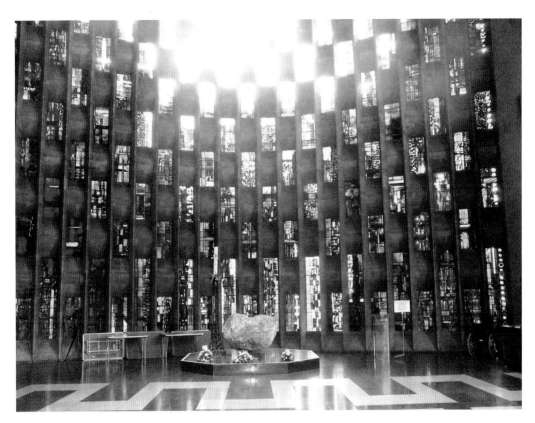

Figure 29 John Piper, Baptistery Window, Coventry Cathedral

and a mediaeval mural, about which Myfanwy had written an article. It depicts the cock, the raven, the crow, the ox and the sheep all joining, in their own way, with the song of the heavenly angels.[23]

The theme of this book is how modern artists have responded to the challenge of Christian iconography whilst retaining their artistic integrity. In this respect John Piper, through a combination of his early of enthusiasm for the particularity of places, his period as an abstract expressionist and the changing circumstances and mood of the time he lived through, was able to produce work that resonated with what people wanted after World War II. First, it is important to remember that despite the radical shift in his art in the mid thirties, he remained a modern artist and his abstract modernism remained fundamental to him. His paintings of buildings and landscapes are fundamentally different from those of earlier centuries, reflecting not just his love of them, and his sense of their history and prehistory being carried over into the present, but with a modern feel for configuration and colour. Above all of course, we can see how in his work in stained glass, his love of colour and his use of abstract or semi-abstract forms, which owes something to the thirteenth century which he loved, come together with his modernism. Some 40 years after he fell in love with medieval glass he reflected on this medium in *Stained Glass: Art or Anti-Art*. He argued that most stained glass produced over the previous 500 years had not been art at all, just poor attempts to reproduce in glass what painters do on canvas. But what the Romanesque stained glass artists

23 For a fuller discussion see Richard Harries, *The Nativity in Art*, Lion, 1995, p.90.

Figure 30 John Piper, The Return of the
 Prodigal: Benjamin Britten Memorial
 Window (detail), Aldeburgh Parish
 Church

Figure 31 John Piper, A Christmas
 Carol, St Mary's, Iffley

produced provided a fresh source of inspiration for modern artists. What was important about their work was not the scenes themselves, but the total effect. As he wrote:

> We are still fairly new and fervent converts to Romanesque. The brightness and the primary colour contrasts; the geometrical arrangements of not *completely* geometrical forms, within bold, black glazing bars; the absence of desire in the makers to achieve any formal recession in drawing or colour – these have provided a sympathetic appeal to the eyes of many in our two thirds of the 20th century.[24]

As Frances Spalding put it:

> As a young man, he had no difficulty aligning his interest in stained glass with his growing commitment to modern art.[25]

[24] Piper, *Stained Glass*, p.23.
[25] Spalding, *John and Myfanwy*, p.33.

In his stained glass Piper's art, with its combination of modernism and love of the particular, came into its own in a way that was entirely natural to the medium and which was accessible to the public. If there is one spiritual note in particular that comes through it is that of light, life, colour and joy.

Ceri Richards

Ceri Richards (1903–71) was born in a village near Swansea, into a highly cultured working-class home. His father ran one of the finest male voice choirs in Wales, and all the family were taught musical instruments. His father, a devout chapel goer, wrote poetry in both Welsh and English. There was no tradition of the visual arts in this puritan home, but when Ceri showed an interest and aptitude his parents were thoroughly supportive. Richards began work as an apprentice electrician but took art classes at the same time and won a scholarship to the Royal College of Art in 1924. Inspired by modernism on the continent, he was particularly influenced by the later Matisse who, as has been written, 'opened a door for him into a room of his own'. His work very much belongs to the period of late modernism, but reflecting always Richards's intense interest in music and his interaction with the poems of Dylan Thomas and Vernon Watkins.[26] He was not religious in a narrow sense, 'but was deeply affected by religious imagery' and this is reflected in his images of human suffering.[27] His work appears in the Tate and other major collections. His major work in a church is the **Sacrament Chapel** of the Roman Catholic Metropolitan Cathedral in Liverpool (Figure 32). What it shows is that although the Christian faith is committed to the revelation of the divine through the human, and is therefore essentially iconic, purely abstract art can be effective in some sacred contexts, as it is here. The use of light from the windows, allied to the yellow and shades of blue, focus the sacramental presence of Christ at the altar.

The story of the appearance of the risen Christ to two disciples falls into two parts. There is first the actual journey on the road to Emmaus, when Christ expounded the Hebrew Scriptures to them. The second part of the story concerns the actual Supper, particularly the moment when the two disciples recognise the stranger to be Christ. At the time of the Counter-Reformation when the Eucharist became subject to renewed attention, this scene became particularly popular amongst Christian artists. A famous example is the painting by Caravaggio. This modern rendering by Ceri Richards, **The Supper at Emmaus**, is no less striking (Figure 33). Commissioned by the Junior Common Room of St Edmund College, Oxford, as part of a competition amongst major artists of the time, it was put in the Chapel to celebrate the transition of the Hall to a recognised college of the University. It was well received at the time, receiving good reviews in both the *Sunday Times* and the *Observer*, and it continues to arouse appreciation.

Luke 24:31 records that 'Their eyes were opened and they recognised him; and he vanished out of their sight.' This moment of recognition was most dramatically caught by Caravaggio in his great shaft of light across the picture and the startled faces of the disciples. In Ceri Richards's portrayal, Christ is seated against a great yellow cross of light which at once outlines him and allows him to melt into it. In the Sacrament Chapel in the Roman Catholic Cathedral in Liverpool, both in the painting behind the altar and in the glass, yellow light plays a crucial role. In this

[26] His painting on the theme of the poem by Dylan Thomas 'Do not go gentle into that good night' is discussed in an illuminating correspondence between the artist and the Anglican priest and scholar Moelwyn Merchant in Ceri Richards's 'Pagan Mystery', in *Ceri Richards*, Mel and Rhiannon Gooding, University College of Swansea, 1964, p.30.

[27] Interview with the artist's daughter, Rhiannon Gooding.

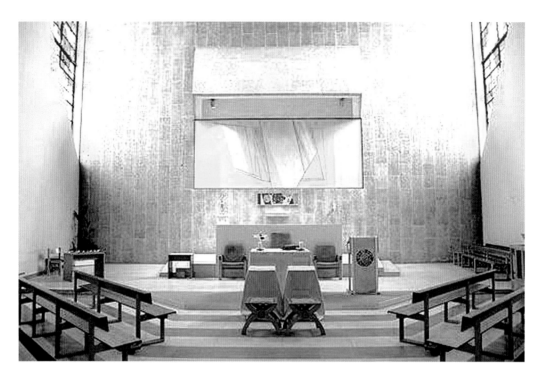

Figure 32 Ceri Richards, The Sacrament Chapel, Roman Catholic Metropolitan Cathedral, Liverpool

Figure 33
Ceri Richards, The Supper
at Emmaus, Chapel of St
Edmund Hall, Oxford

Figure 34 Ceri Richards, 'Deposition', St Mary's, Swansea

painting again, the light is crucial. Here it is not shining on Christ but behind him, forming the background out of which he emerges; the light of eternity in which he is momentarily figured as a human face and form.

The two disciples react to the revelation of Christ in different ways. One rises awkwardly, pushing the chair aside. The other, seated at the side of the table, is 'disturbed but uncomprehending; his clasped hands are pressed to his mouth in the gesture of a slow man gaining time to readjust his mind'. It is a powerful icon in which the sudden apprehension of one disciple and the delayed recognition of the other are juxtaposed.

The most unusual feature of the painting, however, is the large hands and feet of both the disciples and Christ himself. Narrowed wrists and ankles make them unusually prominent. The moment of recognition of the risen Christ is also the moment of realisation that Christ's work continues through human hands and feet. The hand raised to bless and teach is a hand that will henceforth work through those large, ungainly yet beautiful extremities of flesh and blood. As has been written, 'It is the imaginative, centrifugal movement of the hands and feet that serves to interrelate the figures and gives them a buoyancy half suggestive of resurrection.'[28] Christ in his risen body gives them the blessed bread, his body broken for humanity, that they might become his risen body in the world.

Richards had a recurring preoccupation with the human body, and an important work that came from one of these periods was his **Deposition** which hangs in St Mary's, Swansea (Figure 34), a study of it being in the Leeds City Art Gallery. Richards said about this and his 'Supper

[28] Neville Wallace, *The Observer*, 28 December 1958.

at Emmaus', 'I was profoundly interested in the religious subject ... I approach these subjects with great care and circumspection, for I cannot decide casually to just 'do' a religious subject.'[29] Describing the two versions of 'Deposition' as presenting an image of 'almost unbearable sadness' with a 'timeless modernity', Mel Gooding writes:

> The dead Christ is laid on a white sheet amidst the mud and debris of a public place. In the Swansea painting, in which the lateral cruciform of the composition is clearly explicit, scraps of litter are incorporated into the paint, and the carpenter, whose job it is to have made the cross and to have removed the nails, and who poignantly reminds of the working profession of Jesus himself, is represented by his work bag, whilst someone out of the picture to the left shows concern by clasping hands in a way that prefigures a million prayers.[30]

The critic Quentin Bell, reviewing the exhibition of religious art in which the painting was first shown, judged that it conveyed a strong sense of conviction which was lacking in most of the other works on show. Mel Gooding, judging this and 'The Supper at Emmaus' to be among the few great religious painting of their time, writes that this was because of the ability of Richards, in an almost impossible time for painting on religious themes, 'to assimilate the private to the public magic, to find in the personal events of love and loss the greater significance of a general myth'.[31]

29 Quoted by Mel Gooding, *Ceri Richards*, Cameron and Hollis, 2002, p.130.
30 Ibid., p.131.
31 Ibid.

Chapter 6
Searching for New Ways

Art has always been subject to fashion. During the twentieth century however, as a result of the influence of the media changes of artistic fashion have been trumpeted as never before; furthermore, the changes have had an international dimension. So it is that since World War II two of the most talked about styles, abstract expressionism and Pop art, originated in the USA. However, what is of immediate interest may not be of long-term significance; and, more particularly, British art in this period has been distinguished by a range of individual styles. Frances Spalding, rejecting a view of art history that sees it in terms of a linear progression with one radically new style following another, has written:

> Innovation has instead been made through a return to personal convictions or native traditions, to a revival of narrative for example, or a realist approach. The individualism inherent in British art has liberated artists from unthinking adoption of fashionable styles.[1]

The Tate mounted an exhibition in 1956 on 'Modern Art in the United States', with the final gallery devoted to the work of abstract expressionists like Pollock and Rothko. This made a powerful impact in Britain. 'But those artists who responded to its challenge did so with varying degrees of enthusiasm, sometimes with an ambivalence that was most clearly voiced in the work of Patrick Heron.'[2]

In the same year Pop art began to make an impact, with a similar ambivalence towards it amongst practising artists in Britain. Then in the mid to late sixties conceptual art started to become influential. Frances Spalding has written:

> 'Conceptual' art could take any conceivable form. Its practitioners, reacting against the excessive emphasis previously given to material presence in art, were primarily concerned with ideas and information and only secondarily with their visual presentation.[3]

That quotation reveals why conceptual art, with its emphasis on ideas, could have been an ally to artists working within a religious tradition, who do indeed have an idea to share. However this turned out not to be the case because of what Spalding refers to as conceptual art's lack of interest in visual presentation. For, as emphasised earlier, the Christian tradition, although it can make use of abstract ideas, is committed to visual representation because of its belief that the invisible has been made visible, though not of course in any purely photographic or literalistic sense.

With these points in mind, particularly Spalding's stress on the individualism inherent in British art which has liberated it from a slavish following of fashion, a number of British artists who made their reputation after World War II but who are no longer living will be discussed. More art on religious themes was being produced than was apparent to most people at the time. For

[1] Frances Spalding, *British Art since 1900*, Thames & Hudson, 1986, p.7.
[2] Ibid.. p.184.
[3] Ibid., p.215.

reasons of space some of these artists can only receive a short mention here. First, however, a very brief look at Barnett Newman, an American artist regarded as one of the great figures of abstract expressionism, but one who could better be termed a minimalist. Although he is really outside the scope of this book, which is mainly on British art, he is mentioned here to show that religious faith can be expressed in even the most apparently inhospitable of styles.

Barnett Newman (1905–70) was born into a New York Jewish family and developed a style in which a narrow vertical line, what he called a 'zip', remained a constant feature. Although his paintings are severely abstract he used to give them titles. These titles sometimes have a Jewish reference, such as 'Adam and Eve', and sometimes one that encompasses both Judaism and Christianity, such as 'Onement'.

Between 1958 and 1966 Newman painted a series of Stations of the Cross, calling them 'Lema sabachtani – My God why hast thou forsaken me?' which he saw as a memorial to the holocaust. They are totally non-representational, and all the stations are variations of his characteristic style with its vertical stripes. When they were shown he added a fifteenth one. They are now in the National Gallery of Art in Washington DC, and often admired. With the very important exception of some stained glass, and the decoration of the sacrament chapel in Liverpool's Roman Catholic Cathedral by Ceri Richards mentioned in the previous chapter, there has been no similar attempt in Britain to deploy abstract expressionism or minimalism so directly for religious purposes. However, the artists now to be discussed – though they would not be categorised as abstract expressionists – were, with their highly individual and varying styles, all decisively shaped by the modern movement as a whole.

Craigie Aitchison

Craigie Aitchison (1926–2009) was born in Edinburgh. His father, Sir Craigie Aitchison, was a brilliant King's Counsel (KC) who became a judge and then the first Socialist Advocate of Scotland. Both the artist's parents had some interest in painting. Although Aitchison did four years' study for the Bar, he had no heart for it, and he spent his time going to the Tate and learning to copy pictures. The result was that he went instead to study at the Slade School of Fine Art, whose emphasis at the time was on meticulous drawing. This was neither Aitchison's interest nor his talent, and he stood out from the first by producing very different kinds of painting. In the 1950s he belonged to the young Bohemian artistic set in London, moving from one temporary lodging to another. However, he did have some success with his painting and was early taken up by a gallery. He moved into a house in Kennington which he decorated in colourful and eccentric ways, and where he lived for the rest of his life with his Bedlington dogs, which were central to his life, and which often appear in his paintings.

At this time Aitchison painted still lifes, such as Still Life with Bird Vase (2004), which he imbued with a pleasing tranquil mood, and arresting portraits, particularly of Georgeous George Macaulay, whom he liked to paint with unusual headgear as in Georgeous Macaulay in Sou'wester (1976) and Georgeous Macaulay in Uniform (1969).

He painted his first crucifixion in 1958 and this continued to be the dominant image of his work for the rest of his life. They were sometimes criticised by art critics for being repetitive but in fact there are very many different variations, as can be seen in Crucifixion (1994), another Crucifixion (1994), which won the Jerwood Prize, and Crucifixion (1995) in which Christ has no arms.

Aitchison was also criticised from time to time for a naïve, childlike style, but in fact it was meticulously contrived and arrived at. He could spend weeks on a painting, rubbing elements out and changing them before he became even moderately satisfied. What he was primarily concerned to

do was achieve a certain surface effect. Admirers of his work were drawn in particular by his use of colour in creating certain moods. He did no outline drawing but painted straight on the canvas with great blocks of roughly textured colour, influenced by the formalism of Mondrian, whom he admired.

Although Craigie Aitchison was primarily concerned with the formal element of a painting, the fact is that it was the crucifix which dominated his imaginative thinking. What did it mean to him? What was he trying to convey?

Looking at Aitchison's studies of the crucifixion one is struck by the loneliness and isolation of the figure on the cross. Did this reflect Aitchison's own sense of isolation? There is no evidence for this in either his surviving writings or the memories of his friends. In fact he was an extraordinarily large, gregarious, generous person who kept open house and who had close friendships with both women and men.[4]

The short answer is that we do not really know why Aitchison returned time and again to Jesus on the cross. A major study on Aitchison has the words:

> It has to be said he is unusually reticent on the subject, content to tell the curious how he considers the crucifixion 'the most horrific story I have ever heard' and little more … 'They are ganging up against one person. As long as the world exists one should attempt to record that. It was so unfair.'[5]

On the basis of this, if one is looking for the roots of this view in Aitchison's own life, it is his sense of pity that seems most relevant. He himself had an unusually shaped body, including, as a child, weak legs that had to be in callipers. It would not be unusual to think that this made him particularly sensitive to other people who were different or in distress.

Aitchison was not a regular churchgoer. However, his grandfather had been a distinguished minister in the United Free Church in Scotland, and his parents took him to a variety of churches when he was growing up in Edinburgh, including Roman Catholic ones, so the image of the cross obviously went in early and deep. He was particularly struck by the candles and sense of show in Roman Catholic churches.[6] In addition Craigie Aitchison had spent some time in Italy as a young man, and the painters of the *Trecento and Quattrocento* had a profound effect on him, especially Piero della Francesca, whose influence we can see not only in his crucifixes but also in his portraits of friends in profile. There is also something of the simple devotion of Fra Angelico in Aitchison's work. That said, all we can do is look at the paintings and let them convey what they will. There is no emphasis on suffering as such, but there is a powerful sense of spiritual isolation, of the lonely individual against the great, sometimes black, panorama of nature. The depiction of Jesus on the cross without arms, pinned to wood, seems to suggest the human being, limited and finite, pinned to the circumstances of his or her life, bound by fate. The sense of spare isolation is further indicated by Aitchison's depiction of trees, either on their own or as a feature of his paintings on the crucifixion, as in The Tree (1968) and Crucifixion (1998). At the same time there is a haunting, other world quality about them.

For the most part there is no other human in these paintings, but there is often a beloved Bedlington, as in Crucifixion (1984). It seems that it was the sadness of human suffering, all human suffering, that Aitchison wanted to convey, and he may have put in the Bedlington, amongst other reasons, because the presence of a pet animal can add to that sense of pathos. The Bedlington,

4 From an interview with Cate Haste, who is writing a biography of Aitchison to be published by Lund Humphries. She has access to Aitchison's papers and has interviewed his friends.

5 Andrew Gibbon Williams, The Art of Craigie Aitchison, Canongate, 1966, p.64.

6 Haste, interview.

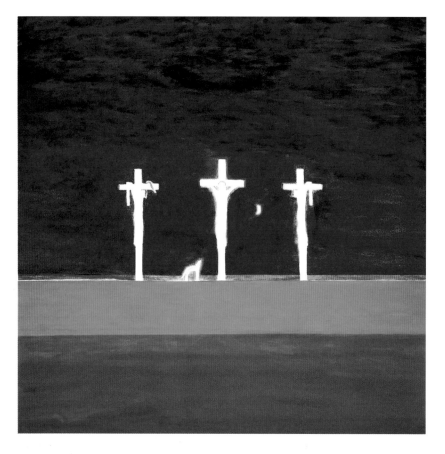

Figure 35 Craigie Aitchison, Calvary 1998, Liverpool Cathedral

however, looks somewhat like a sheep, and can bring to mind the image of the Lamb of God. Sometimes there are also two birds on the crossbar. Aitchison kept canaries in the house. So this isolated figure has the consolation of the animal world, the affection of his dogs and the song of the birds. Such paintings resonated with the wider public, and at least two cathedrals felt that they were saying something important. Truro Cathedral commissioned a triptych, and Liverpool's Anglican Cathedral, a crucifix.

The painting of the crucifixion in Liverpool Cathedral, **Calvary 1998**, is different from the majority of Aitchison's studies of the subject in a number of respects (Figure 35). Normally he shows Christ alone, an utterly isolated figure; here he is set between the two bandits as in the crucifixion story. Again, normally Christ is shown draped over the cross, usually sideways on to the viewer. Here he is upright and facing the front. The Bedlington terrier is present, looking up towards Christ. But another marked feature is the penumbra of red round the central cross, with all three crosses having a luminous quality against the arresting blue and black of the sky.

The Dean of St Paul's at the time, Alan Webster, wanted to buy a crucifixion for the cathedral but this was vetoed by other members of the chapter. The Dean wrote of the crucifixion, which is now in the Tate, 'Here, the divine is vulnerable and disturbing, not almighty or ecclesiastical. As in some Eastern religious thinking, the divine is seen to be at one with nature, the birds and the beasts, suffering with suffering humanity.' And a colleague on the chapter noted that Aitchison's

crucifixions 'reflect what is stirring in the hidden subconscious of his generation'.[7] This is borne out by the interviews that Cate Haste has conducted with people who respond to these paintings. For such people they have a spiritual, not just an aesthetic appeal. This has, I think, to do not just with the subject matter but also with his highly distinctive use of colour. This is borne out by other paintings of Aitchison which seem to have a particular religious aura about them even though the subject is very different – the ones he did towards the end of his life of the Isle of Arran in the Forth of Clyde, and of Holy Island, just off its coast. This was where he spent his childhood holidays with his parents, and where his parents' ashes were buried. Holy Island now has a community of Buddhist monks on it. The colouring in all his painting has a magic quality about it, as though it is taking the viewer into another world – not just a child's world, but a world of wonder and awe. Goatfell, Isle of Arran (1993) and Holy Island (2001) are particularly marked in this respect, and they have an undeniable numinous feel to them.

Elisabeth Frink

Elisabeth Frink (1930–93) was educated at Guildford and Chelsea art schools. She developed a technique, following Giacometti, of building up figures in plaster, from which she later made a bronze. She was one of a group of British artists who exhibited at the 1952 Venice Biennale and whose work was characterised by Herbert Read as 'The Geometry of Fear', a title which reflected both the atmosphere of the Cold War and the growing awareness of the horrors of the Holocaust. Some of her work with male heads, both then, and later when she was very conscious of the oppression in the world, reflect this menacing side of humanity. But she also witnessed to victims in heads of a much gentler aspect.

Frink was brought up in the country and had a great affinity with animals, and it was their relationship with humanity that concerned her and which is often reflected in her sculpture. Her work was summed up in the *Times* obituary as concerned with the 'horseness' of horses as well as with the human figure and the divine in the human. She was widely acclaimed in her lifetime and was kept very busy with commissions.

Brought up as a Roman Catholic, she admitted to strong views about Catholicism.[8] She was drawn to Christ, one reason being that this enabled her to explore the male body, her main theme, in various forms. So we have her Head of Christ (1951), Head of Christ (1983) and **Head of Christ** (1983), commissioned for All Saints', Basingstoke, which reflects both the strength and vulnerability she saw in Jesus (Figure 36). She has also focussed on the passion story, and this is reflected in her Pietà (1956), in the Methodist Art Collection; the Crucifix (1983), in St Mary's Lutheran Church in London and a Crucifix (1966) for the Roman Catholic Metropolitan Cathedral in Liverpool. She received a number of commissions on other Christian themes as well. This included an Eagle Lectern for Coventry Cathedral in 1962 and a sculpture of St Edmund (1966) for the courtyard of St Edmundsbury and Ipswich Cathedral. One of her best-known works is a Walking Madonna for the green of Salisbury Cathedral. She said she deliberately decided not to do a Madonna and Bambino because she wanted to depict the Madonna when her children had grown up and left home.[9]

[7] Williams, The Art of Craigie Aitchison, p.115.
[8] Interview with Norman St John-Stevas, 1981, BBC archives.
[9] Ibid.

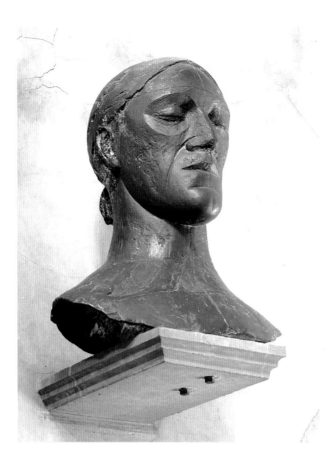

Figure 36
Elisabeth Frink, Head of Christ, All
Saints', Basingstoke

The **Head of Christ** was commissioned for All Saints', Basingstoke by Canon Keith Walker who, as discussed in an earlier chapter, also commissioned windows by Cecil Collins for the same church. It is a strong head, firm in the jaw, nose and shape of the cheeks. There is a sense of the implacability needed by someone with a mission to accomplish.

Frink was commissioned to do a statue of The Risen Christ (1966) for Our Lady of the Wayside, the Roman Catholic church of Shirley, Solihull. Dominating the church, it depicts the risen Christ showing his five wounds to his disciples. It is said that if you look from the left you see the beard and Semitic features accentuated, if from the right, the Greek ones, so he looks more like Apollo. As the New Testament brings together both perspectives, Jewish and Greek, in its understanding of Christ, this twin aspect has theological as well as aesthetic purpose.

Another well-known church commission was the Risen Christ (1993) for Liverpool's Anglican Cathedral, which Frink was able to see installed just before her death (Figure 37). She had suffered a number of bouts of cancer over the years, and she worked on this bronze in her final illness. We may have doubts over its position, high above the West Door of the monumental building by Giles Gilbert Scott, but as Frink saw it in place she herself presumably approved of this setting. The foreshortened limbs and the green patina of the bronze against the orange red sandstone have led to it being described as alien and lacking a sense of triumph by some very familiar with the work, though others affirm that the head does indeed convey a sense of resurrection.

Frink, who was drawn mainly by the male form, did not find it difficult to respond to church commissions. This was not the case for Barbara Hepworth (1903–75), who was a little older than

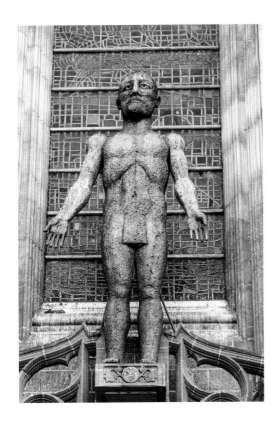

Figure 37
Elisabeth Frink, "The Risen Christ". Bronze.
Liverpool Cathedral.

Frink and who worked in an abstract style. Hepworth produced one work for a church, a cross for Salisbury Cathedral, which is at once recognisable as a Christian symbol and which is also clearly a work of modern art. But the main body of her abstract work, much of which is deeply satisfying, supports the view of Henry Moore quoted earlier, that real art cannot be produced without faith of some kind. Hepworth herself said that 'A sculpture is a real object that relates to body and spirit as well as appealing to our sense of form and colour.'[10] What is interesting about those words is her recognition that our response to art is not just physical, a matter of chemistry, but of the spirit also.

F.N. Souza

Francis Souza (1924–2002) was born in Goa. His father died when he was young, and he himself caught smallpox. His mother vowed that if he survived she would dedicate him to the priesthood. He was given the extra name Francis in honour of the patron saint of Goa, Francis Xavier, and was sent to a prestigious Jesuit school of that name. He was expelled from there and later from his art college for supporting the 'Quit India' movement. He founded a progressive artists' movement in India and then in order to come closer to the international art scene came to Britain, where in due course his paintings and writing achieved some recognition. There is an erotic element in much of his art. In 2008 one of his works sold for the highest ever price for a painting by an Indian on

[10] On the wall in the Hepworth Wakefield Museum, where there is also a full-scale replica of the cross which she made for Salisbury Cathedral. She also produced a Madonna and Child for St. Ives Parish Church.

the international market. Eventually he moved to New York. Brought up as a Roman Catholic, he acknowledged the Roman Catholic Church to be a very big influence on him, especially in his early years, and he produced a number of paintings on Christian themes in an expressionist style, though one also influenced by the Art Brut movement of the time. His ambivalence about the church is reflected in his art. His <u>Head of Christ</u> (1948), with its Byzantine elements, shows the powerful attraction Christ had for him, whilst <u>Crucifixion</u> (1959) betrays his ambivalence. The blond hair and blue eyes of Western depictions of Christ and the emphasis on violence and cruelty reflect his struggle against British imperialism in India. <u>St Francis</u> (1961) has greater serenity, and illustrates a point made by John Berger that there was an eclectic element in Souza's style. We see this in the different styles of <u>Two Saints in a Landscape</u> (1961), <u>The Paraclete</u> (1962) and <u>The Crucifixion</u> (1962). This last painting, which has an element of folk art about it, can be viewed in the Methodist Art Collection. It is a painting that catches the eye in a way that is at once modern and traditional; but it is not a painting that would hang easily in a sacred context.

John Reilly

John Reilly (1928–2010) trained at Kingston Art College from 1949 to 1952 and, having been brought up to love sailing, he initially painted marine subjects. He settled in the Isle of Wight, where for 30 years he earned his living as a ceramic artist but where he continued to paint as well, his work gradually gaining recognition. He began to paint full time in 1981. Always interested in biblical painting, four of his paintings were purchased by the Methodist Art Collection, and in 1964 the BBC made a film about his work. Reilly was never interested in representing the scene as it might have appeared to onlookers. He tried to paint it in such a way as to bring out its spiritual significance for all people of all time. Nevertheless, as a Christian believer he was aware of what has been called 'the scandal of particularity', the Christian belief that the Eternal has been specially manifested in one particular person at one particular time. He developed a particular method for holding these two aspects together, the universal and the particular, the spiritual and the material, the invisible and the visible. He brought out the historical and visible by showing the figures in enclosed self-contained spaces. This can be seen, for example, in his painting <u>Cain and Abel</u>, one of the pictures in the Methodist Collection, where each of the figures is shown in a separate enclosed space. At the same time Reilly seeks to indicate the dimension of the spiritual by means of flowing open lines and curves, which can be seen in the way he has painted the fields, hills and sky. This dimension of the spiritual reflected in flowing lines and curves is even more apparent in <u>Raising of Lazarus</u>. What happened over the years is that this flowing, harmonious element became more prominent, dominating the picture, usually taking the form of part or full circles. This is seen for example in his **Miraculous Draught of Fishes** (Figure 38). All is drawn into the bright circle of eternal life. Not surprisingly the circle has often been used as an image of eternity, as in Henry Vaughan's lines from his poem 'The World':

> I saw eternity the other night
> Like a great ring of pure and endless light,
> All calm as it was bright.

Figure 38 John Reilly, The Miraculous Draught of Fishes

As Reilly himself has written:

> My paintings are not concerned with the surface appearance of people or things but try to express something of the fundamental spiritual reality behind this surface appearance. I try to express in visible form the oneness and unity of this invisible power binding all things into one whole. [11]

Again, as he has said, 'I am trying to paint the glory of God and through that the meaning of life.'

Reilly was interested in the deeper meaning of a story. Daniel and the Lion's Den is a clear example of this. It shows five highly stylized lions surrounding a standing figure. From this figure emanate faint circles and shafts of light that hold their ferocity at bay. There is nothing literalistic about this scene. It is clearly meant to convey the feeling of being under the protection of God even when faced with the trials of life. This is brought out by the text which he uses from Psalm 7: 'In thee O Lord do I put my trust: let me never be put to confusion.' Another theme which emerged in Reilly's art over the years was that of the relation of the human figure to the environment, to indicate the possibility of the natural and human worlds being in harmony. We see this in Great Pastures Beside Still Waters, in which a figure lies in the earth in tranquil countryside. It is not just

[11] John Reilly, The Painted Word, Cross Publishing 2008, p.7. More of Reilly's paintings can be seen, and prints purchased, by visiting http://thejohnreillygallery.co.uk.

Figure 39
John Reilly, Jacobs Ladder –
Vision of Unity

the relationship of humanity with nature but also the harmony of earth and heaven, the eternal and the temporal that he wishes to convey. An example is **Jacob's Ladder – Vision of Unity** (Figure 39). In this painting there is a contrast between the rather stiff, wooden figure at the bottom and the curved, relaxed one above.

Emma Spencer, discussing Reilly's position in Christian art, links him particularly with the iconic tradition of the Orthodox Church, for whom icons are not so much educative tools as windows into eternity. She also discusses his relationship to painters of the Renaissance. Like them Reilly is concerned with particular biblical scenes, but he does not want to represent people or events as they are seen with the visible eye. In relation to developments in twentieth-century art she suggests he has some affinity with the multiple views of cubism, which can indicate other dimensions. She also sees him in relation to fauvism, with its free vivid colours representing a personal vision rather than what the physical eye registers. She suggests that these developments have freed Reilly to produce a biblically based art appropriate to our time.[12]

The strengths of Reilly's works are clear. They are accessible, they are appealing and they convey a strong spiritual feeling that is fully integrated with the forms he uses. He has used the developments of twentieth-century art to bring fresh life to old images, and done so in a style which is unmistakably his. Having found his artistic voice, he used it in a consistent and effective way.

[12] Emma Spencer, 'Tradition and innovation in Christian Art', in Reilly, *The Painted Word*, p.111 ff.

Figure 40 John Reilly, Crucifixion (2)

If we have doubts, it is in the downside of his very strengths. From a theological point of view his desire to give a universal meaning to the biblical scenes, to see them as a way into a spiritual world which we can experience now, tends towards a Platonic vision rather than an incarnational one. As indicated in the discussion of Collins in an earlier chapter, Platonism has for most of Christian history been a good friend and ally of the Christian faith. However, the Christian faith also claims that God is not just the Eternal now, but has become a particular now. The icons of the Orthodox Church also seek to take us in and through the particular now of a biblical person or scene into that Eternal now, but they never lose sight of the fact that this is done in and through the particularity of time and place made manifest in Jesus. In contrast to this, Reilly depicts the biblical scenes more as launching platforms out of the particular into the eternal.

The second doubt, one linked to the previous point, is the way everything in a scene is taken up into a design of harmony and elegance. This is revealed artistically in the way his paintings are geometrically driven. It is noticeable that the suffering of Jesus on the cross is never a focus in Reilly's paintings. This is a stark contrast with almost every other artist painting Christian themes in the twentieth century for whom it was the suffering of Christ above all that resonated with the terrible events in the world. In one respect his difference of approach is to be much welcomed. **Crucifixion (2)** is a rare example of a painting in which the crucifixion and resurrection of Christ

are seen as part of one saving event, as they were in the fourth century – and this is its strength (Figure 40). There is no stress on the suffering of Christ in itself. Instead Jesus appears almost dancing off the cross into the resurrection, which itself raises the world into the dance of new life.

This perspective offers a startlingly different focus from that of the suffering and anguish depicted, for example, by Grünewald in his Isenheim Altarpiece at Colmar. The reconciled, harmonious element is also particularly apparent in Reilly's <u>Resurrection</u>. The dominant motif in both this and the crucifixion is the circle of eternal light into which we are taken up in Christ. This is an abiding truth of the Christian faith; but that truth needs to sit alongside the brutal cruelty of so much human life, an agony which God has taken into himself in the cross of Christ.

During this period there were quite a number of artists who at one time or another worked on Christian themes. Amongst them was **Enzo Plazzotta** (1921–81), who was born near Venice but spent most of his working life in London. He made his living mainly by making bronzes of horses. Many of his sculptures of attractive moving figures appear on the streets of London. He also worked with Christian themes. A fine example is <u>Crucifixion</u> (1974) made for the Anglican Order of <u>Franciscans</u>. This is unusual in that it shows Christ in intimate physical contact with the bandits on either side in such a way that his arms on the cross bear up their bodies as well. The grace of this gesture well indicates a theological truth. In contrast to Plazzotta, **John Hayward** (1929–2000) was much in demand for commissions and had more than 230 windows or church interiors to his credit. Two of note are <u>The Baptism of Christ</u> and <u>Jacob's Ladder</u>. **Hans Feibusch** (1898–1998) was also in demand for church commissions. He had made his name as an artist in Germany before World War II, and was exhibited in the 1937 'Degenerate Art' exhibition put on by the Nazis. He fled to England, converted to Christianity and, as mentioned earlier, was befriended by Bishop Bell, who commissioned him to do a mural on the theme of the Baptism of Christ for Chichester Cathedral. He received many commissions in his life for civic as well as church work, for which he used a mainly naturalistic style, as in the chalk drawing <u>Christ Nailed to the Cross</u>. He reconverted to Judaism before his death, which was just short of his 100th birthday. By way of contrast **Kyffin Williams** (1918–2006), who was regarded as the foremost painter of Wales of the twentieth century, was not commissioned to do any work for churches. He studied at the Slade and then taught at Highgate School for many years. He came from Anglesey and lived there for much of his life. He was predominantly a painter of Welsh coastal scenes, mountains and landscape. However, he did paint a few biblical stories, which very much rely on Renaissance prototypes, such as <u>Christ on the Cross, Christ being taken down from the cross</u> and <u>Christ being lowered into the grave</u>.

Hilsdegart Nicholas

Hilsdegart Nicholas (1913–95) was Swedish by birth and trained as a designer. She lived in Oxford and was married to the Principal of Brasenose College. A visit to Ravenna in mid life inspired her to make mosaics. She produced a number of miniature mosaics, each hardly more than 2 feet long and a foot high, made up of many thousands of tiny pieces of splintered glass. However, she received two commissions for larger works, which are very fine. For the <u>chapel of the John Radcliffe Hospital in Oxford</u> she produced a deceptively simple **Mosaic Cross** (Figure 41). The central, irregular cross in brown has all the fragility of a thin piece of wood. But it is enclosed in a much wider, richer cross of gold. The whole piece is held together in a circle that, though partly broken, is at once an all-embracing love and a divine mandorla. Two small squares of red at the end of the arms of the cross indicate the cost of the cross, the wounds still to be seen on the risen

Figure 41
Hilsdegart Nicholas,
Mosaic Cross, chapel
of the John Radcliffe
Hospital, Oxford

Figure 42
Hilsdegart Nicholas,
The Prodigal, chapel of
Bournemouth General
Hospital

body of Christ. The way it uses a simple, familiar image to disclose so much spiritual truth, without being forced or banal, is a remarkable accomplishment. The technique is in the best sixth-century Ravenna style, so that the irregular tesserae of the mosaics glitter with life, rather than seeming dull and flat as in too many Victorian mosaics.

Nicholas also made a version of **The Prodigal**, for the chapel of Bournemouth General Hospital, which again is both accessible in its iconography and fresh in its approach (Figure 42). The father embracing the son could be a human father and son looked at from above. In fact what the mosaic, with its background of blue sky colours, suggests is a heavenly father embracing prodigal humanity. The father has a tender smile which avoids being sentimental, and the son is totally given up into the enclosing arms of the heavenly father.

Albert Herbert

When Albert Herbert (1925–2008) was Principal Lecturer at St Martin's School of Art in the 1960s and 1970s he gave up painting in a representational way for a period, repressing his drive to make images that tell stories. However, finding abstraction too restrictive, he eventually found a way back to figurative painting through looking at children's art and making primitive, illustrative etchings. Most of these paintings have a strong religious theme. Herbert had no prior religious education or interest in religion, but this spiritual dimension emerged in adult life, and he was received into the Roman Catholic Church in 1958. Over his last five decades Herbert consistently painted surprising and dream-like images that are the product of an unusual and highly individual imagination. His seemingly naïve yet sophisticated paintings were the result of his lifelong journey exploring 'what lies beneath the surface of the mind' as he put it. He was on a lifelong search for 'the marvellous' which began with a youthful encounter with surrealism.

Recognised as an artist with a powerful and original poetic vision, Albert Herbert is of particular relevance to the theme of this book. First of all, as an artist and art lecturer in the last half of the twentieth century, he found himself in the midst of radical and rapidly changing artistic fashions. Finding himself out of sympathy with the prevailing styles, he struggled long to find his own visual voice. Secondly, discovering that he was by nature religious, a fact he could not do anything about, he also wrestled with how to express his religious vision; and the two struggles fused into one. Although he was friends with the fashionable avant-garde of the time, he knew himself to be an outsider. However, he was early championed by Sister Wendy Beckett, who regarded him as the most significant religious artist of the time.

Herbert was born in Bow and brought up in Forest Gate in a very modest home with no cultural hinterland. When he left school he worked for a picture library and read a magazine on surrealist art, which affected him deeply. It came as a revelation to him that 'art was about revealing the marvellous'. Always a compulsive drawer, he attended evening classes at St Martin's, and 'totally fell in love with art and wanted to study full time, which seemed then quite impossible'.

This sense of the marvellous never left him. In **Nativity with Burning Bush**, 1991 (Figure 43), there is the burning bush through which Moses heard the voice of God and before which he took off his shoes in awe (Exodus 3:1–6). In the traditional iconography of the Orthodox Church, as seen for example in St Catherine's monastery in Sinai, the bush is a sign of the Virgin Mary with the Christ Child at her chest facing frontally (Our Lady of the Sign). In Herbert's painting the Virgin is standing apart from the bush holding the Christ Child, whilst an old man kneels. It could be Moses, or any man. The painting conveys a strong sense of wonder and awe, leading to a profound humility.

Figure 43 Albert Herbert, Nativity with Burning Bush

In 1943, at the age of 18, Herbert was called up. He took part in the second wave of the Normandy landings and the advance afterwards, during which three-quarters of his regiment were killed or wounded. This period is reflected in some later paintings such as <u>He Remembers Himself as a Soldier Aged 18</u> (2003). After the war a series of scholarships enabled him to study art, eventually taking him to the Royal College of Art, where his contemporaries like John Bratby were realists of the 'kitchen sink' school. Herbert found he was looking for something more subjective, art with more emotional significance, and he saw something of what he was looking for in the work of Francis Bacon. When he exhibited with the realists a critic said of his work that it was 'like a John the Baptist crying in the wilderness'.

Herbert held teaching jobs at Leicester and Birmingham art colleges, and then at St Martin's, where for a number of years he was senior lecturer. However, during this time American abstract art became all the rage for his students. Feeling himself old-fashioned and outdated, it was a difficult time for him. Herbert threw himself into modernism, producing paintings such as <u>Wasteland</u> (1960) and <u>Thames</u> (1960), which are in fact evocative and successful images in an abstract style. However, he found this style was not for him. As mentioned, he decided to try to find his way back into figurative painting through etching. 'I used to creep down to the etching room in the basement of St Martin's and work at these little prints, literary, illustrative, with bits of theology hiding behind childish jokes; all the opposite of what my modernist colleagues were teaching on

Figure 44 Albert Herbert, Jonah and the Whale

the top floor.' Eventually he learnt to draw again by looking at children's drawings and this led him to 'drawing what I felt and knew rather than what it looked like'.[13]

One of the persistent images in Herbert's painting is the story of Jonah and the Whale. He painted aspects of this story from 1985 to 1989. It was a theme which had a very personal meaning for him. He had run away from his true calling and then been swallowed by the whale of modernism. However, the whale had spewed him up on the shore of figurative painting, his true calling. In **Jonah and the Whale** (1987) we see him about to be put back on land with a friendly woman there to welcome him (Figure 44).

Studying in Rome, Herbert found himself attracted to Roman Catholicism and he became a Catholic, though not an uncritical one. He simply found himself religious, unable to resist the impulse. 'At a certain age you realise what you are and there is nothing you can do about it … I just am religious. It is not rational but if I try to reject or repress it, I have a sense of loss.'[14] This Catholicism was far from narrow, however, and a visit to a Zen monastery in South Korea gave him a feel for Buddhism as well. This inclusive religious faith is beautifully conveyed in such paintings as Seeking Treasure Blindfold (1999), She Finds Hidden Treasure (1999), Within

13 Albert Herbert, *Recent Paintings*, England & Co., 1994, p.3.
14 Albert Herbert, *Retrospective*, England & Co., 1999, p.8.

Figure 45 Albert Herbert, Presentation in the Temple, II

Everything (1998), The Interior Journey (1963), The Temple (1964) and The Marvellous House (1962), whose titles speak for themselves of an awesome mystery in all things which is there for us to seek out and explore.

Notwithstanding this wider understanding of religion, Herbert needed and used biblical images because this was the way above all that he could get away from art simply as a form of private self-expression. He believed biblical stories have a wide, potentially universal resonance. However, his interest in Buddhism and indeed other archetypal images, such as the goddess figure, gave him a profound sense of the inner life and the religious quest as a whole, which fused happily with his use of biblical images. At the same time, such was his unerring sense of colour, it has been well said that his paintings can work at the abstract level alone, even without any religious connotations.

When he first found his true vocation and style as an artist he began a series of Stations of the Cross for an Anglican church, but had to abandon them when they were rejected as too disturbing. Apparently they hang today in a private chapel in London. However, championed by his gallery, England and Co., Herbert continued producing work well described as magical realism.[15] The paintings became increasingly colourful and enigmatic. 'Art is not about meaning but about

[15] The best introduction to the works of Herbert are the catalogues for the exhibitions of his paintings mounted by England & Co.

Figure 46 Albert Herbert, Elijah Fed by a Raven in the Desert

feelings', as he said. Familiar biblical stories, painted in his unique style, came to be his distinctive and distinguishing feature. This is seen in such paintings as <u>The Feeding of the Five Thousand</u> (1996–98), <u>Jesus Stripped of his Garments</u> (1987), <u>Jesus Sleeps through the Storm</u> (1994), <u>Sermon on the Mount</u> (1996) and **Presentation in the Temple, II** (1994).

Presentation in the Temple II is an interesting example of how Herbert brought together his wider interest in religions such as Buddhism with a biblical image, whilst at the same time drawing on details of earlier Christian iconography (Figure 45). In this painting, for example, the house with 'Deus, Deus, Deus' written round the door evokes something of the buildings he painted in his Buddhist phase. The curtains, one closed, one slightly open, convey the sense of a mystery still to be penetrated. In earlier Christian iconography – for example the sixth-century mosaic of the Emperor Justinian, his wife Theodora and their retinue in St Vitale, Ravenna – there is also a curtain half drawn, indicating the mystery behind, beyond and within things. Mary, in Herbert's painting, is about to enter not just the physical temple but the mystery of God. However, she does not look at the entrance, but at the dog in the corner of the painting – an enigmatic touch that leaves us guessing at its meaning.

Albert Herbert was one of those people who after going through a dark wood for much of his life found his style and himself to enter a productive and happy final period. This is reflected in

such paintings as <u>Coming Home</u> (1998) and <u>Crossing the Water to the Promised Land</u> (1992–94), whose titles again speak for themselves.

Some of his last paintings, such as <u>Garden</u> (2001) and <u>Clock</u> (2008), were of women set in idyllic gardens and perhaps looking out of a window. They are inscribed with the words 'Made for joy and woe', a reference to William Blake – his favourite artist.

Elijah being fed by a raven was another familiar theme for Herbert, and it is a helpful one in which to focus his whole approach to religious art. Once again he draws on traditional iconography, for an icon on this theme is familiar in the Orthodox Church, and the image, in both West and East, has been taken as a sign of the Eucharist, the heavenly bread with which Christians are fed. In the painting **Elijah Fed by a Raven in the Desert** (1992/94) Elijah is no fierce ascetic – just an ordinary, plumpish, bald and vulnerable middle-aged man (Figure 46). Forbidding clouds hang overhead but the bright house of God is on the horizon, which is also lined with light. The raven brings divine sustenance to help the man through. Meanwhile a coiled worm looks on with an enigmatic look as though to suggest, yes, life is serious and life is full of foreboding, but the man should not take himself too seriously. There is still a proper playfulness about things, as there is in children's art.

Norman Adams

Norman Adams (1927–2005) was born into a working-class family in Walthamstow and, despite his father's opposition, developed from the age of six a passionate desire to be an artist. He won a scholarship to the Harrow School of Art when he was 13, but at 18 further progress was interrupted when he was called up to do National Service. Under the strong political influence of Anna Butts, a fellow student whom he married, he registered as a conscientious objector. After some time in jail he was sent to work on a farm. His drawings from this period, for example <u>Gates of Paradise</u> (1947), reveal a strong sense of sympathy for suffering humanity, as well as the influence of the German expressionists and James Ensor: 'I grew up beginning to associate art and religious and political thinking as one big thing that had to be dealt with as a whole.'[16] At this time he had the support of the communist art critic John Berger until, as Adams put it, 'the religious thing kicked in'. After his time on the farm he went to the Royal College of Art, where he was a prize winner. For most of his career Adams combined teaching with painting, obtaining a number of prestigious posts, including being Keeper of the Royal Academy.

His time at the College was followed by recognition of his work in a prestigious 'Young Contemporaries' exhibition, and commissions to paint large murals and sets for operas. However before long he made one of the most important decisions of his life, to move to Yorkshire, high in the Pennines. It was here that he really discovered colour, though much later in life, when pursuing the Van Gogh trail, he did discover some even more vivid reds and blues in France. Colour was fundamental to his art and it was through colour in all its shades and forms that he pursued his vision. John Ruskin wrote: 'If the artist has to choose between form and colour-go for colour.' Adams could be said to have followed that advice, though for him there was no final tension in the achieved balance of colour and form. A further momentous decision was made when he and his wife first stayed in and then purchased a croft on the isolated island of Scarp in the Outer Hebrides. Many of his paintings are based on these landscapes and seascapes, examples being <u>Trees in Snow</u>

[16] Nicholas Usherwood, *Norman Adams: Memorial Exhibition: Paintings and Watercolours 1952–2000*, 108 Fine Art, 2006, p.14.

(1956), <u>Stormy Weather, Sgaresta, West Harris (</u>1965), <u>Evening Study from Scarp</u> (1970) and <u>Mist in the Sound</u> (1971). Although his paintings went through several different phases, they all had behind them both the Yorkshire Dales and the skies and seas of the Outer Hebrides.[17]

These paintings from Scarp and the Pennines are deceptively simply. Certainly they can make an immediate appeal. But Anna, his wife, spoke of the long, complex process from which they emerged. They are works of great compression, indeed they are almost minimalist; but Anna recorded that they sometimes went through as many as 18 versions.

Although Adams sometimes felt that his career had suffered by moving away from the London art scene, he also knew that nature was absolutely fundamental to his vision. He needed to be in isolated places like the Outer Hebrides. Yet he was not a nature artist in any simple sense. It was nature that allowed his imagination to take off. In 1970 he wrote: 'My favourite artist (indeed my favourite man) has always been William Blake, and he, of all people, has had most influence on me, except in his opinion of nature, and I don't believe him when he says, 'nature always dried up the imagination in him'.' Unlike Blake, it was nature that set his imagination going. Although a city dweller for much of his life because of his teaching commitments, Adams seems to have connected the countryside with spiritual inspiration, claiming that city artists 'lose their heritage and are spiritually emasculated'.

Art for him was a work of the imagination, so when in 1970 he did a large commission based on Bunyan's *Pilgrim's Progress* for St Anselm's, Kennington, he did not try to depict the scenes in any obvious sense. He allowed the story to fire his imagination. These murals tell the story of a journey from the wilderness of this world through to paradise via the slough of despond and death, mainly through the use of rich and contrasting colours. After the place of deliverance the pilgrim meets Apollyon, the master of this world, and, after sustaining injuries, defeats him.

The Lent and Holy Week devotion, the Stations of the Cross, originated with the Franciscans and was rooted in the Via Crucis in Jerusalem which was first walked in the thirteenth century. The number of stations stabilised as 14 in the seventeenth century and was adopted in all Catholic churches in eighteenth century. Adams worked with his wife, a ceramic artist, to produce a set of stations for the Church of Our Lady, Milton Keynes in 1974/75. He said he tried to:

> make them simple and intimate – passionate and unthreatening. Small in scale and placed at eye level on the wall, I hope the viewer will find him or herself taken into the drama and able to identify with the main characters.

As well as the Stations, Adams and his wife also produced a version of the resurrection as an altarpiece.

In 1993 Canon Denis Clinch of St Mary's, Mulberry Street in Manchester asked Sister Wendy Beckett to recommend an artist for a commission in his church. She submitted a list and he chose Norman Adams, who produced another set of **Stations of the Cross** (Figure 47). He regarded this as the greatest work of his life. The stations are indeed profoundly moving in their sense of suffering and compassion. The cumulative effect of the stations is almost overpowering in its consciousness of agony. Then in the last one, there is a remarkable shift in consciousness. What is seen appears to be a garden with flowers growing in it. Yet what it conveys is a sense of undying life, of resurrection.

[17] There is an excellent website for Norman Adams on which can be seen a large number of his paintings, including the religious commissions: http://www.normanadamsra.co.uk. Full-page reproductions of the Manchester Stations of the Cross, together with essays by Norman Adams, his wife Anna and Sister Wendy Beckett, are published by St Mary's, Mulberry Street, Manchester, 1995.

Figure 47
Norman Adams, Stations of the Cross:
Station 10 – Jesus is Stripped of his
Garments, St Mary's, Manchester

Towards the end of Adams's life his work, at least from a spiritual point of view, came to its consummation in his large watercolours. He described himself as a 'compulsive believer', but one who looked to religion to give him inspiration rather than instruction. This move away from oil to watercolour was largely forced on him by the progress of his Parkinson's disease. But it had the effect of bringing out even more strongly his spiritual vision. This vision was influenced not just by Blake, as mentioned, but also by Grünewald's Isenheim Altarpiece and Giotto's Scrovegni Chapel in Padua.

The emergence of 'Brit Art' left Adams feeling rejected. Indeed when a Saatchi-inspired exhibition appeared in 1997 under the title 'Sensation' he exploded with the words 'Art is about anything *but* sensation.' Earlier in life he had experienced a moment of revelation when looking at a butterfly. He realised that the beauty of the butterfly existed just for its own sake, and it gave him an abiding sense that whatever else might be seen in a picture, beauty needed to be part of it. He denied that his paintings were abstract. He saw them in terms of the human journey, that journey with its joy and suffering being conveyed through forms of colour. He needed nature to inspire him, but what it inspired was this search for form through colour. However, these forms were not for their own sake. 'Subject has always been most important', he wrote. 'I cannot start a painting until I am driven by an almost moralistic idea. Of course the idea-subject-and form must match perfectly – becoming a homogeneous root.'[18] 'The thorough integration of the forces of the medium – pigment, texture, light, colour – and the forces of nature – emotion, drama, the joy and the sorrow and to find precise equivalents in the former for aspects of the latter has been a major

[18] Usherwood, *Adams*, p.23.

task.'[19] He did a number of major religious commissions, and his exhibition in Bradford in the 1960s had an introduction to the catalogue that refers to his mystical and religious works of the time as being without parallel in the twentieth century.

Nativity provides an arresting perspective on the birth of Jesus, as it were looking down upon it through a flight of angels (Figure 48). It has a joyous cosmic dimension to it. It is not just the birth of any child, but an event that radiates out and sets worlds seen and unseen dancing in joyful circular movement.

Adams was brought up in a household with no religious belief and the religious paintings in his grandparents' house struck him as being about death and were something he feared. The religion he found his way into though art was a religion of life. This was a religion in which the aesthetic and the religious, and indeed all life, was one. As he said in an interview in 1978:

> I discovered art before I discovered religion ... what art – and I include music as well as painting – did for me was to open a new way. It showed that religion was not all about death, but about life. I think art is about life – about people – about living.[20]

Figure 48 Norman Adams, Nativity

Again, as he put it:

[19] Usherwood, Adams, p.85.
[20] Ibid., p. 12.

The religious subject matter of many of my paintings is rarely a statement of faith. It is nearly always a formal questioning. All my work evolves from a kind of puzzlement, excitement, and – at best – love. It is fed by the arts and nature. I believe that the best of man is in the arts; they are the best reason for optimism.[21]

Again after suggesting that all the arts have a message, one which is conveyed in part by the great religions of the world, he adds:

Please don't ask me what the message is. I don't think it is given to artists to know what the message is. I believe the artist is essentially the doer, the maker. He merely carries out, affectionately, the orders that are passed on to him and he doesn't ask any questions.[22]

His paintings convey life and joy. But they are far from sentimental; and, as A.S. Byatt emphasises, the dark side of life is integral to them:

Figure 49 Norman Adams, The Golden Crucifixion

[21] Ibid., p.58.
[22] Ibid., p.89.

They are Blake's Songs of Experience combined with, or masquerading as, the Songs of Innocence. He disliked being compared with Cecil Collins, and with reason – his gaze was altogether harder and grimmer. There is no sentiment in his world.[23]

The critic Peter Fuller saw a great sadness running through much of the work, though he, like others, thinks that Adams does in the end give a message of hope and promise. Adams felt his paintings had a strong message even though he could not say what that message was. To so many who admire his paintings, that message was about something more to life than that which we normally apprehend, something beyond the senses. Indeed Adams did from time to time understand his work as a painter in those terms. He said that a diving gannet revealed another world beyond it: 'I am constantly being made aware of things that I can't pick up with my senses.' In painting or drawing one is 'constantly, imaginatively, trying to pick up things beyond one's actual comprehension'.[24] The only way he could indicate what this might be like was to suggest the analogy of sound. There is, he said, a sound in his paintings. For him this sound was one that was originally inspired by the sound of the wind and waves of the Outer Hebrides. The vicar who took the funeral for Norman Adams reported that in an earlier conversation when he had asked if he knew what heaven looked like, he received the reply 'No. But I know how it sounds. It is like a movement of a Mahler Symphony.'[25] Sister Wendy Beckett sums up the effect of his work well when she writes: 'Norman communicates by colour, creating an atmosphere far more profound and spiritual than any more explicit iconography can command.'[26]

The Golden Crucifixion (1993) does not lose sight of the sadness and suffering of the world (Figure 49). A woman is kneeling with her head in her hands. Another woman is stretching out her arms beseeching. Soldiers in tin helmets huddle together plotting. There are patches of darkness in the painting, including on the wings of the butterflies and on Christ himself pinned to the cross. Yet the dominant effect is of butterflies opening their wings to fly. The crucified one is being raised into new life. In a world so dominated by tragedy, tragedy reflected in so much art, this is one of the most genuinely hopeful icons of our time. Not in the least sentimental, its beauty is not decorative but redemptive.

23 A.S. Byatt, ibid., p.6.
24 Usherwood, *Adams*, p.37.
25 Ibid., p.78.
26 Ibid., p.75.

Chapter 7
A Vibrant Contemporary Scene

This chapter is concerned with artists who are still alive, and whose work relates fairly directly to Christian iconography. This means that I am not considering here a number of artists whose work is recognised has having a spiritual dimension or which sometimes has visual echoes of Christian themes. I think of Anselm Kiefer, whose work, despite focussing on the destruction of Germany, often has a mystical feel to it; Anthony Gormley, whose work has been shown in cathedrals, and Mark Wallinger, whose work, like that of Gormley, might be categorised as the expression of a spiritual humanism. I think also of Bill Viola, whose work, like that of Damien Hurst and Chris Ofili, sometimes makes verbal or visual reference to particular Christian subjects. Some of this work I greatly admire but it is outside the particular focus of this book. I will be considering a number of artists, some well known, others not, who focus more specifically on Christian themes. I am conscious of others, whose work I respond to but whom I have not been able to include for reasons of space

Fenwick Lawson

Fenwick Lawson (1932–) was born and brought up in County Durham. He studied at the Royal College of Art and was influenced by Epstein. He became head of sculpture at Newcastle upon Tyne College of Art (later the Polytechnic, where he also became Principal). More than 50 works of Lawson have been commissioned, almost all in the north-east of England, with the majority of them being situated in churches. Lawson, who works in wood, leaving much of the surface rough, conveys a strong sense of emotion in his sculpture. In this way he can be said to stand in the tradition of German expressionism as represented by someone like Ernst Barlach (1870–1938), who also worked in wood but most of whose art was destroyed by Hitler. Good examples of Lawson's work are Cuthbert of Farne (1984) in the Durham Heritage Centre, The Risen Christ (1968) in St Paul's, Jarrow, and The Journey. This depicts the body of St Cuthbert being carried by monks from its original burial place on Holy Island (Lindisfarne). In 875, because of fear of a Viking invasion, the body was taken from there to various places, eventually ending up in Durham. The original, carved from seven elm trees in 1999, is on Lindisfarne. A bronze was made from this, which now stands in Millennium Square in Durham, where it was unveiled in 2008. His **Pietà** (1981) in Durham Cathedral is particularly fine. Unlike the traditional depiction of this scene, in which Mary cradles the dead body of Jesus on her lap, here the body is on the ground, utterly stricken, and Mary is looking down in great sorrow (Figure 50).

Lawson's early training gave him a feel for the symmetry of classical art, but he was released from a narrow understanding of realism into a freedom beyond this by a love of mediaeval sculpture. A defining moment for him was the famous photo of a child fleeing from a napalm attack during the Vietnam War. He felt that a composer would respond with a requiem. How could he respond in wood? I first saw the Pietà in York some 25 years ago and was deeply affected by it. I was not surprised to learn later that the work had cost him a great deal. Begun in 1974, the artist came to a point where he felt he could not go on because of a sense of personal inadequacy in

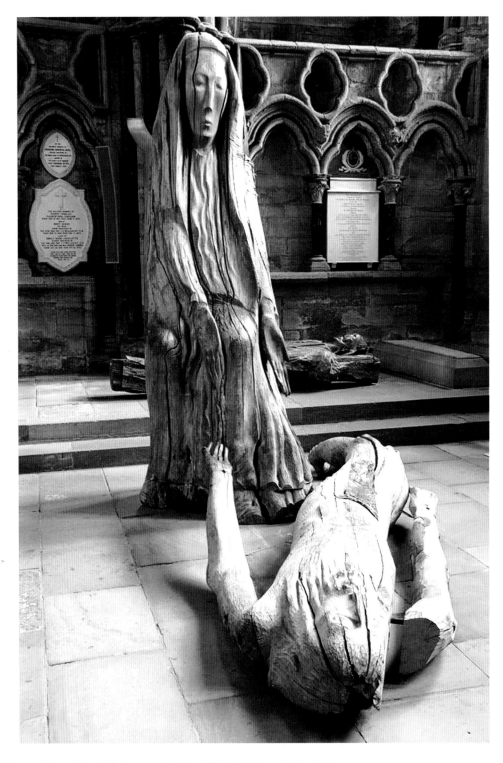

Figure 50 Fenwick Lawson, Pietà, 1981, Durham Cathedral

trying to convey the great theme he had in mind.[1] Then several years later he returned to the work and experienced a sudden release through an awakening of a sense of Mary as the universal mother and himself as a child, rooted in Christ's words to Mary on the cross. After that he had a sense that he no longer controlled the work: 'I was being taught – it was speaking to me, tumbling into being, revealing itself.' The beech of which the work is made split across Mary's face, but the artist decided to leave the crack as it was. This, together with damage done to the work in Durham by a sudden wind, and in York by fire, has only added to what Lawson describes as the mystery of the work. This is a mystery which tries to convey a 'message of suffering and hope which is uniquely expressed in the form of the crucified and risen Christ and the Mother who watches over him'.

Peter Ball

Peter Ball (1943–) was born and brought up in Coventry, where he was much influenced by teachers at his local school. He trained at Coventry School of Art and has worked full time as a sculptor since 1968. His secular work has often been described as witty, and he usually begins this, as he does his religious commissions, with a piece of driftwood. Peter Ball must be the most commissioned of all contemporary artists working on religious themes, with over 60 of his works in churches or cathedrals. This popularity is partly related to that fact that he seeks to be sensitive to the setting and purpose of a work of art in a religious space, and has said that a work in a church setting 'has to be a devotional object not an architectural set piece'. An exhibition of his in Salisbury Cathedral which was highly popular brought forth the response: 'Ball himself claims that he is not a believer yet he is able to evoke within his pieces aspects of the Christian story that resonated with a wide number of people.'[2]

The first word that comes to mind on seeing one of Ball's sculptures is 'Romanesque'. But this word, though apt, should not mislead us into thinking that he is simply imitating some past style. Pamela Tudor Craig, after describing the driftwood and copper plate materials of his work writes, 'So his Christus has, in the nature of its composition, the battle-scarred endurance of a time-worn Romanesque Christus.' However, as she continues:

> The large eyed narrow bearded heads of Romanesque art come naturally to Peter Ball. He is not the heir of the comely Gothic but of the tormented prophets of Souillac, or even further back, of Celtic spirit figures. His way of seeing is most suited, perhaps, to commissions for the Hanging Rood, or for a gaunt Pietà, but there is a tenderness in his treatment of the Nativity and in his Madonnas he can suggest something of the mystery that hedges about, for instance, the Holy Virgin of Rocamadour. But this sculptor is in no way a pasticheur of the Age of Faith. He has none of the subservience that would imply. His visual quotations are made with panache.[3]

Of particular note are <u>Christus from the Flames</u>, Cotgrave (1998), <u>Christus Rex</u>, Southwell Minster (1987) and, because of its unusual, witty character, <u>Hope, St Martha the Housewife</u>, Broxtow, Nottingham (1997). Winchester Cathedral, in addition to the **Pietà**, 1990 (Figure 51),

[1] This and the rest of the paragraph are drawn from Tina Beattie in an interview with the artist printed in *Art and Christianity* 57, Spring 2009.

[2] Mark Bonney, *Art and Christianity* 60, Winter 2009.

[3] Pamela Tudor Craig (Lady Wedgwood) and Richard Davey, *Icons of the Invisible God: Selected Sculptures of Peter Eugene Ball*, Chevron, 1999, p.8.

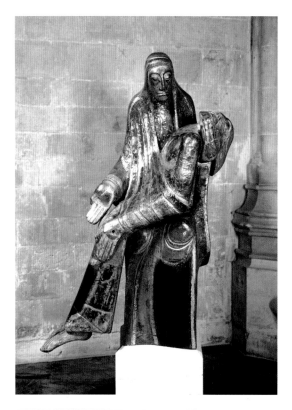

Figure 51
Peter Ball, Pietà, Winchester Cathedral

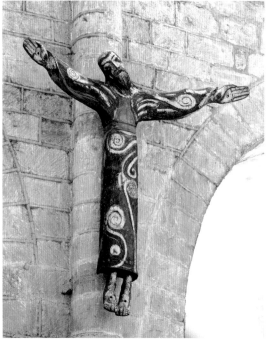

Figure 52
Peter Ball, Crucifix, Winchester
Cathedral

has commissioned two pieces from Ball, <u>Virgin and Child</u> and a **Crucifix**, 1990 (Figure 52). The former not only expresses the sorrow and tenderness of Mary in a palpable way, but also shows her with an open palm and outstretched arm, as though offering her son's sacrifice to the world.

The latter work is called Crucifix but it might just as truly be called the Risen Christ, or even The Risen, Ascended, Glorified Christ. For there is no wooden cross, and though the arms are outstretched as they might have been on a cross, in fact the arms convey embrace and welcome. The sculpture wears a heavenly robe of golden Celtic spirals. The total effect is less one of sorrow than of a love that holds us in an eternal embrace and which will prevail over all that drags the world down.

Anthony Caro

Sir Anthony Caro, OM (1924–) originally read engineering at Cambridge but after war service studied art at Regent Street Polytechnic and the Slade. For a period he worked under Henry Moore; however, he reacted against the smoother surface of Moore's sculpture. He developed the technique of dropping a lump of clay from a height and then working with the forms suggested. This resulted in expressive works like <u>Woman Waking Up</u> (1955), now in the Tate, with another version in the Hepworth Wakefield. However, a visit to America brought about a radical shift in his approach to art and he started to work first with steel and then with a variety of materials, including industrial waste, to produce non-figurate sculpture. He has said that his work is to be seen rather than felt, and sometimes it is painted. Frances Spalding has written:

> As his control of this new language developed, Caro, in his relating of the parts to the whole, brought to his work a fine control of phase, interval and melodic line, often creating effects of surprising lyricism and casual grace. Mood is heightened by colour … this further unified the work.[4]

From 1987 to 1990 he worked on large sculptures stimulated by Rembrandt's 'Descent from the Cross' in the Alte Pinakothek in Munich, as well as a Descent by Rubens. His <u>The Last Judgement</u> (1995–99) was presented at the Venice Biennale. It represented Caro's response to the atrocities of World War II.

Badly damaged in World War II, the church of St Jean Baptiste at Bourbourg, some 20 miles from Calais, had remained a ruin. However, the French equivalent of the Director of the Arts Council for northern France had seen Caro's 25-piece sculpture 'The Last Judgement' at the Venice Biennale and wanted him to produce a work of art in the then blocked-up chancel area. Caro was amazed that when he and the director saw this ruin together he was given complete freedom to do what he wanted. As the chancel was to be turned into a baptistery, a priest suggested the theme of water, and this is what Caro produced, **The Chapel of Light**, associating it also and naturally with the theme of creation. There is a separate abstract metal sculpture in each of the niches in the chancel area, with names like 'Waterfall'. The centre of the space contains an elegant pulpit and lectern in wood designed by Caro, from which people can read or speak (Figure 53).

Jewish by background, Caro does not like the connotations of the word religious. However, he has said that despite everything life is wonderful and he wanted to convey a celebratory mood. This is expressed, for example, in some representative work on animals in the piece. Caro has said that he loved the space and light of the building and he wanted to create a spiritual space for people

4 Frances Spalding, *British Art since 1900*, Thames & Hudson, 1992, p.207.

Figure 53
Anthony Caro, The Chapel of Light,
St Jean Baptiste, Bourbourg

Figure 54
Anthony Caro, Deposition,
Christ's College, Cambridge

whatever their beliefs. The work took some eight years to come to fruition, and posed both the major challenge and a consummation of Caro's distinguished career.[5]

In 1999 Caro was commissioned to produce a **Deposition** for the chapel of Christ's College, Cambridge (Figure 54). *i.e. Taking down of Jesus from the cross*

T.S. Eliot showed how in literature the most radically modern work can be produced by entering deeply into the tradition, indeed that it is only by entering into the tradition that one becomes fully sensitive to the newness of the present moment. Fenwick Lawson, Peter Ball and Anthony Caro exhibit the same truth in their sculpture. Each of them in their different ways are indebted to the work of the past, yet their sculpture is recognisably modern, in the case of Anthony Caro, radically so.

David Wynne

David Wynne (1962–) occupies a very different position in the artistic canon to that of Anthony Caro. Wynne's sculptures would be regarded as pleasing, rather than great art. They stand in public squares in London and other cities, and are much enjoyed by passers-by. He has a particular affinity with animals, and indeed read zoology at Cambridge before switching to sculpture. Although

[5] A very positive response to the work was given in an article by Tom Devonshire Jones in *Church Times*, 14 October 2008.

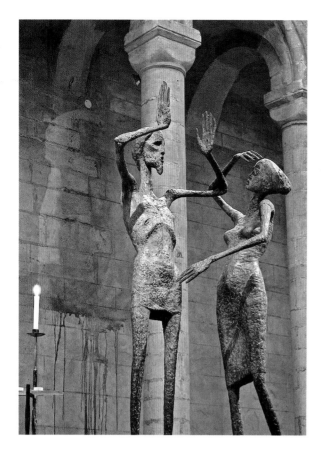

Figure 55
David Wynne, Mary Magdalene and
the Risen Christ, Ely Cathedral

primarily self-taught, he received much encouragement, as well as lessons, from Jacob Epstein. Wells and Ely Cathedrals contain examples of his work.

When I lived in Oxford I was much drawn to a small version of **Mary Magdalene and the Risen Christ** which now stands in a garden outside the chapel of Magdalene College, Oxford, and indeed used it on a TV film I made about modern works of art in Oxford. This work was donated to Magdalene in 1964 by an old student, although at that time it was on loan to Ely Cathedral. Another version was made and presented to Ely Cathedral in 1967, which is the one shown here (Figure 55). The Gospel scene, usually entitled Noli me tangere (Do not cling onto me), has inspired some wonderful paintings by the great masters. What is interesting about the version by David Wynne is that instead of focussing on Mary reaching out to hold onto Jesus, he has conveyed the movement implied in the subsequent words which Jesus said to her:

> Do not cling onto me for I have not yet ascended to the Father. But go to my brothers and tell them
> 'I am ascending to my Father and your Father, to my God and your God.' (John 20:17)

The thrust of the sculpture is vertical, with the hands of Jesus pointing upwards and with Mary lifting her face to look in the same direction. Jesus is ascending and it is as if Mary is ascending spiritually with him at the same moment. In the text the followers of Jesus are being addressed as brothers, and the emphasis on 'my' and 'your' suggests that they are being drawn into the same relationship with God that he himself eternally enjoys – one of intimacy and indwelling.

Figure 56
Shirazeh Houshiary,
East Window in St
Martin-in-the-Fields,
2008

Shirazeh Houshiary

Shirazeh Houshiary (1955–) was born in Shiraz but has lived and worked in UK since 1976. She trained at the Chelsea College of Art and her work appears in many major collections round the world. Her work draws on Sufi spirituality, particularly Persian mysticism.

The **East Window** in St Martin-in-the-Fields was commissioned as part of a major refurbishing programme by the then vicar, Nicholas Holtam, now Bishop of Salisbury. Deceptively simple, it is extraordinarily effective (Figure 56). Like Anthony Caro's work on religious themes, it is not purely abstract, and there are hints of Christian themes. For example, the lead lines of the window indicate a cross, whilst the central egg shape, which stretches the lines as though a birth is about to take place, suggests at once a body on the cross and new birth. As mentioned earlier, purely abstract art can work in a church or cathedral if situated appropriately, as is the case with the Sacrament Chapel in Liverpool's Roman Catholic Cathedral by Ceri Richards, and as will be seen in a work by Alison Watt, shortly to be discussed. But subtle suggestions of a traditional image not only make it easier for the average viewer to respond to; it is congruous with the fundamental Christian conviction that the Word has been made flesh. Laura Moffatt found this work 'oddly conservative' compared with the original design that was submitted, but agrees in the end that it is successful. She describes it as

'a quiet, egg-shaped form, expectant and almost prosaic, commanding the hearts and minds of the individuals who step in from Trafalgar Square for a moment of reflection and solace'.[6]

Alison Watt

Alison Watt (1965–) trained at the Glasgow School of Art and was the youngest artist to have had a solo exhibition at both the Scottish National Gallery and the National Gallery in London, where she was artist in residence from 2006 to 2008. She began as a figurate, in particular a portrait painter, but her work is now associated with studies of fabric. As has been written, 'These exquisite canvases edged towards the abstract yet had a strange quality which suggested human presence, or at least absence.'

Still (2004) was awarded the 2005 Art and Christianity Enquiry (ACE) award for commissioned artwork in ecclesiastical space (Figure 57). 'A presence at once given and denied' are words that Robert Pogue Harrison used of the Vietnam War Memorial in Washington DC. Richard Holloway finds them particularly apt for the Warriors' Chapel in Old St Paul's, Edinburgh, where Alison Watt's painting hangs. He describes how Alison Watt went into the chapel and was moved by its special atmosphere to paint 'Still' in response. He writes of the painting:

> It suggests the presence of a huge absence, the brimming over of a vast emptiness. It glimmers against the grey sorrow of the stone, but does not attempt to subdue it. And the Warriors' Chapel looks as if it has been waiting for it from the beginning.[7]

Figure 57
Alison Watt, Still, Old St Paul's, Edinburgh

6 Laura Moffatt on Shirazeh Houshiary, *Art and Christianity* 55, Autumn 2008.
7 Richard Holloway, *Leaving Alexandria*, Canongate, 2012, p.196.

Sophie Hacker

Sophie Hacker (1963–) produced a major work, 'Nine Panels in Response to Messiaen's *La Nativité du Seigneur*', for Winchester Cathedral in 2008. She listened to the Messiaen many times in a variety of recordings over the period of a year and produced nine works of art related to the life, and especially the nativity, of Christ. Each panel is 60 centimetres square. The works are low-relief sculpture, made mainly out of slats of wood, lead, wire and all manner of found objects, rather than stone. Sophie Hacker has a great love of these found objects and their possibilities as art.

Les Bergers (The Shepherds), on that theme, includes flattened bark, hand-made paper, hessian of different kinds, string and old leather. It has five thick strands of materials at a diagonal across the work, with their roots in the earth, against the background of a rising sun (Figure 58). Although Sophie Hacker sees herself as a sculptor, she trained at the Slade as an abstract painter, and one of the strengths of these works is the unity and interplay between the objects and the way they have been painted. Using acrylic, there is a powerful use of colour, which helps give each work both its unity and its distinctiveness.

Some of the works are very accessible, such as **Les Anges (The Angels)**, with its swirling shapes in different blues (Figure 59). As has been written about this, 'Soft textures evoke the surface of feathers. Shards of mirror reflect light over the image, as the main shape sweeps up like a swarm of starlings. Metallic leaf and iridescence bring even more glimmer. All this articulates the chattering, high notes of the music.'

Figure 58
Sophie Hacker,
Les Bergers (The
Shepherds)

Figure 59
Sophie Hacker,
Les Anges (The
Angels)

Other panels, such as <u>Jesus' Acceptance of Suffering</u>, require more attention before they make their impact. Dominating the piece is a rough piece of wood of interesting texture with subtle shapes in it, which emerges from a metallic background of brown with glints of gold.

Hacker's work is interesting in a number of ways. It shows the possibilities in the interaction of music and the visual arts. It is at the cutting edge of the modern in its use of found objects and its insistence on the abstract. It is unusual in that it brings together the sculptural and the painterly in a real unity in which both are equally important. Yet at the same time it succeeds in being accessible without being simplistic, and suggestive of Christian images without being over obvious.

Maggi Hambling

Maggi Hambling (1945–) studied at art schools in East Anglia, then at Camberwell and the Slade. She has become one of the best known of modern British painters, first of all for her portraits in an expressionist style of people such as Max Wall and George Melly, then for her controversial public sculpture, including the memorial to Benjamin Britten on the beach at Aldeburgh, of giant scallop shells. More recently she has turned to landscape and seascape in her native Suffolk. Every Good Friday she spends first reading the Gospels and then contemplating and painting the crucifixion. She began this discipline in 1986 partly as a tribute to her mother, who was then very frail. Brought up to go to church every Sunday, she says 'Consequently it is very difficult for me to think of

Figure 60
Maggi Hambling, Good
Friday, 2002

Figure 61
Maggi Hambling, Resurrection Spiri,
St Dunstan's, Mayfield.t

(several Mayfield ?)

anything else on Good Friday but the crucifixion. The mystery. The sacrifice. The simultaneous life and death, and vice versa.' She now describes herself as 'an optimistic doubter'.[8] These studies include Good Friday, 1991 in which the head of Christ is a different way round from the usual depiction. In this painting there is an ambiguity about whether Christ is alive, as expressed in the pink, or dead as indicated by the blue.

In her **Good Friday, 2002** what comes across is the terrible isolation and loneliness of the figures (Figure 60). The painting is dominated by the grey and white sky pouring down from above, out of which a small golden Christ emerges on a dark cross. This and the crosses of the two bandits, shadowy in the background, stand on a curved horizon which can be the hill of Golgotha, but which also conveys a global significance. By contrast, in Good Friday, 2007 the cross is high and lifted up for contemplation.

Hambling's studies of the crucifixion each year are all very different, but deeply felt and fresh. Some, reflecting a recent visit to the continent, are more traditional in image, others highly abstract.[9] She says that Good Friday brings out of herself some different image of Christ, which she cannot predict in advance. Maggie Hambling, like Anthony Caro, is an artist with a major reputation whose work is primarily on secular subjects. When she, like Caro, turns to a religious theme, she discovers new strengths which add considerably to contemporary insights into Christian themes.

Maggi Hambling's sculpture **Resurrection Spirit** was unveiled at St Dunstan's, Mayfield, in March 2013, where it hangs high above the central altar, well placed to be seen as people enter the church (Figure 61). For Maggi Hambling herself the work is very much about the human spirit able to soar. For others its angelic, bird-like quality might bring to mind the Holy Spirit. But it also has Johannine resonances. In St John's Gospel the cross, resurrection, ascension and coming of the Holy Spirit are all part of one movement to the Father, of one process of revealing the Divine Glory in Jesus. So the soaring upwards of the human spirit is taken up into that movement of the human to the divine made possible in Jesus, and through whom the Holy Spirit comes to us, making our glorification possible.

Helen Meyer

Helen Meyer (1929–) trained at Camberwell and Edinburgh Colleges of Art. Her favourite medium is wood but she also works in clay. In addition she paints landscapes and has produced a moving set of Stations of the Cross.

In John 13:23, when Christ says he would be betrayed by one of his disciples, we read:

> One of them, the disciple he loved, was reclining close besides Jesus. Simon Peter signalled to him to find out which one he meant. That disciple leaned back close to Jesus and asked 'Who is it?'

In **Christ and John the Beloved Disciple** Helen Meyer has beautifully captured the intimacy and poignancy of this scene (Figure 62).

In **Jesus in the Garden of Gethsemane** Helen Meyer has taken a different perspective on the scene from most traditional depictions, which on the whole show Jesus kneeling at some distance

[8] Andrew Lambirth, in *Cross Purposes*, ed. Nathaniel Hepburn, Mascalls Gallery, Ben Uri Art Gallery, London Jewish Museum, 2010, p.65.

[9] Maggi Hambling, *Good Friday: Paintings, Drawings and Sculpture 1965 to 1999*, Gainsborough's House Society, 2000, with essays by Andrew Lambirth and Tom Devonshire Jones.

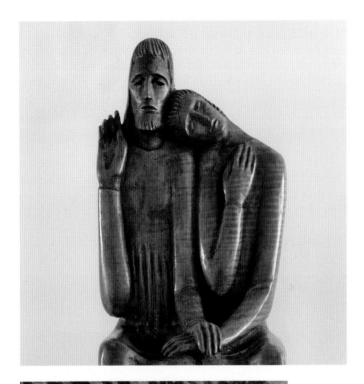

Figure 62
Helen Meyer, Christ and
John the Beloved Disciple

Figure 63
Helen Meyer, Jesus in the Garden of
Gethsemane

Figure 64 Helen Meyer, Stations of the Cross: Jesus Falls for the First Time

from the viewer (Figure 63). Here we are above him, able to see a face pleading with the father to take away the cup of suffering. That suffering threatens in the sheer black of the trees and the sharp spikes of its roots.

Helen Meyer was asked to produce a set of Stations of the Cross for All Saints', Fulham, one Holy Week, and these were subsequently the subject of a television programme in which I discussed their meaning with her. In this series she communicates a deep sense of sadness first of all through the use of colour. In **Jesus Falls for the First Time** the dark silhouette of the jagged hills against a deep red sky creates a sombre background, which is taken up in the foreground by the looming black cross and its shadow (Figure 64). This is further enhanced by the simple purple robe that Jesus is wearing. This sadness gains a particular poignancy in the gentle, submissive kneeling of Christ, and his vulnerability, as shown in the bare upturned feet, and the prominent white hands clasping the cross so carefully.

Helen Meyer said that when painting The Crucifixion as part of this series, the words of Simeon to Mary kept coming to mind: 'A sword shall pierce through thine own soul also' (Luke 2:35). Her brother was killed in France with a Highland regiment in 1944 when he was 22 and she was 14. The sense of loss has remained with her and surfaced strongly when she was painting this scene.[10]

Unlike some modern artists who have worked on Christian themes, whose work conveys the sense of violence and alienation which is so prominent a feature of the modern world, Helen Meyer's sculpture and painting is characterised by a deep sense of tenderness and pity. It is imbued with the same spirit of reverence before the human Christ that we see in the work of people like Duccio and Giotto.

Peter Howson

Peter Howson (1958–) was born in London but moved to Scotland at the age of four. He began as an infantry soldier in the Scottish Fusiliers but left to study at Glasgow College of Art. He has concentrated on tough, working-class figures and those on the edge of society. As well as being shown in major galleries, his work has been collected by celebrities. In 1993 he was an official war artist in Bosnia. After a long battle against abuse and addiction, as well as being diagnosed with Asperger's syndrome, he converted to the Christian faith in 2000. This faith is now reflected in some of his paintings. These works reflect both the violence of the world, as in Jesus Falls for a Second Time, and the possibility of compassion within it, as in Jesus Meets Mary, two of his paintings in a series of Stations of the Cross (2003). His painting Judas, 2002 shows Howson entering into the mind of the great betrayer.

Ecce Homo has something troubled and troubling about the face of Jesus (Figure 65). But as Jesus did indeed come to trouble us, and cannot but have been troubled both about the state of the world and his own vocation to save it, Howson has perhaps shown an aspect of the story that most of us prefer to gloss over. **Legion**, referring to the man in the Gospels who had the devils expelled from him, has a similarly disturbing effect, no doubt because it reflects something of Howson's own fragility and torment (Figure 66).

[10] See Richard Harries, *The Passion in Art*, Ashgate, 2004, p.130, where the painting is reproduced.

Figure 65 Peter Howson, Ecce Homo

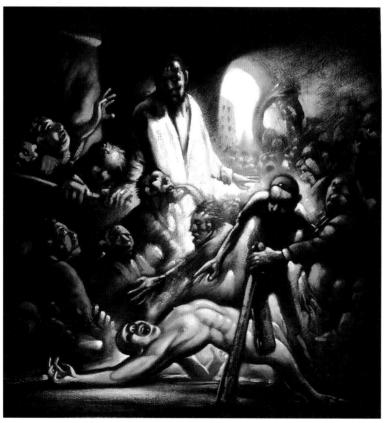

Figure 66
Peter Howson,
Legion

Nicholas Mynheer

Nicholas Mynheer (1958–) was born and brought up in Horton-on-Otmoor, a little village 10 miles from Oxford. That is where he still lives. His father was a draughtsman, and both parents were artistic. He himself has always drawn. He studied design at Hornsey College of Art and then went into advertising. Newly married, with a very well-paid job, he was copying an old master one day when he knew he had to throw everything up and become a painter. With a young family to support, he has known difficult times financially but has been kept going by a strong sense of Christian vocation. He has always focussed on biblical themes and Christian iconography and has not been drawn to other subjects. Some of the first works of art that made an impact on him when he was young were the paintings of the German expressionists, and his own work has a strong expressionist element, a powerful emotional charge expressed through his distinctive use of form and colour. Like a number of the artists who have been considered in this book, he also is an admirer of William Blake and Samuel Palmer.

Mynheer's style is highly individual. A picture or carving by him is instantly recognisable. Like his vocation to become a painter in the first place, this style came about in a moment of insight. He had spent more than two months painting Christ in the Garden of Gethsemane in the naturalistic manner that he used at the time, when he suddenly realised the picture was really bad. Very depressed, he cut out a small piece of cardboard, looked at the scene again and simply drew on that piece of cardboard the elements in it that seemed essential to what he wanted to express. So his approach is now is always to focus on the essential figurate elements and to cut out all extraneous detail, which is one of the reasons why in the first place he was drawn to small paintings. In these there was less temptation to put in surplus detail. The result is that a particular gesture can be highly exaggerated, and some parts of the body, an arm for example, if they are not part of the essential element, are simply not painted in at all. The only way in which his style has changed over the years is that the exaggeration has got less, and the emphasis has become more subtle.[11]

The Women at the Empty Tomb is from Mynheer's Sarum series on the Passion, which was first shown in Salisbury Cathedral. These paintings deal with the traditional scenes of the Passion with heightened colour and a sense of drama. Mynheer will not sell them, but they have been shown from time to time in a church or cathedral. In **The Women at the Empty Tomb** there is a fierce, numinous quality to the scene (Figure 67). The story of the women coming to the tomb and finding it empty was the earliest way in which the church depicted the resurrection of Christ, but in these early depictions the angels are shown sitting calmly by the tomb and the women are demurely asking what has happened. In Mynheer's version there is nothing calm. The women are distraught and pleading, the angels inaccessible and awesome, flaming spirits or fire, as the Bible sometimes suggests.

Mynheer sees his paintings as standing in the iconic tradition, in other words they are not simply works of art, but are there to help people in their life of faith. Sometimes, as in Elijah Being Fed by a Raven, he explicitly draws on the traditional iconography of the Orthodox Church. However, his intention is that his art should first work both at an artistic level and in relation to some universal experience with which people of any or no belief can identify. The biblical resonances are designed to work in and through this wider intention.

For example his two paintings **The Flight to Egypt** (Figure 68) and Rest on the Flight to Egypt are to be seen first of all as relating to the many people in the world today who have had to flee

[11] The information in the two previous paragraphs and later on in this section are derived from my personal interview with the artist.

their homes as refugees. At the same time they take up well-known iconography from mediaeval art in the Western tradition, based partly on the story in an apocryphal gospel about the flight and how the holy family rested on the way. Mynheer's hope is that even people totally unfamiliar with this traditional reference will be able to identify with the experience.

Figure 67 Nicholas Mynheer, The Women at the Empty Tomb

Figure 68 Nicholas Mynheer, The Flight to Egypt

Figure 69
Nicholas Mynheer, Christ and St Peter

Figure 70
Nicholas Mynheer,
The Harvest

In recent years Mynheer has taken to carving, for which he has received a number of commissions, most recently for some bas reliefs for a font he has designed for a new church in Qatar. He took up carving by accident. He was on holiday with his wife in France and had promised her he would not do any painting so that they could enjoy looking at things together. However, he picked up a piece of wood and started whittling it with a penknife. When he got home he happened to show what he had produced to a gallery owner who immediately wanted to sell it for him. A meeting with Fenwick Lawson also encouraged him in this direction. In **Christ and St Peter** we see Mynheer's capacity to tell a story, in this case a series of stories, by focussing on a few telling gestures (Figure 69). Peter is looking up at Christ and making his confession, 'Thou art the Christ', but his arm is also raised in a gesture conveying 'Save me', for when he tried to walk on water he felt himself drowning. In Peter's arms there is a bowl of fish, for he was to become a fisher of men. At the top, on Christ's left, is a rock on which other followers of Christ are standing, so we are reminded of the words to Peter: 'You are a rock on which I will build my church.' Below the rock is the cock that signalled Peter's betrayal. The whole story of the relationship of Christ and Peter is presented through a few highly selective details.

In recent years Mynheer has worked in glass as well as other media, including a series of windows for Abingdon School chapel.

The strength of Mynheer's work is obvious. It is an accessible, fresh and striking reworking of familiar Christian images. His early training in design and work in advertising has clearly lent its influence here. His work is full of symbolism, as illustrated by the carving of Peter, just discussed, and in his more recent **Harvest** (Figure 70). Some might find this symbolism overloaded, but it clearly works for many, especially when we bear in mind that these are works designed for Christian churches and chapels. The main point is whether it works first at an artistic level, and many of his pieces clearly do. A further question is whether the dark, disordered side of human life, so prevalent in our time and reflected in so much art of the twentieth century, is fully taken into account. But here again, it might be said, that in a dark time it is good to have work that reflects the words of Julian of Norwich that 'All shall be well, and all manner of thing shall be well.'

The Harvest is characterised by vivid colouring and stark forms which immediately arrest the eye. As such it works at an aesthetic level. But it is a painting that carries heavy symbolism, as Mynheer himself has written:

> The Harvest picture is an example of the growing influence of the countryside in my paintings. I see this as a Deposition. The basket of apples represents Christ as the fruit of the tree. The basket is being received by a figure [possibly his mother] whilst the figure lower right reaches to pick up a fallen apple [she represents Eve]. The three trees are the crosses and the one to the left has a few fruit on (the Good thief). The two ploughed fields represent the tearing of the Temple curtain.

That kind of symbolism is not in fashion today but, whether or not one responds to that kind of interpretation, the painting succeeds first as a work of art with a suggestive spiritual dimension to it.

Sr. Bridget admired his work and was present at her funeral.

Mark Cazalet

Mark Cazalet (1964–) was educated at Stowe and then Falmouth College of Art. He is capable of painting in a range of different styles and indeed it is possible to see the influence of a variety of different artists in some of the work he has done: for example iconic, as in <u>Raising of Lazarus;</u> Stanley Spencer, as in <u>Angels in Peckham;</u> and Georges Rouault, as in <u>Mr and Mrs Hosea.</u>

Figure 71
Mark Cazalet, West London
Stations of the Cross: Christ
being Judged

Figure 72 Mark Cazalet, Three Johannine Miracles, the Blind Man

Figure 73
Mark Cazalet,
Judas

In contrast to Nicholas Mynheer, Cazalet does not confine himself to biblical subjects and does not like the description 'Christian artist', for he wants to say that even when painting secular subjects there can be a religious response.[12] He also likes to involve schools and local communities so that they produce a work of art together. He is at his strongest and most original in his cityscapes, as in Everyday Epiphany III and Kensal Rise Gasholders, Sunrise, Midday and Evening. Such cityscapes came together with Christian imagery to produce a very effective series entitled **West London Stations of the Cross**. Whilst believing that the Bible expresses timeless truths, he thinks they come alive for us by giving them a contemporary setting; hence he sets the Passion story in West London, as he also gives a contemporary setting to his painting Jesus's Childhood in Nazareth.

In **Christ being Judged**, one of the paintings in his West London Stations of the Cross, Cazalet has well captured the all-dominating motorway and what it must feel like to live nearby and play under it (Figure 71). At the same time the motorway junction is not without the kind of beauty that can characterise all good engineering. Although in recent years Cazalet has focussed on the beauty of the natural world, especially trees, there is an urban beauty to be discerned as well, if an artist can open our eyes to it, as he has here. But the point of the picture is the little group in the middle, which almost seems inspired by a game of urban cricket; or is it a group of youths ganging up on a weak member, with a few lolling spectators prepared to jeer? In fact it is Christ being judged, similarly the victim of a tacit conspiracy between an aggressive few and an unthinking crowd.

[12] The details in this section are derived from my personal interview with the artist.

What is really going on in 'Christ being Judged' is hidden from the world. This is because Cazalet thinks that Christianity is essentially a hidden and oblique exercise, and this should be reflected by Christian artists in their art. Artists are prophets and seers, on the edge of things, suggesting a different way of seeing and understanding life. Something of this conviction, also using a contemporary setting, comes out for example in **Three Johannine Miracles** (Figure 72). In this painting we are confronted by an ordinary city scene: a man fishing in a stretch of water, perhaps a canal, against the background of empty gasholders. The clue is in the white stick lying on the ground. You see the scene in a new way, a man with newly restored sight being able to enjoy, perhaps for the first time, the ordinary sights around him.

Cazalet works in a range of materials – textiles, glass and mosaic as well as painting. He has received a good number of commissions for churches, in which these different media have been used in a way which both responds to what is desired by the commissioner and the liturgical setting. Such works include The Tree of Life for Chelmsford Cathedral; The Cross of the Nations for the church in Doha, Qatar; an Altar Frontal for Holy Trinity, Bosham; and a very lively Notting Hill Carnival for St Clement's, Notting Hill.

Although fully conscious that there is no 'symbolic order' that unites our society, and that the old images have lost their freshness, Cazalet is optimistic that there are fresh ways of treating the themes that can break through to people's feelings. He has sought to do this in such paintings as Jesus in the Garden of Gethsemane, Christ's Entry into Jerusalem, perhaps reflecting the influence of Ana Maria Pacheco, and **Judas**, in which a combination of strong, dark colours and facial expressions make the point (Figure 73). In the earliest of all depictions of the crucifixion, a small ivory dating from 420 now in the British Museum, Judas hanging dead on a tree is juxtaposed with Jesus alive on the cross. The twentieth century has been more interested in the psychology of Judas, as in Peter Howson's study of him as here in Cazalet's work.

As mentioned, Cazalet works in a range of both materials and styles. His work is evolving all the time and it may be that in contrast to Nicholas Mynheer, above, and Roger Wagner, to be discussed, who found a distinctive style early on and have kept to it, he will continue to exhibit versatility. Meanwhile his work has already shown its capacity to revitalise traditional Christian themes by giving them contemporary contexts and a fresh perspective.

Charles Lutyens

Charles Lutyens (1933–) studied at the Chelsea, Slade, St Martin's and Central schools of art in London, and later in Paris. Though mainly a painter, he has worked in a range of media and has exhibited widely. From 1963 to 1968 he worked on a commission for a mosaic mural of Angels of the Heavenly Host on the four long panels high above and surrounding the congregation and altar of St Paul's, Bow, with light flooding down from the large lantern on top. At 800 square feet it is almost certainly the largest contemporary mural in the British Isles. Lutyens was commissioned by the architects of the church because they thought his work consistently revealed 'a feeling for states of mind or spirit'. They thought that as we do not know what angels look like it was important that the work be not too representational, and they thought the work had achieved just the right balance 'between the figurative and the abstract, between severity and empathy, between assertiveness and recession'.[13] Mainly a portrait and landscape painter, Lutyens has turned to Christian themes from

[13] Charles Lutyens, *Being in the World: Paintings, Drawings, Sculptures, Mosaic*; info@charleslutyens. co.uk, 2011, p.64.

Figure 74 Charles Lutyens, The Mocking

time to time, as in **The Mocking** (1968). What is interesting about this depiction is the way the tormentors hide behind a great sheet, as though they do not want to see what they are doing. The great red sheet also heightens the sense of Jesus exposed and vulnerable (Figure 74).

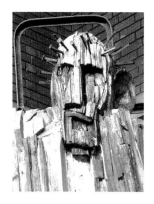

The highlight of a 2012 exhibition of work by Lutyens at St Paul's, Bow, was a recently completed sculpture, **The Outraged Christ**, in which Liverpool Cathedral has shown an interest. This is much larger than life, being some 15 feet high. It is made of carved and recycled timber shaped in the form of slats (Figure 75). The first Christians liked to show Christ victorious on the cross. The mediaeval period focussed on his suffering for the sins of the world. The twentieth century too focussed almost exclusively on the suffering of Christ, but more often than not as a paradigm of the suffering of a terrible century with its innumerable victims.

The depiction of Christ outraged in **The Outraged Christ** is a fresh addition to Christian iconography. It is a moving, impressive work. Instead of Christ being shown battered or anguished, it depicts him with mouth open, slightly to one side, with his knees pushing forward from the cross, in rage. But here is rage, indeed fury, not just at what is being inflicted on him but at the tragic nature of the world and what we humans do to one another within it.

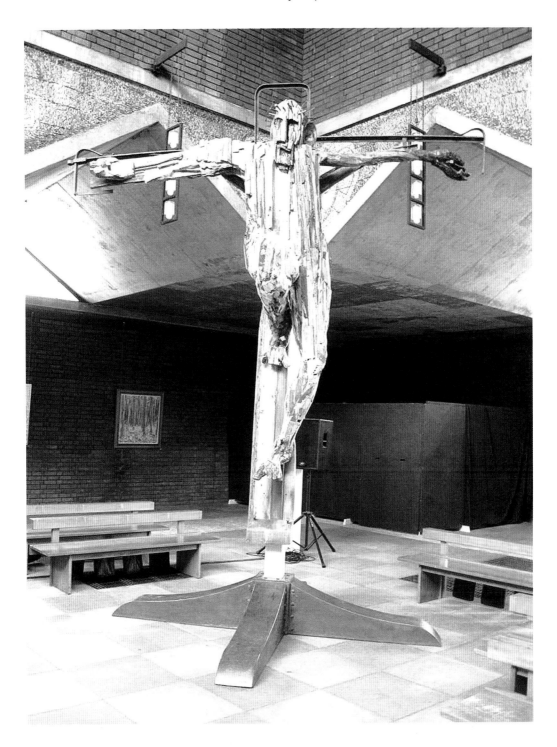

Figure 75 Charles Lutyens, The Outraged Christ (for detail see previous page)

Greg Tricker

Greg Tricker (1951–) was born in London but for many years has made his home in Gloucestershire. Two facts about his early childhood are decisive for an understanding of his art.[14] One is that his parents were Jehovah's Witnesses. He had a bad relationship with them and reacted against their faith. Nevertheless they left a deep understanding and feel for the Bible. Secondly, at the age of 10 he discovered Van Gogh, who affected him deeply at both an emotional and a spiritual level. This led him to study and copy Van Gogh's paintings time and again, and since then painting has been his life and obsession. After a number of jobs as a young man, for some time he earned his living mainly as a mason and carver, all the while continuing his painting, which for a number of years he has done full time. Early championed by Sister Wendy Beckett, his art is now becoming better known, with recent major exhibitions in both Salisbury Cathedral and Berlin.[15] He is as equally skilled in sculpture and stained glass as he is in painting.[16]

A characteristic feature of his work is he that he is impelled to do a series of paintings on a particular person or theme, rather than a number of unrelated works. These include Anne Frank, the Catacombs, St Francis of Assisi, Kaspar Hauser, Bernadette of Lourdes, the Christ Journey and, most recently, Joan of Arc.

Tricker's need to work on a particular person or theme is intimately connected to his whole method of working. He needs to get fully inside a person in their setting. So it is that he has gone to stay in the places connected with the people whose story he paints. Even more important, for him painting is about getting inside a subject spiritually, almost feeling their presence. Indeed 'presence' is a word he will use when talking about them. So for him, even the contours and folds of a person's garment will be something that he feels from inside the subject. As mentioned earlier, Stanley Spencer's paintings reveal something of the same characteristic of being within the physical body depicted in a painting rather than an onlooker.

Tricker uses bold, clear lines and he is clearly a skilled draughtsman. But without downplaying that essential element it is his use of colour that is so striking. He would agree with Norman Adams, discussed in the last chapter, about colour being the essence of painting. It was the colour in Van Gogh, as much as anything, that drew him into painting in the first place. And colour, for Tricker, has profound spiritual resonances. He talks about 'Gethsemane' green. There are many kinds of green he says, but he sees the green which he uses in a number of his painting quite clearly and unequivocally as Gethsemane green. Some of the colours, such as those in the Joan of Arc series, are very strong. But in some ways his most successful paintings are those with extremely subdued and subtle shades of grey and blue, with occasional touches of green and white.

Tricker is reluctant to say anything about his technique of painting, because at the heart of it for him is the feeling of almost being taken over by a spiritual impulse beyond him. This means that he paints conscious of a vocation that he cannot resist, with great spiritual intensity. What people are now discovering, following the lead of Sister Wendy Beckett, is that the strong spiritual feel which Tricker himself has about his paintings is most assuredly conveyed to the viewer. This is not separable from his use of line and colour, but is in and through them. Wendy Beckett is not alone in seeing a particular 'grace' in them. He would I think be very much in sympathy with the statement of Stanley Spencer quoted earlier, that painting is in the end not a talent or technique but an act of love. And, as for Spencer, that love is integrally rooted in a spiritual vision of life.

[14] The information in this section is derived from my personal interview with the artist.

[15] His work is promoted by Robert Travers at http://piano-nobile.com.

[16] Sister Wendy Beckett, *The Christ Journey*, St Paul's and Piano Nobile, 2011.

Figure 76
Greg Tricker, Christos: 'I am the Bread of Life'

Something of Tricker's understanding of art is revealed in his response to other artists. Eric Gill, for example, however skilled, he finds cold, leaving the viewer outside the experience. He responds positively to Epstein, particularly his Lazarus, discussed earlier. Cecil Collins, whom he admires, he finds too focussed on paradise, for the world is a much rougher place than that. It is therefore not surprising that Tricker often uses rough old doors, still with their metal hinges on, instead of canvas. His works have a spiritual purity about them but they are earthed in the actual world of old, cracked wood.

Tricker's spiritual vision, the driving force of his work, is not easily categorisable. Although he has focussed on a number of Catholic figures, such as Bernadette and Joan of Arc, he is not a Roman Catholic. He is supportive of the church and what it does, but is not himself an active member in any formal sense. He is drawn to people who have a direct, powerful experience of God, like Francis and Bernadette and, most recently, Joan of Arc. Yet his art comes across as not just spiritual in a general sense but as profoundly Christian. This is revealed also in his account of his own spiritual journey. At its origin there is indeed a sense of the spiritual dimension of the whole cosmos, and that is why he is drawn for example to the work of Rudolf Steiner. However, when he went to visit the Catacombs to do his catacomb series he experienced that cosmic reality becoming, as he put it, 'incarnate'. He believes that figures like Helios (the sun) and Orpheus expressed spiritual truth in mythological terms, but in Christ this truth became incarnate. So he sees Christ and the Christian movement as one of the great turning points in human history. After Christ, as it were, heaven and earth were joined, never to be unjoined. That meaning of the incarnation has remained with him and been expressed through his subsequent painting; so for example Brother Sun, in the high heavens, becomes united in Francis with Lady Poverty, in the actual lived life of a particular person.

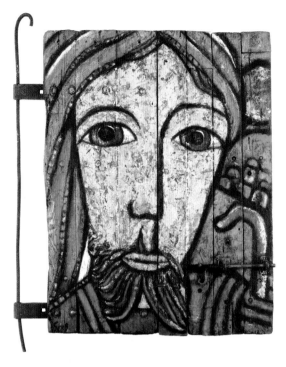

Figure 77
Greg Tricker, I am the Good Shepherd

Stained glass is a medium which is particularly well suited to Greg Tricker, allowing his spiritual feel for colour and light full play. In **Christos: I am the Bread of Life** we are drawn first to the face and then the hands. The spears of light round the halo point to the head of Christ, which emerges luminous out of the rich red and dark background (Figure 76). This is not a portrait of the historical Jesus; it is a timeless Christ present in every time – a Risen Christ as universal spiritual presence, looming out of the infinite unknown into an accessible focus for every generation. Sister Wendy Beckett sees Christ looking mystically inward. I rather see him rather coming out of that hidden inwardness to gaze at the viewer. The hands shield some half-hidden loaves of bread. The effect is of Christ at the Eucharistic table giving of himself to the believer, not so much at the Last Supper as now.

On either side of the Christos is grain, which like bread in the Bible is an image that is rich with meaning. In particular perhaps we think here of the grain of wheat which if it dies brings a rich harvest.

'I am' is one of the most profound utterances in the whole of the Hebrew Scriptures (the Christian Old Testament). It is the word of the Divine Other, as received by Moses. In St John's Gospel Jesus uses this phrase in relation to himself, in association with a number of different images – bread, as discussed above, and shepherd as here in **I am' the Good Shepherd** (Figure 77). Tricker has drawn on the 'I am' both for the two paintings which are illustrated here and also for three others: Christ as the true vine, as the way of the cross and as the light of the world. If Tricker's work has something of folk art about it, it is folk art imbued with a deep mystical appeal, expressed amongst other ways in the large eyes of Christ here and in the other portraits. The onlooker is not so much looking as being looked at, with a gaze that goes to the heart and invites a response.

Roger Wagner

Roger Wagner (1957–) read English at Oxford, where he obtained a First, and then studied art at the Royal Academy. His work is totally unlike any other modern artist, Christian or not. It is painstakingly old-fashioned in its sheer artistic skill, for Wagner can spend a year or more on a single painting; and at the same time it is surrealistically modern in its mythopoetic power. It is interesting that of modern painters the biggest influence has been Giorgio de Chirico, even though Wagner does not usually respond to surrealism. As a schoolboy he saw an exhibition of modern masters in Venice and of all them it was 'The Rose Tower' of de Chirico that leapt off the wall for him and left the deepest impression. The colour, energy and empty spaces gave a sense of strangeness that made him see the poetry in painting. Whilst he admires Picasso's talent and virtuosity, the only painting to which he responds is *Guernica*, which he regards as a great work. As far as modern painters depicting Christian themes goes, he tends to admire individual works rather than a whole *oeuvre*, for example, Graham Sutherland's early crucifixions rather than his work in Coventry Cathedral.[17]

Wagner has thought long and hard about what it means to be at once a modern painter and one who responds to the Christian faith.

He regards the defining feature of modernism as the relentless urge to create something new. Noting the rapidly changing artistic fashions during the twentieth century, he has said: 'The driving force in all this churning succession of movements is the idea that art must constantly re-invent itself if it is to be relevant to the ever changing force of the modern world.'[18] This immediately presents a problem for an artist who wants to focus on religious themes, whether Christian or not, because all religions look back to founding figures and events. He remembers how when he was at the Academy experimenting with sixteenth-century painting techniques his tutor asked him if he would not think it odd if a modern playwright wrote plays in Elizabethan English. Also, quoting the question the distinguished philosopher Bernard Williams posed to his young doctoral student Jonathan Sacks – 'Don't you believe there is an obligation to live within one's time?' – Wagner remarks that these are deep and serious questions. I believe the effect of these questions has made it clear to him that as an artist he must indeed live within his time; he must be a modern artist, even though his painting at first glance seems so different from most contemporary art.

The relentless search for the ever new that characterises modernism and its successors affects the arts in a very distinctive way. It means the very rules of art seem to change, the criteria of what makes art good or bad. It is as though the rules of football changed from one generation to another. Here, drawing on the dialogue between Gombrich and Karl Popper, Wagner takes comfort from the conclusion of the latter that 'while it is true that standards in art change, the new standards that appear do not invalidate the old ones'. Indeed they only make sense when and where they organically develop from the old ones. In new forms of art there can still be objective standards – 'standards engendered by the work of uncounted workers before him, together with his own'.

With this fundamental approach he takes particular inspiration from the philosophy and poetry of T.S. Eliot, who with de Chirico has been the other decisive influence on his understanding of what it means to be a modern artist. Wagner responded early to the shifting perspectives and crazy

[17] From my interview with the artist, which is also reflected in the rest of this section on Wagner.

[18] This and much of the next paragraphs is the argument Wagner put forward in a lecture at Gresham College, 'Marching to an antique drum?', on 30 March 2012, available on the Gresham website, http://www.gresham.ac.uk.

juxtapositions of *The Waste Land* and how they came together as a whole to form a haunting dream logic. Then later he came across Eliot's writing on tradition and his view that:

> the historical sense compels a man to write not merely with his own generation in his bones but with a feeling that the whole literature of Europe from Homer and within it the whole of the literature of his own country has a simultaneous existence and composes a simultaneous order.[19]

Here he discovered an approach to modernism that he found profoundly sympathetic, one that was worked out for Eliot in the magnificent poetry of *The Four Quartets*.

With this carefully thought through understanding of modernism Wagner has had the confidence to pursue his vision of juxtaposing past and present within the same canvas; to draw on styles of different epochs by including visual echoes in much the same way as Eliot used verbal ones.

The other basic feature of Wagner's artistic philosophy is the way is he not shy of saying that art should aim at beauty, and the way he holds together both aesthetic and spiritual beauty. We see beauty in nature, and this points us to the one St Augustine addressed as 'Thou beauty most ancient and withal so fresh'. But for a Christian the touchstone of beauty is the sacrificial love of God for us shown in Christ. Beauty in nature and art and the spiritual beauty of love all draw us, and they draw us beyond their manifestation to God himself, the source and standard of all beauty.[20] This means that in his paintings Wagner strives for the kind of haunting beauty he saw in the de Chirico painting as a teenager. He also juxtaposes images of Christ and his cross with the modern world in both its beauty and capacity for evil.

In addition to his painting Wagner is both a poet and someone who has learned Hebrew. A major feature of his work is his fresh translation of the Psalms published in limited editions with his own woodcuts.

Ash Wednesday, 1982, takes us into a haunting surrealistic landscape (Figure 78). It also brings to mind the opening lines the poem of that name by T.S .Eliot on which it is based:

> Lady, three white leopards sat under a juniper-tree
> In the cool of the day, having fed to satiety

We can see in this painting the work of a strongly visual literary imagination. It is not surprising therefore that Wagner also imagines, and therefore paints, the biblical stories in a highly visual way. These are at once traditional and surreal, with a contemporary setting and meaning, as we see in **Walking on Water III**, 1995 (Figure 79).

Wagner is also an accomplished poet, and sometimes he has written a poem to go with a painting, as he has for 'Walking on Water', with its scriptural quotation at the head:

[19] T.S. Eliot, 'Tradition and the Individual Talent', in *Selected Prose of T.S. Eliot*, ed. Frank Kermode, Faber, 1975, p.38.

[20] This was an argument that I also put forward in *Art and the Beauty of God*, Mowbray, 1993.

Figure 78 Roger Wagner, Ash Wednesday, 1982

'Lord if it is you' Peter replied
'tell me to come to you on the water.'
'Come' he said. (Matthew 6:27)
To step out of ourselves on to that sea
Forsaking every safety that we know
Becoming for one moment wholly free
That in that moment endless trust may grow.
To step into that love which calls us out
From all evasions of one central choice
Besieged by winds of fear and waves of doubt
Yet summoned by that everlasting voice.
To walk on water in astonished joy
Towards those outstretched arms which draw us near,
Then caught by winds which threaten to destroy
We sink into the waters of our fear.
Yet underneath all fears and false alarms
Are sinking, held, by everlasting arms.

Figure 79 Roger Wagner, Walking on Water III

When it is pointed out to Wagner that his method of painting biblical scenes against a contemporary background is what all the great artists in the past have done, he responds by saying that he had never been drawn to be an archaeological painter, trying to imagine the past as it was. Nor is it simply a question of recreating the scene. Rather, it is more a question of seeing the contemporary burgeoning with a biblical element. Wagner cites Rembrandt at this point, for with him you do not know if the scene is biblical or contemporary. It is this biblical element which gives depth and meaning to the painting. He also mentions Tobias Jones, who when he paints a wall leaves the impression that there is something mysterious and important behind it.

Wagner has done many studies of the poplar trees on Port Meadow in Oxford which, as his poem on one of them indicates, he sees in mystical terms. It is not surprising that trees are also prominent in a number of his specifically biblical paintings, not least his window in Iffley Church, which will be discussed. Here is his poem which relates to his study of a tree, again preceded by a biblical quotation.

> *He makes winds his angels*
> *His servants flames of fire (Psalm 104:4)*
> Who hears the ocean roaring in a tree
> That rustles like a thousand angels wings
> And feels the rising wind he cannot see,
> Is seeing to the burning heart of things.

> For as a book has pages stamped with ink
> While yet some meaning rustles all its leaves,
> So all things are as words that forge a link
> Between the writer and the one who reads.
> And that exulting love which made all things
> Whose laughter is the ocean in a tree
> that rustles like a thousand angels' wings
> Stirred by a wind no human eye can see,
> Breathes love into a world he would inspire
> In winds that flame with Pentecostal fire.

Wagner has done a series of paintings on Job and also, as mentioned, books on the Psalms with his own fine translation of the Hebrew and illustrations. The strong biblical images occasionally come with a marked Renaissance feel, as in <u>There is a River</u>, which illustrates Psalm 46. The origin of this is the influence of the Italian Renaissance paintings that hung on the walls of his parents' home. These were part of the collection of his uncle, Henry Wagner, who donated many of them to the National Gallery.

The first major painting of Wagner to catch the eye was '<u>The Harvest is the End of the World and the Reapers are Angels</u>' (1989), based on Matthew 13:39. There is no better comment on it than the poem he himself wrote:

> I saw the cherubim one summer's night
> Reaping it seemed a field of endless wheat.
> I heard their voices through the fading light
> Wild, strange and yet intolerably sweet.
> The hour such beauty first was born on earth
> The dawn of judgment had that hour begun
> For some would not endure love's second birth
> Preferring their own darkness to that sun.
> And still love's sun must rise upon our night
> For nothing can be hidden from its heat;
> And in that summer evening's fading light
> I saw his angels gather in the wheat:
> Like beaten gold their beauty smote the air
> And tongues of flame were streaming in their hair.

As discussed above, Roger Wagner is acutely aware of the challenge presented by modern art to artists who want to explore Christian themes, and has written thoughtfully about it.[21] But he did not deliberately set out to meet that challenge; rather he refers to Kenneth Clark saying that when he read something he had written earlier he recognised his own voice. He says his own style and subject matter emerged out of himself. He first recognised his own voice in his study of the harvest at the end of the world, having been dissatisfied with the first attempt as well as his first attempt at the Menorah, where he could see what he was trying to do but could see that he had not done it. In the later version he judged that he had achieved what he had set out to do. Asked about its contrariness

[21] Roger Wagner, 'Art and Faith', in *Public Life and the Place of the Church: Reflections to Honour the Bishop of Oxford*, ed. Michael Brierley, Ashgate, 2006, p.133 but see the whole chapter.

sp of c Lim

compared to the current zeitgeist, he says he has never taken the slightest notice of the zeitgeist. He likes paintings which convey a sense of a country where he is not quite sure where he is.

Another of Wagner's many striking painting is Menorah (1993), owned by the Ashmolean Museum but now hanging in St Giles Church in Oxford. A full discussion of this painting can be found in *The Passion in Art*[22] and also on Wagner's own website. Ostensibly it depicts Didcot Power Station, which dominates the landscape for 20 miles around. But the chimneys and the smoke billowing from them also bring to mind the gas ovens of Auschwitz, not least because there are seven chimneys and the painting is called Menorah. In front are three small crucified figures, whilst on the clay loam in the foreground Jewish figures turn away in lamentation and grief. An unearthly light slants across the scene, at once exposing and judging.

How does Wagner manage to convey in his paintings such a sense that something more is going on than can be seen with the physical eye? One characteristic has already been mentioned, his capacity to take us into a 'surreal' world which is at once not our world and yet which is strangely related to it in some way. Linked to this, and fundamental to his talent, is his use of light. The image of light and darkness is both the most ancient and the most fundamental of all religious images, common to all the world religions. In Christianity it has the particular connotation of the light of God's truth in Christ which reveals everything as it is both for judgement and salvation. In 'The Harvest is the End of the World and the Reapers are Angels' the wheat is lit with a brilliant light, as are the edges of the trees, whilst the sky is a sombre blue streaked with black, a black which is repeated on the back side of the trees, the wheat and the shadows. As indicated above, the effect in 'The Menorah' is even more stark. The loam of the clay and the cooling towers are lit with an eerie light, whilst the grieving figures are dark, and the blues and blacks in the sky are at once threatening and hopeful. In Woman Why Do You Weep? (2007) the foreground is dominated by black and purple. But the other side of Jesus is a wall that is lit up, and on the other side of the wall there is a mysterious hidden other world in which the sky is lighting up and the tops of the clouds are bright. The role played by the wall here reminds us of what Wagner has said about walls in the paintings of Tobias Jones. Clouds often play a key role in Wagner's paintings, usually with brightness on them evoking some sense of hope, but occasionally with a sense of foreboding. Overall the effect in this painting is of Jesus in the land of death and deep darkness bringing intimations of a realm of immortal light.

When we look at Wagner's work as a whole and reflect on how he has tried to convey certain distinctive Christian insights, the following features can be noted. First, an increasing emphasis on the fact that Christianity is a hidden and secret affair. We see this in the contrast between the very dramatic effect produced by some of his early paintings with the stillness and hiddenness of Christ in some of the later ones. 'The Harvest is the End of the World and the Reapers are Angels' is a highly dramatic, startling work, as also is his first study of Walking on Water. In this the mountains are dark, the waves rise threateningly and Peter, about to sink, gestures desperately. In '**Walking on Water III**' not only is the setting a modern one, on the Thames, but Jesus and Peter are tiny figures dwarfed by the towering Battersea Power Station on the opposite bank. Furthermore the water in the river is calm, and there is a stillness about Peter and Jesus that permeates the whole scene.

The story in Genesis of Abraham offering hospitality to three strangers and discovering they were angels was taken by the church from an early age as a sign of the Trinity, and resulted for example in the wonderful icon on this theme by Andrei Rublev in the fourteenth century. But the Abraham story is followed by the destruction of the cities of the plain, so in Abraham and the

[22] Harries, *The Passion in Art*, p.134ff.

Figure 80 Roger Wagner, Abraham and the Angels

Angels (1995) Wagner has set the meal against the background of Sizewell Nuclear Plant. Asked about the way he showed the biblical image as almost hidden against the background, he says that this is the way it was. He pointed out that Breughel did the same, though he himself had done this independently.

After a trip to Syria some years later a number of his paintings were given a Syrian background, and **Abraham and the Angels** (2002) features the meal in close-up, reflecting the hospitality of the Bedouin, against the background of a cement factory indicating the destruction of Sodom and Gomorrah. In this picture also, Abraham and the Angels, though very much present, do not dominate the scene. The eye is drawn first to the smoking chimneys of the cement factory (Figure 80).

Another example of the way that Christian truth is to be understood as a mysterious, hidden affair is displayed in **The Road to Emmaus**, 2008 (Figure 81). The house where the supper at Emmaus is held is just one house like any other on the road, and you have to look closely in order to find figures sitting under the trellis on the roof.

A further feature of Wagner's Christian vision is the humility and gentleness apparent in his portrayal of Jesus. In 'Woman Why Do You Weep?' Jesus is sitting on some steps turned towards Mary with outstretched arms and palms uppermost in a gesture of compassion. In his series on Job, after a series of images in which the power and wonder of nature is juxtaposed with Jesus as the divine power behind them, there is a painting of Jesus kneeling before Job with gentle posture, clasping both his hands and looking at him with love. It is entitled My Ears Had Heard of You but Now My Eyes Have Seen You (1995).

Figure 81 Roger Wagner, The Road to Emmaus

5 p 33

Opposite the window in St Mary's, Iffley by John Piper, discussed in Chapter 4, is a no less fine one by Roger Wagner – **The Flowering Tree** (Figure 82). In his interesting lecture 'Thinking theologically about modern art: marching to an antique drum?'[23] Wagner discusses how he was faced with the daunting challenge of producing work to match that of Piper and which was fully contemporary. Drawing inspiration from T.S. Eliot, both in his essays and poetry, Wagner concluded by saying: 'When I came to make the Iffley window I felt no hesitation in quoting from Palmer, from medieval painting, from Rouault or from wherever I liked.' So it was that both visual echoes of artists of the past, from Palmer, and some of the images from his previous paintings come together in a creative whole: the sheep he saw on Dartmoor, the great trees he loves to paint, the river of God discussed above, and the twelfth-century mosaic tree of life he saw in San Clemente in Rome are all integrated into an overall vision. As Pamela Tudor Craig has rightly commented, 'Iffley is the place to seek if you are looking for the best that we have done and can do today.'[24]

Roger Wagner has long been friends with Mark Cazalet, Nicholas Mynheer and two other artists: Tom Denny, the stained glass artist whose work can be seen in more than 30 churches

[23] Available on the Gresham College website.
[24] Pamela Tudor Craig, *Church Times*, 16 November 2012.

Figure 82 Roger Wagner, The Flowering Tree, St Mary's, Iffley

and cathedrals; and Richard Kenton Webb, who has exhibited widely and who is currently senior lecturer at the University of the West of England. They meet regularly to support one another. They are all conscious that, given the current artistic climate, it can be lonely trying to produce work inspired by a consciously Christian motivation. As Tom Denny has put it:

> A lot of things we are interested in are not generally esteemed in the contemporary art world. If you look at the reviews of contemporary art in any newspaper, there are certain words and phrases that are always used, such as 'irreverent', 'referencing', and 'humorous take on'. What we are interested in is not being irreverent but reverent; not 'referencing things', but 'being' things.[25]

These artists are also united by a desire not to see a church just as a useful backdrop to their work, as they feel some fashionable artists do, but as integral to the building. They wish to integrate their work with it, liturgically, sacramentally and theologically. Do these artists form a movement? They are certainly not a movement in the same way that the Pre-Raphaelites were. Their styles are very different for a start. They do not have a manifesto, though Simon Jenkins believes they are united by 'a shared vision of the transformative potential of art'.[26] Also, he argues, all good art, whatever the subject matter and by whomsoever produced, has a transformative potential. That is true, but this description by itself is not enough to signify what is distinctive about this particular group of friends. For all the dangers of the description, the one that comes to mind is 'Christian symbolists'. The original symbolists in the last decade of the nineteenth century, who were related to the symbolist movement in poetry, were concerned with the expression of inner and mystical truths in symbolic form. Roger Wagner and his friends are unashamed Christian believers, but they too show in their paintings how form can convey spiritual truths, in their case Christian truths. The description, as well as the practice, has significant dangers in that it can lead to the jejune, the over-obvious and the overdone. In their best work these artists avoid that danger.

If Roger Wagner is the most sophisticated theorist in his understanding of the dilemma presented by the modern movement to artists like himself, as well as one of its most brilliant exponents, what this chapter has tried to show is that the challenge as set out at the beginning of this book continues to be met by a range of talented artists in ways that are arresting and effective.

[25] Quoted by Simon Jenkins, ibid.
[26] Ibid.

Index

(Illustrations indexed in bold)